WORCESTER

A Portrait of Central Massachusetts

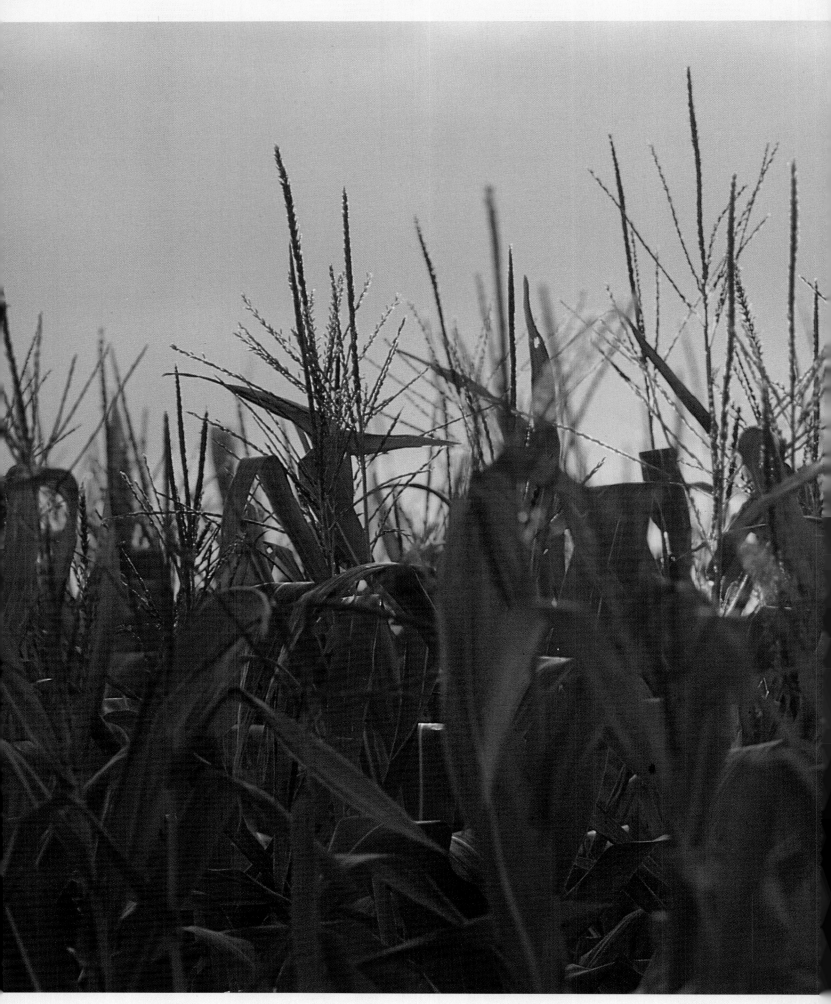

WORCESTER

A Portrait of Central Massachusetts

EDITOR
Lester W. Paquin

PROFILES OF ENTERPRISE
Janet Stone and Micky Baca

ART DIRECTOR
Christopher Miller

PROFILES DESIGNER
Thomas A. Miglionico Jr.

PUBLISHER
Donna Brassard

LARRY KNIVETON

WORCESTER PUBLISHING LTD.

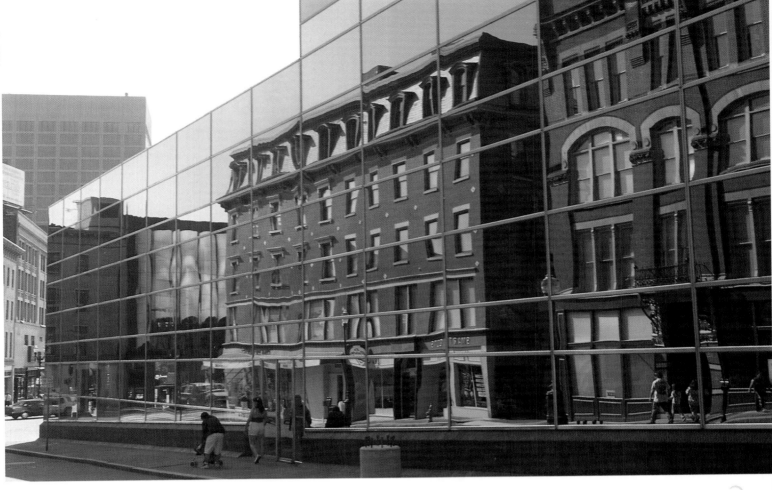

Copyright 1998 by Worcester Publishing Ltd.
IBSN # 0-9668420-0-6
Library of Congress
Card Catalog Number: 98-61658

Worcester Publishing Ltd.
172 Shrewsbury Street, Worcester, MA 01604
EXECUTIVE EDITOR, CHAIRMAN OF THE BOARD:
Allen W. Fletcher
PUBLISHER: Donna Brassard
GROUP PUBLISHER, COO: Peter R. Stanton
EDITOR: Lester W. Paquin
PROFILES OF ENTERPRISE EDITOR: Janet Stone
PROFILES OF ENTERPRISE WRITER: Micky Baca
ART DIRECTOR: Christopher Miller
PROFILES DESIGNER: Thomas A. Miglionico Jr.
PROOFREADER: Janice MorganJones
PROFILES OF ENTERPRISE ACCOUNT MANAGERS:
Betsy Abeles-Kravitz, Jeffrey B. Forts, Bonnie Leroux, Catheryn Colin McEvoy, Kathleen Real-Gowen, Jan A. Sullivan, Gary F. White
BUSINESS MANAGER: Jennifer Collentro
Printed in the U.S.A by
Walsworth Publishing Company, Marceline, MO.
Dustjacket printed by
LaVigne Press, Worcester, MA.

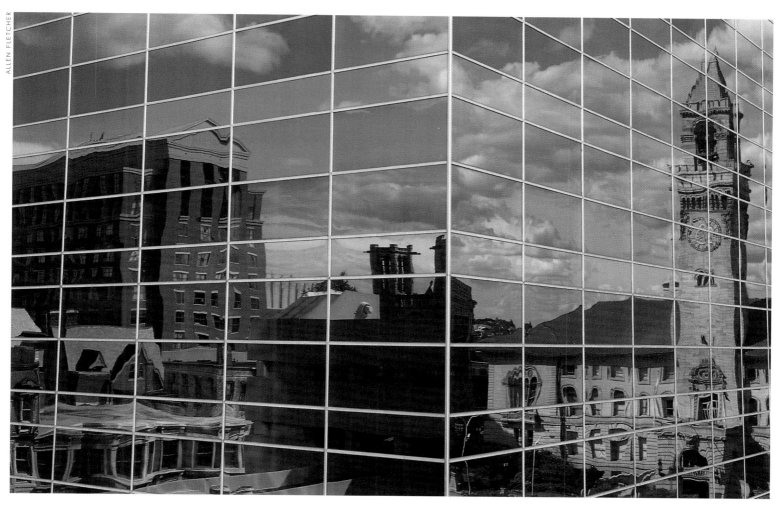

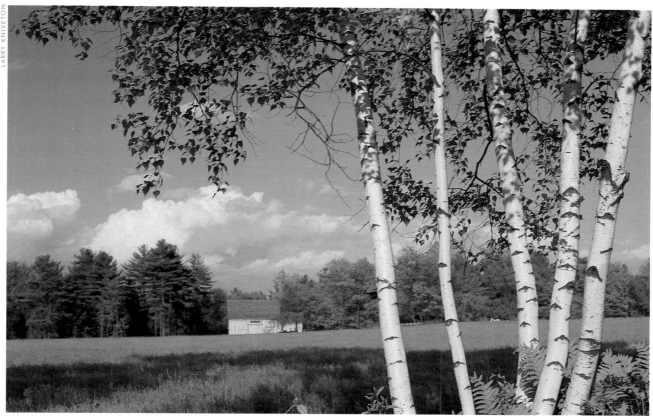

OVERLEAF: CHRISTOPHER NAVIN

Centuries ago, when the Old World discovered the New, the North American continent began its transformation from wilderness to colonies. Predominant among these early establishments of European influence were the settlements in New England, beginning at the shores of Cape Cod and spreading westward with steadfast purpose.

Eventually this progression of independent thought and reason, tempered by religious obligation and sustained by the daily fascinations of an old culture in a new land, found its way to the rocky hills and valleys of Central Massachusetts.

There were the inevitable quarrels with the land's native inhabitants, but for the most part a doctrine of peaceful coexistence was followed. This region's determined early settlers were blessed by more than their own adaptability and fortitude. The new arrivals gathered in community surrounded by the geographic confluence of New England's natural wonders. A journey to the northeast would end on the rocky shores of Maine, which was then part of this Commonwealth. To the northwest were the verdant mountains of Vermont, which descended southward in unbroken line to form the Berkshires. Rhode Island's outcroppings into the sea were off to the southeast

COURTESY WORCESTER HISTORICAL MUSEUM

and Connecticut's rich farmlands beckoned to the south.

At the heart of it all there was Worcester, which had grown from village to town by 1722. This emerging settlement was in turn surrounded by the beginnings of others. Farmers tilled the rocky soil in towns like Barre, Petersham and Hardwick; places like Gardner, Templeton and Winchendon crafted furniture in sawdust-strewn wooden buildings and America's Industrial Revolution came to life in the Blackstone Valley. As seasons changed — from winter's bite to spring's promise, from summer's languor to fall's glory — and the years went forward, the ongoingness of life in this remarkable region became as much a symbol of who we were as scarlet leaves in autumn.

With the right combination of leadership, ingenuity, industry, determination and good fortune, Worcester distinguished itself from the surrounding towns and became the center of activity and commerce in the county that bore its name. Making the transition from town to city in 1848, Worcester had become, both in symbol and fact, the centerpiece of one of the most vibrant and historically significant regions in New England.

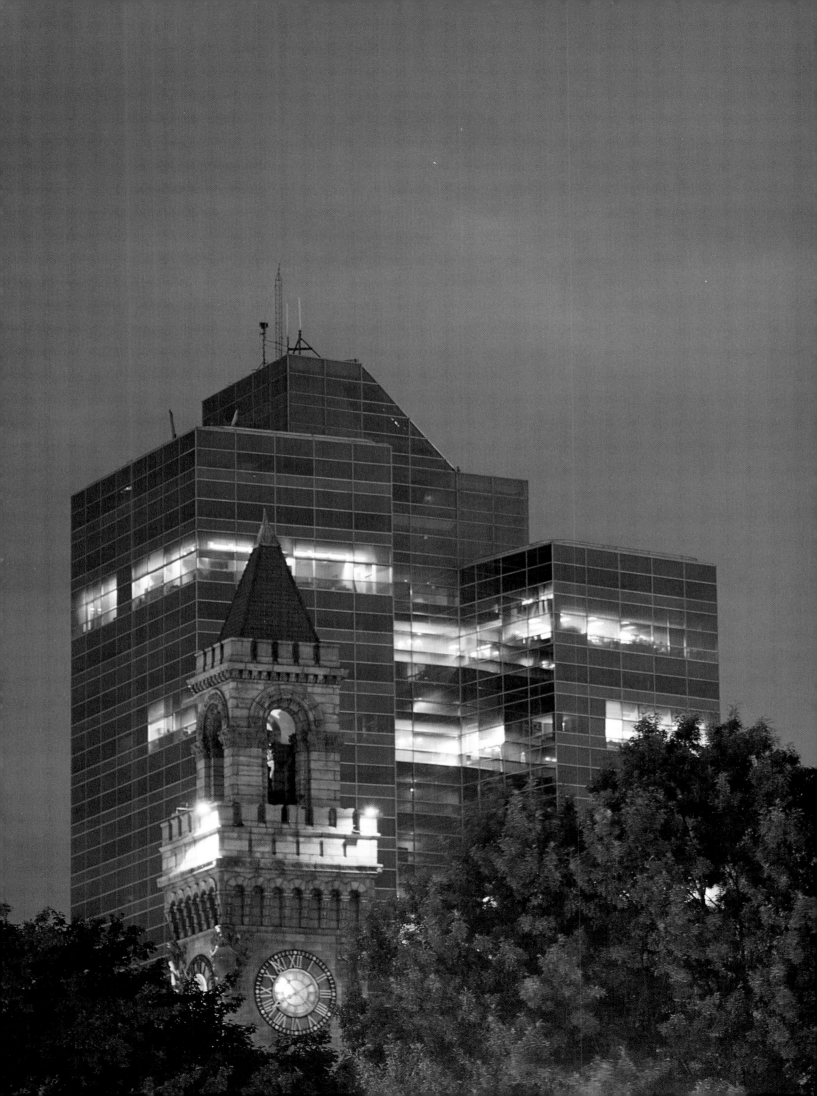

Worcester and the surrounding communities are a haven of traditional Northeast culture. Just as in Colonial times, the area attracts a diverse population, eager to fulfill their dreams and build their futures on the foundation of our illustrious past. New arrivals to the area are discovering — and long-time inhabitants are rediscovering — the region's beauty, charm and rich traditions.

History has been made here as well. Men and boys from all walks of life left their plows and workbenches to follow the drums of discontent. They fought for home and hearth in the Revolutionary and Civil wars, the Spanish American War, World War I, World War II, the Korean and Vietnam conflicts, Grenada, Lebanon and the Persian Gulf. Monuments both heroic and humble grace village greens throughout the region, testament to their spirit and sacrifice.

There have been achievements no less noble, but of equal importance and, at times, greater happiness. Long before the issue of slavery divided a nation, a former slave named Quork Walker fought for his freedom in a Worcester courtroom and won, establishing an abolition of slavery in Massachusetts three quarters of a century before the Civil War. The valentine originated in Worcester, as did barbed wire, the birth control pill and the smiley face. Mechanics Hall on Main Street still echoes with the voices of philosophers and presidents — Mark Twain spoke here, as did Charles Dickens, Henry David Thoreau and Teddy Roosevelt. The Worcester Art Museum is peerless, featuring antiquities and the works of Rembrandt, Renoir, Monet, Sargent, Whistler and del Sarto. And, on a hilltop in Auburn, Dr. Robert Goddard launched a rocket in the early years of this century that would eventually carry men to the moon.

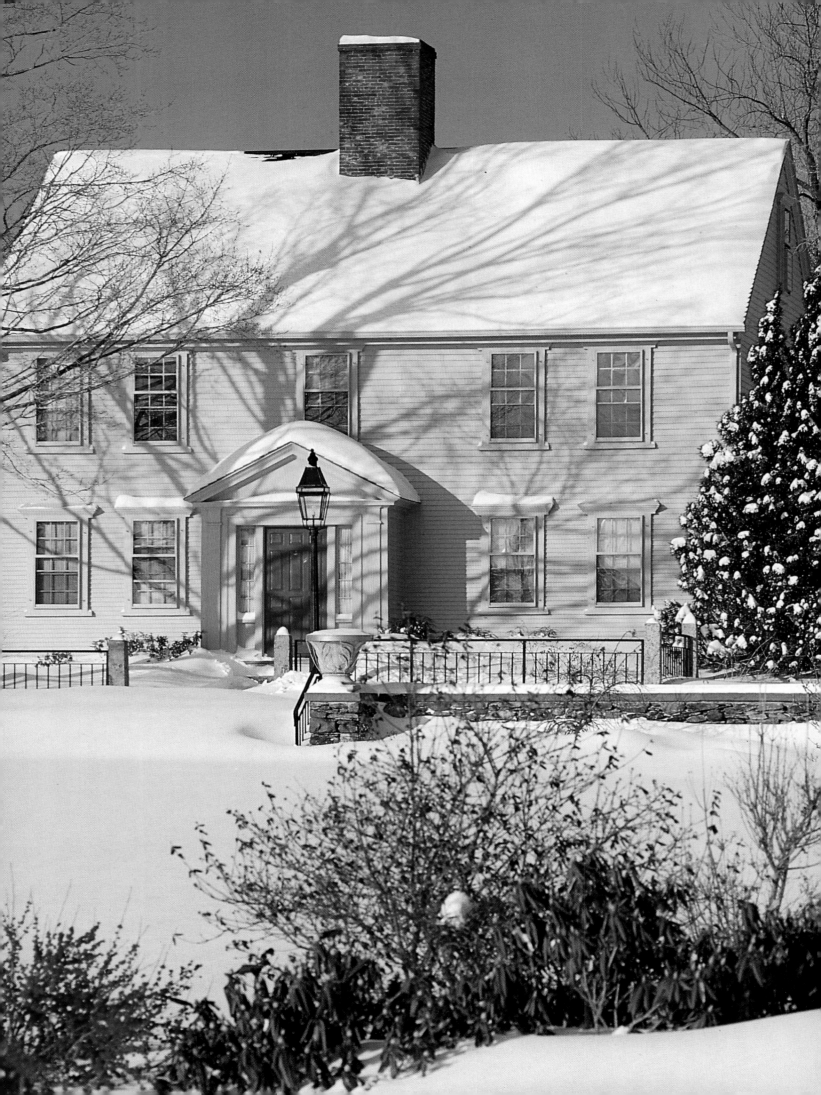

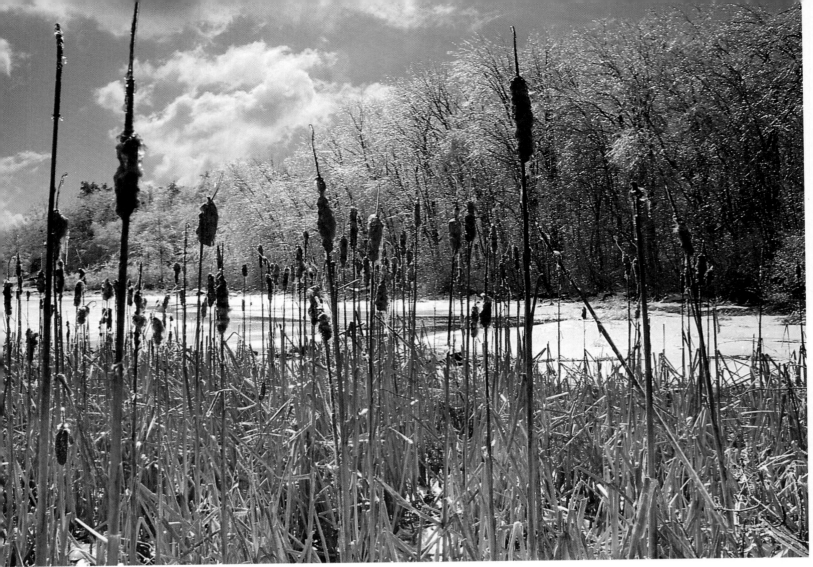

In Central Massachusetts today, it is a time of change and contrasts. Throughout the region you can witness new roads and bridges under construction, you can watch steel and stone being fashioned into huge complexes, you can see single-family homes rising toward completion and marvel at the resurrection of old mill structures. All the while, you can admire the public buildings, houses, parks, town commons, historic sites and ever-changing natural beauty that is unique to this area of the world.

In addition to the environment created by land and atmosphere, who we are can also be measured by the businesses which govern our economy and the near-dozen institutions of higher education that have the most daunting task of all — preparing the minds of today for the challenges of tomorrow.

Worcester and Central Massachusetts are strengthened by industries such as insurance, traditional manufacturing, plastics, biotechnology, health care and transportation. From the New Hampshire border to the Connecticut state line, business is booming in the Bay State, and no where more splendidly than right here in Central Massachusetts.

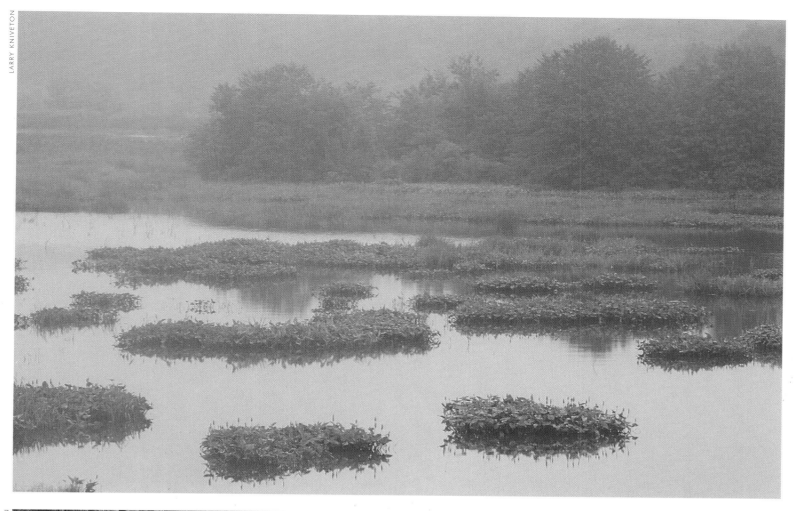

CHRISTOPHER NAVIN

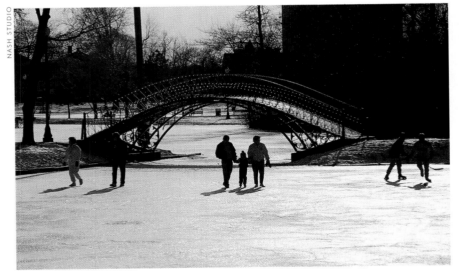

NASH STUDIO

While it would be impossible to capture the true culture and character of this region between the covers of a book, there are glimpses into our collective soul that are reflected in this volume. Unique landscapes and foliage are included, as are our museums, sporting events, businesses, architecture, neighborhoods and festivals. Froms dogs to diners, triple-deckers to bison, it's all here.

And, of course, we have people. Six million of them within an hour's drive of Worcester. At work and at play, smiling and sorrowing. Each face you see here, each figure testing its limits, each human being full of life, love, respect and remembrance — they represent all of us. Bursting with ethnic diversity, the region is home to those whose heritage can be traced to the four corners of the earth. All manner of worship, artistic endeavors, language and cultural exuberance can be found in the neighborhoods of Worcester, all brilliantly illustrating the wonder of our collective urban experience. People are what Worcester and Central Massachusetts are all about, and it is the honor of their lives — then, now and to come — that we celebrate in these pages.

—LESTER W. PAQUIN

FACING PAGE: NASH STUDIO

OVERLEAF: LARRY STEIN

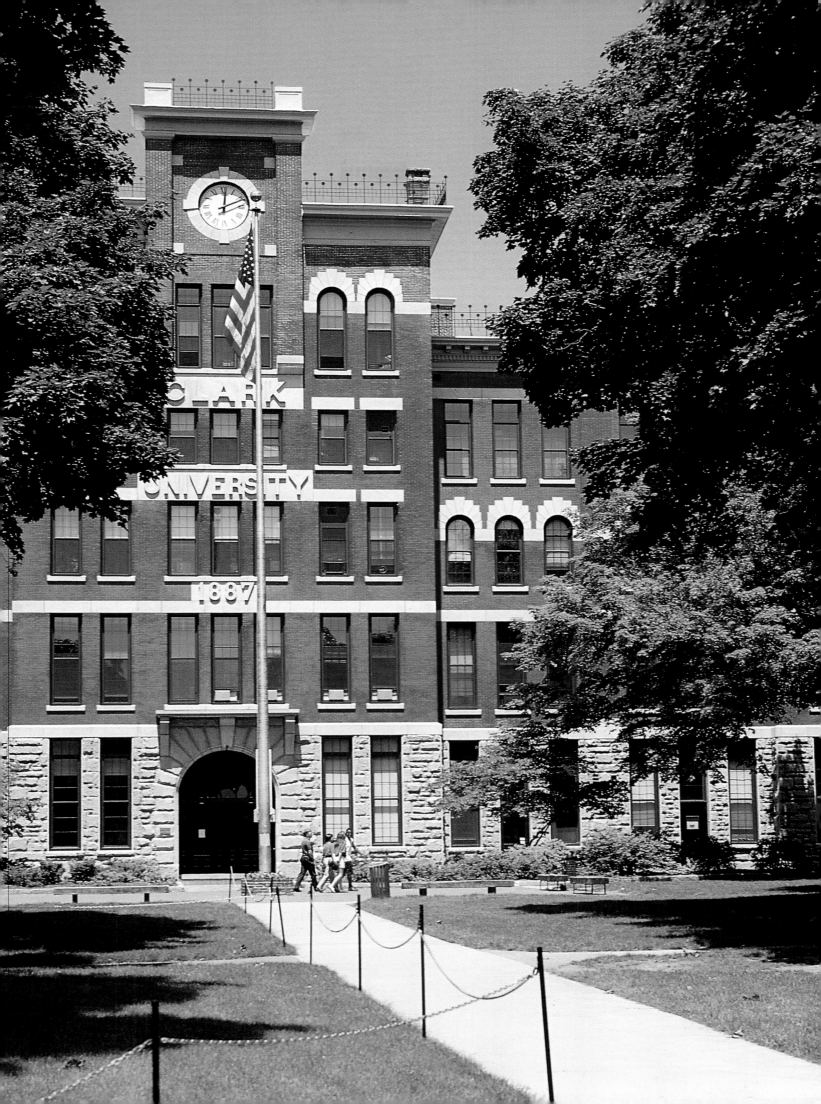

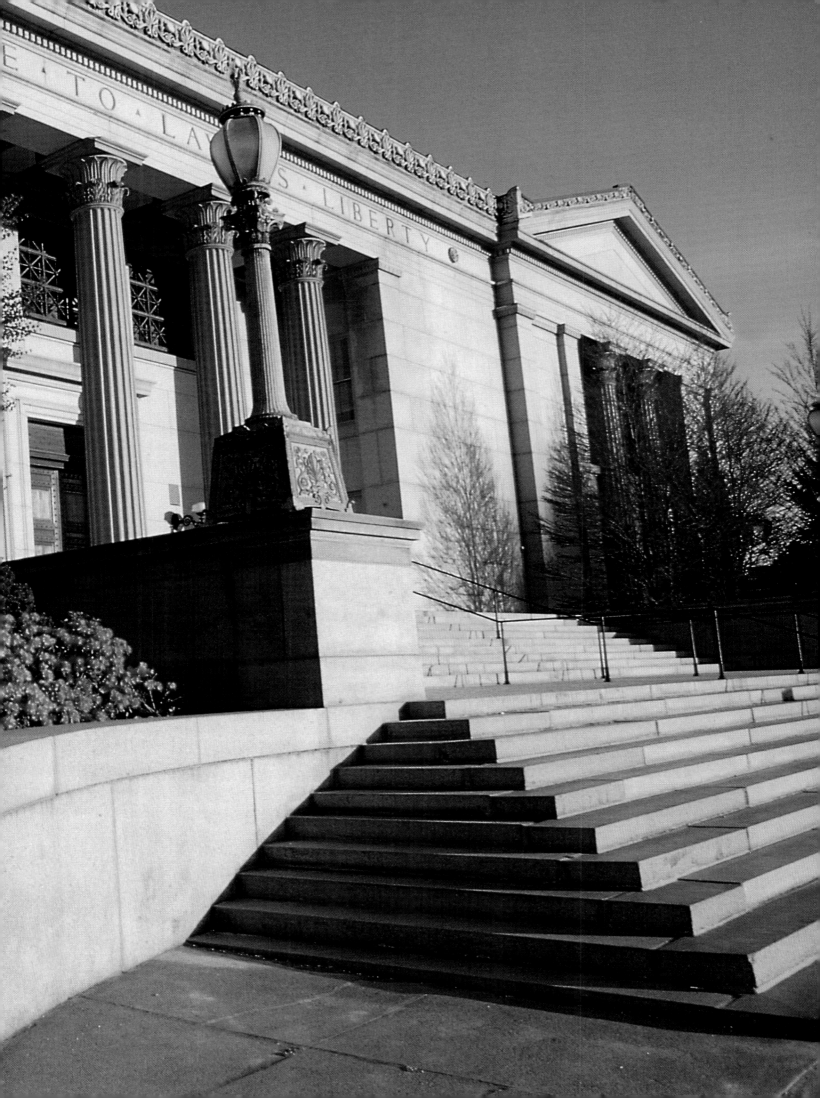

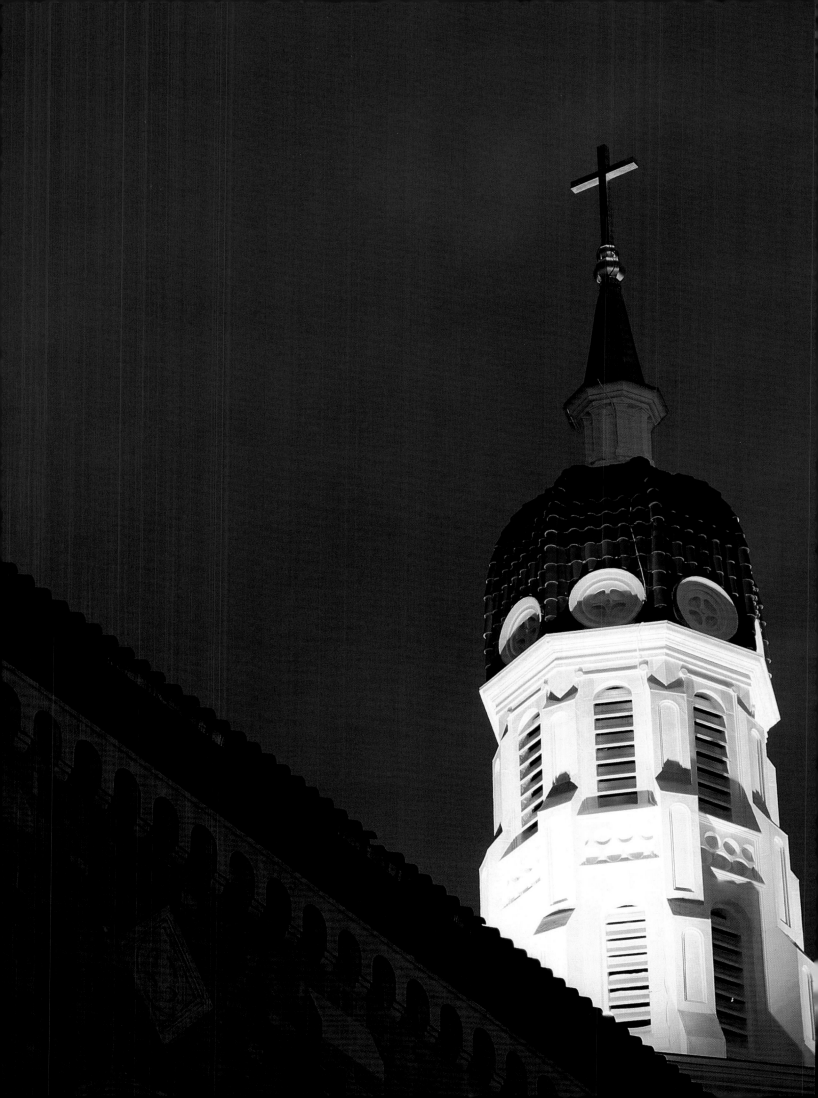

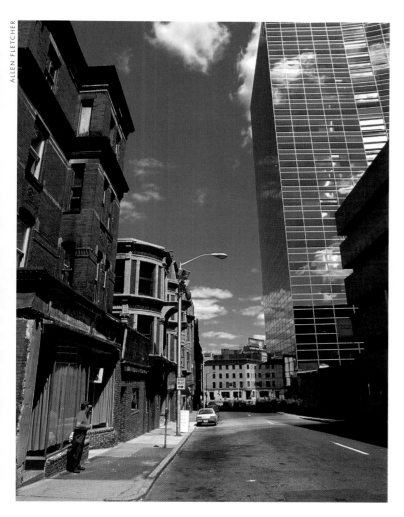

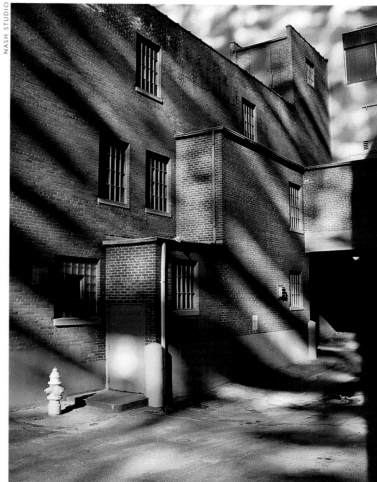

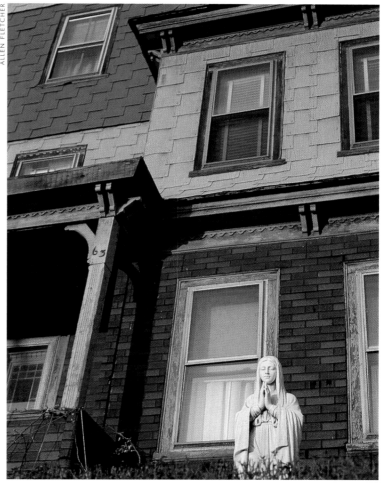

The character of a community is defined in many ways. Landscapes, climate, architecture and people all come together to give a region its flavor and balance. The buildings of Central Massachusetts are derived from a combination of rich heritage and practical utility. Combining the needs of different cultures, the adaptability of the land and the vicissitudes of New England's weather to form a mosaic of brick, mortar, wood and stone. The structures of the region, and their juxtaposition to each other, are both unique and remarkable.

FACING PAGE: PATRICK O'CONNOR

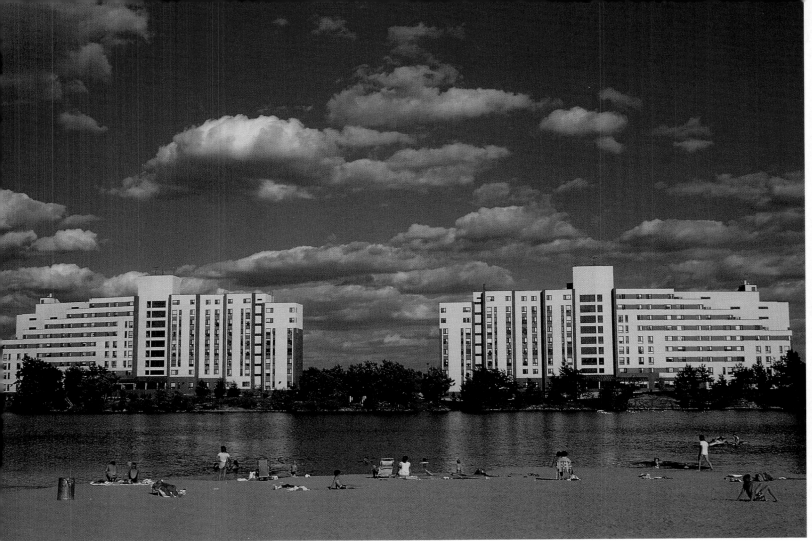

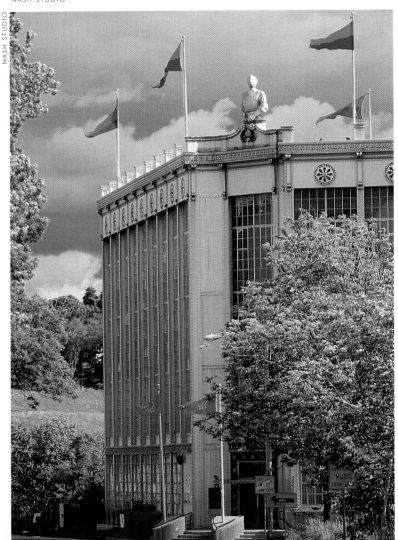

S tyle and substance: High-rise apartments shimmering on the water, a museum's steel facade and fluttering pennants.

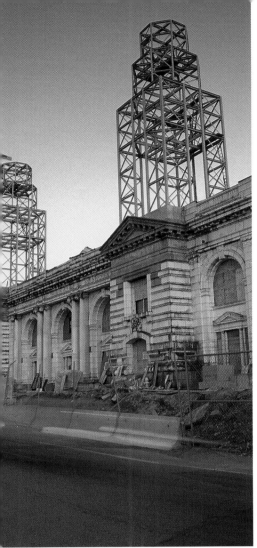

DAN VAILLANCOURT

ALLEN FLETCHER

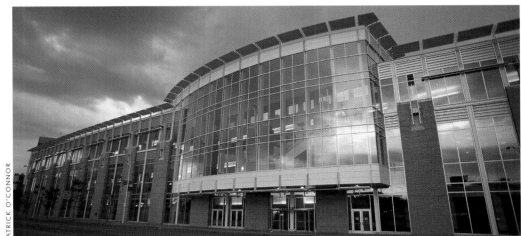

PATRICK O'CONNOR

The rebirth of a landmark from the decay of neglect, the emptiness of a darkened venue, the glitter of tomorrow's promise and the formidable beauty of a federal presence.

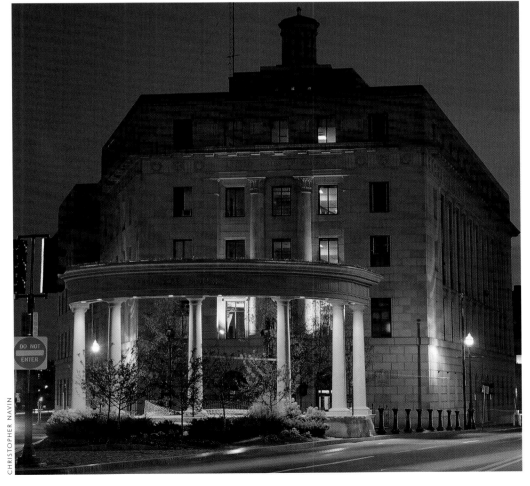

CHRISTOPHER NAVIN

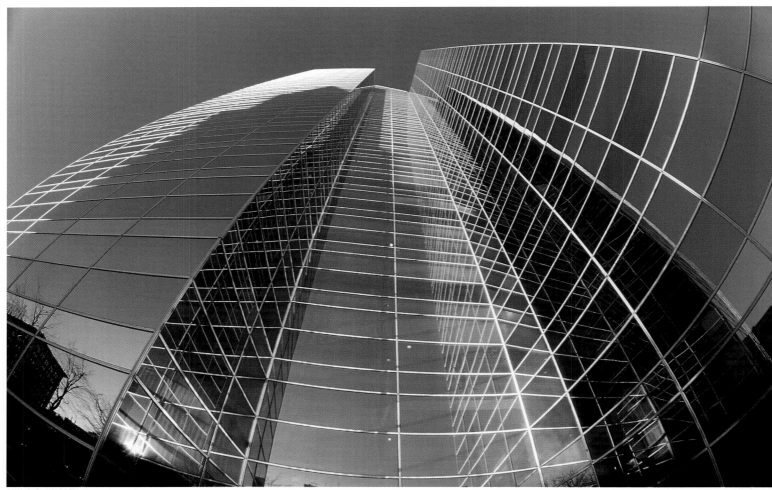

PHILIP C. WARREN

STEVEN P. BALL

STEVEN KING

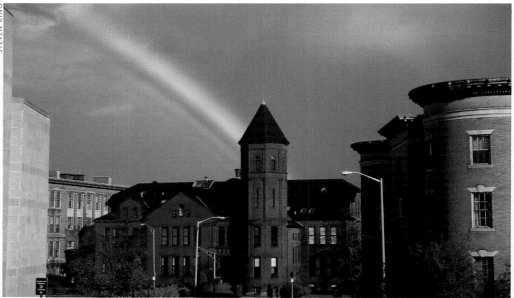

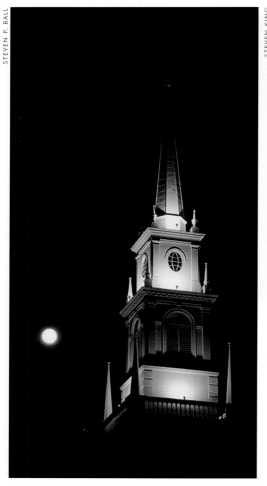

The hand of nature: Sunlight gleams on towering glass, the moon reminds us of a higher power, a rainbow pierces the gloom and autumn's glory overwhelms the works of man.

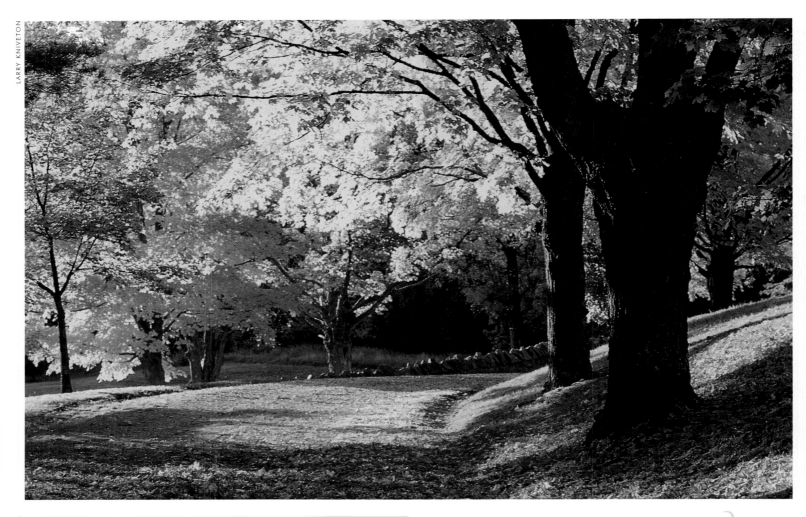

LARRY KNIVETON

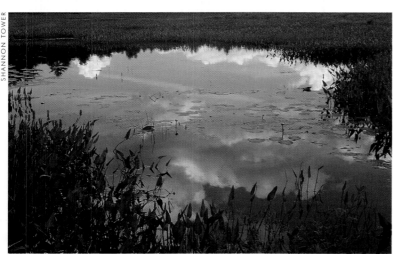

SHANNON TOWER

The miracle of seasonal evolution is best experienced in the mountains and meadows of our region. As our days are consumed with burdens and responsibilities, we would do well to pause and contemplate the abundance and blessing of nature's gifts. As New Englanders, we must never take scenes like this for granted: The stillness of a quiet country road ablaze with a canopy of autumnal foliage, summer's creation of golden grain and blissful reflections in a shallow marsh.

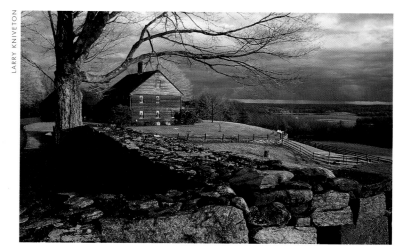

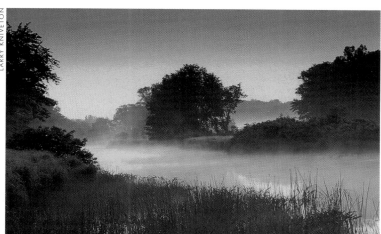

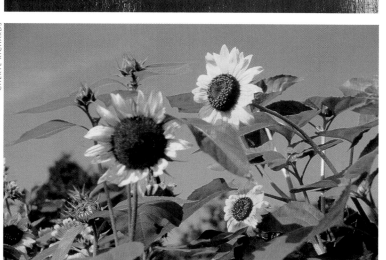

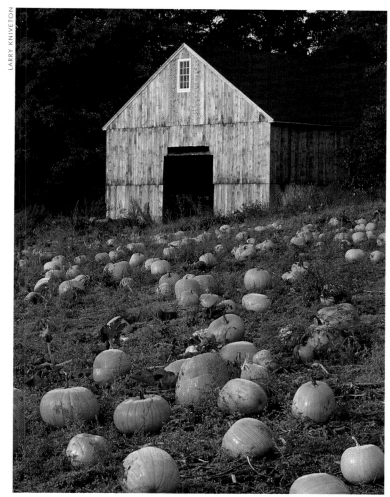

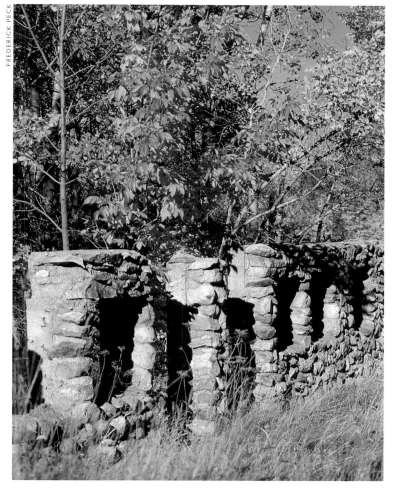

The passing of time: Spring's promise comes again to ancient farmlands, morning mist draws breath for a new day, sunflowers dance on summer breezes, pumpkins gambol on an October hillside and the ruins of an earlier age are reclaimed by the land.

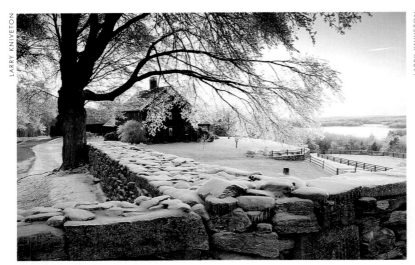

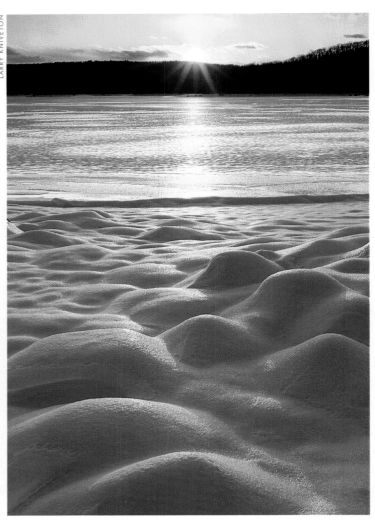

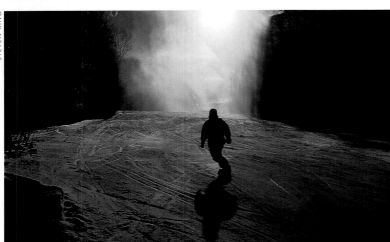

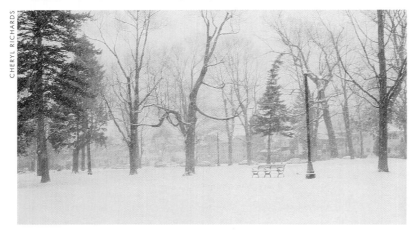

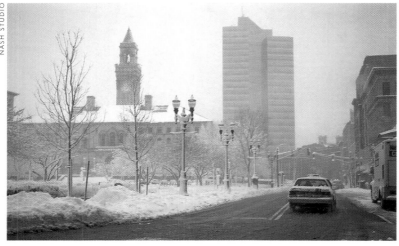

There's a saying in New England that there are but two seasons — winter and everything else. The season of ice and cold has its beauty, too: Trees, stones and pastures garbed in a mantle of white, the pleasures of conquering the icy domain, winter's fury slows a city and sunlight dapples a frigid lake.

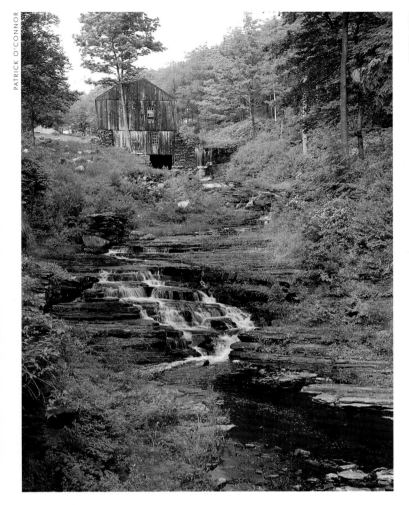

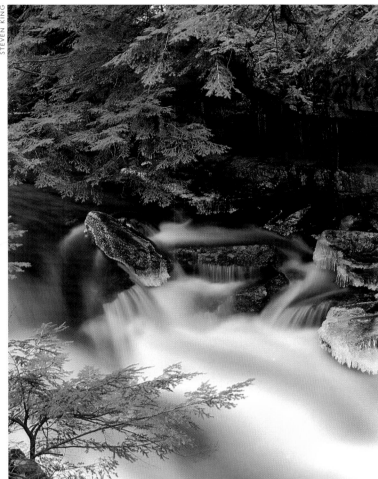

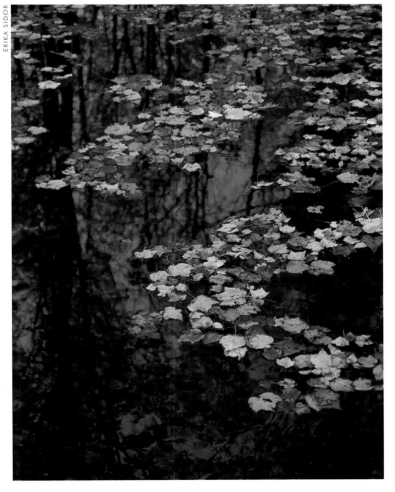

Soothing moments: A cataract gently tumbles by an old mill, daylight falters, a cool cascade rushes beneath languid humidity and a coating of leaves frost the stillness of a deep woodland pool.

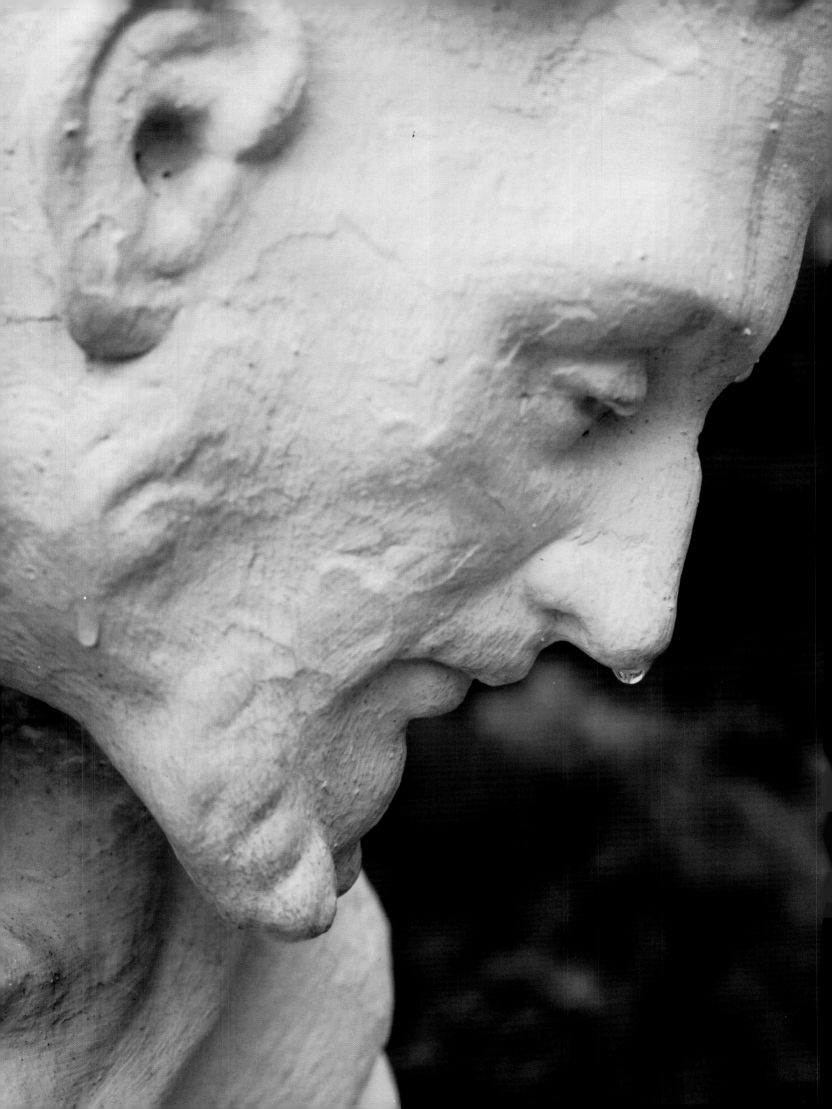

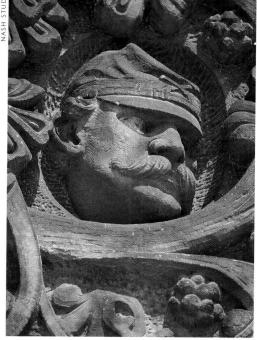

NASH STUDIO

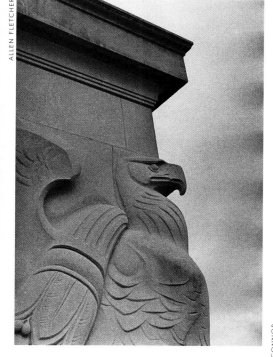

ALLEN FLETCHER

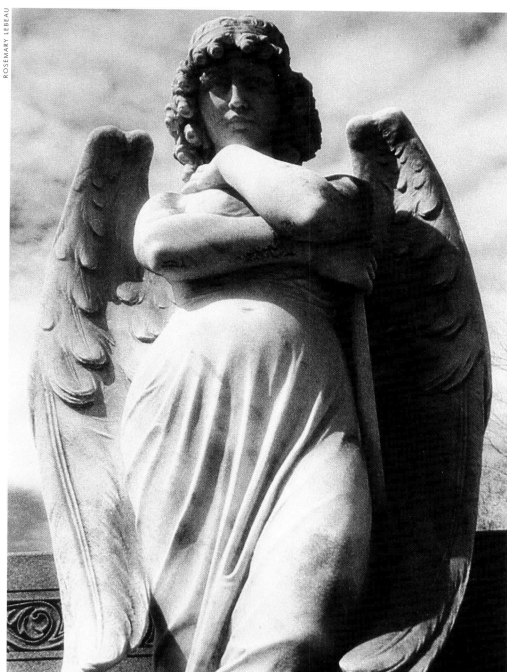

ROSEMARY LEBEAU

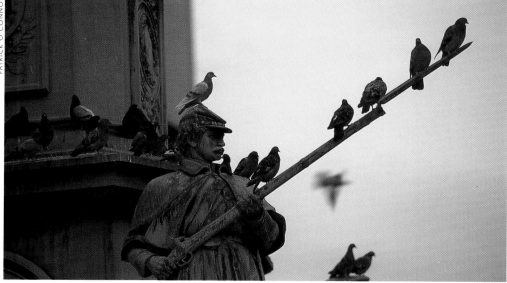

PATRICK O'CONNOR

O ur buildings provide shelter from the elements and fulfill our desire to combine distinct materials to create a new ediface. Adornment of those masterpieces may not be necessary, but the presence of architectural enhancements delights the eye and stirs our sense of whimsy.

FACING PAGE: PETER FAULKNER

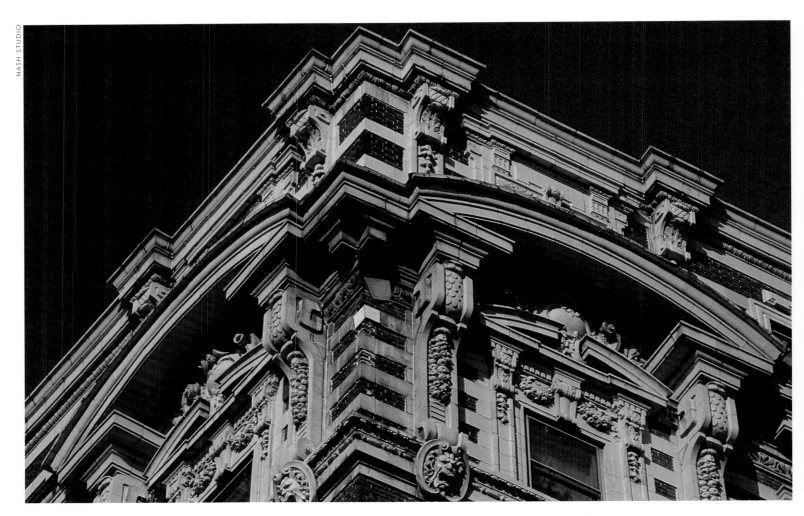

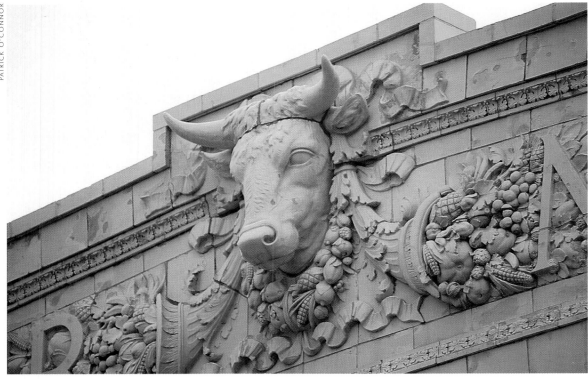

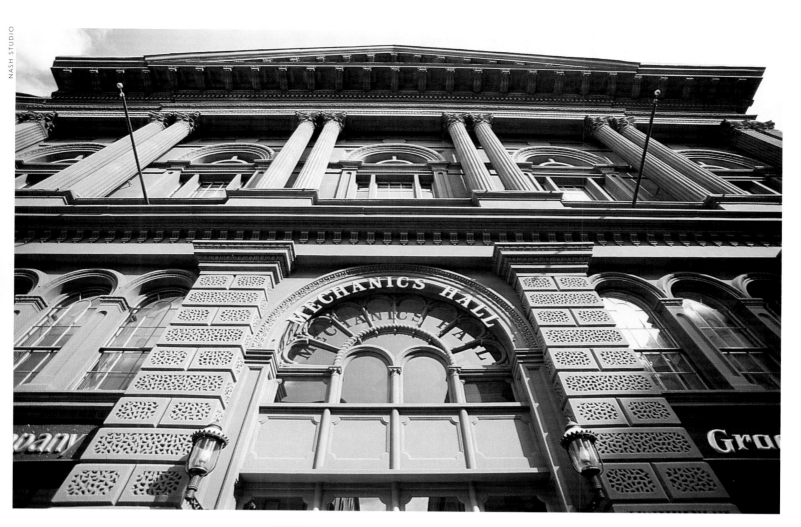

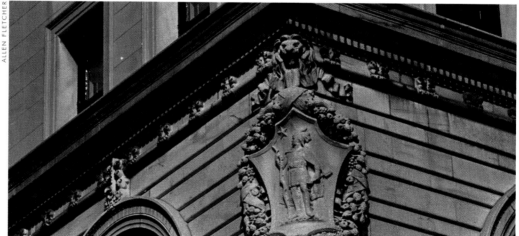

E ntablature ennobled: Sunlight on a parapet rich in detail, an agricultural icon immortalized in stone, the symbol of a city's cultural renaissance soars above the street and corners guarded by gargoyles jut proudly into the air.

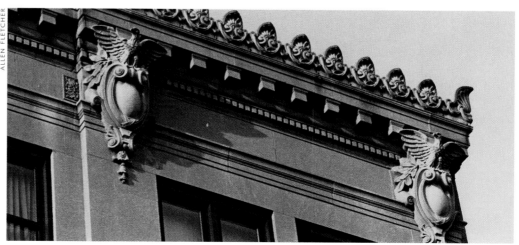

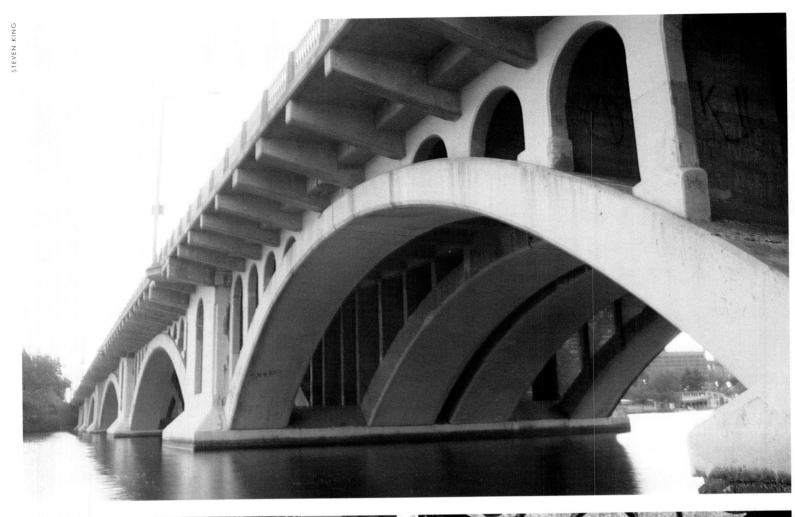

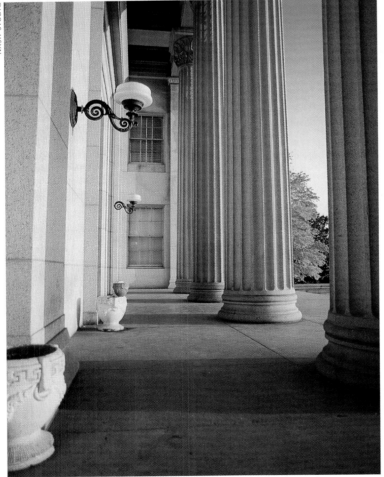

Spanning a lake, sunlight and shadows play hide-and-seek in a colonnade, and iron wrought by the hand of man welcomes and protects.

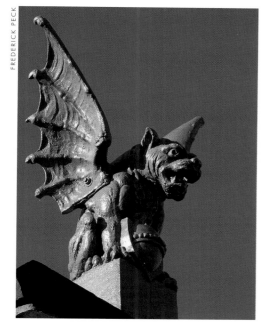

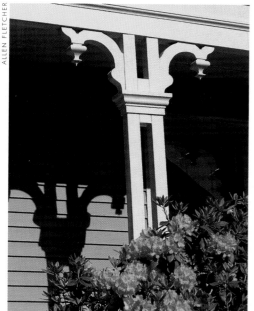

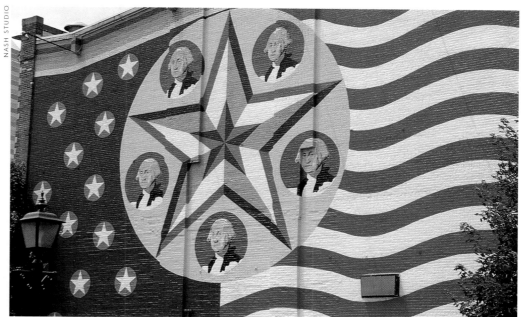

A griffin's warning, a porch elegantly supported, the runes of a time long forgotten, bicentennial brashness and a statesman's towering tribute.

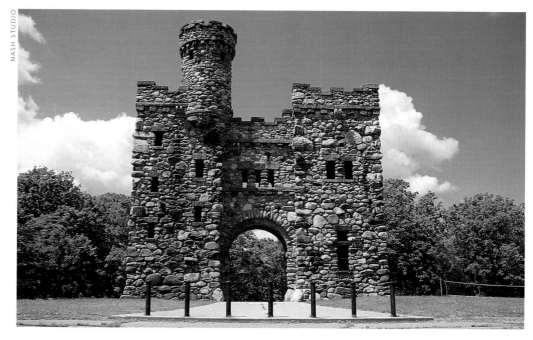

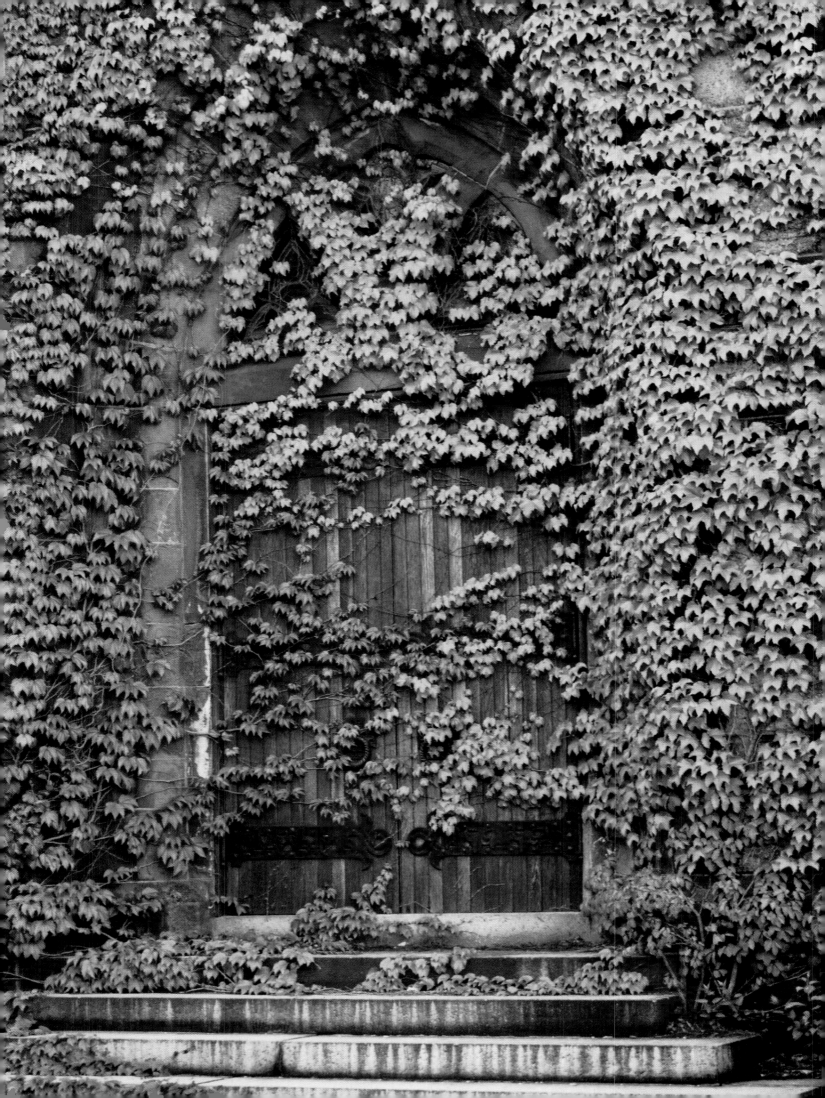

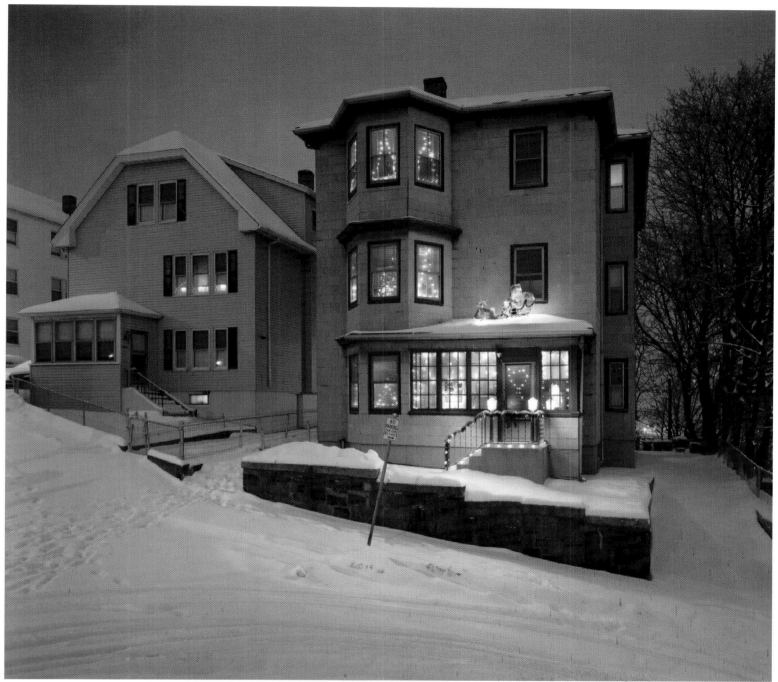

A study in contrast: Portals of a bygone era are suffocating in a green profusion of ivy that reminds us of the power and determination of nature, while a snow-swathed residence neatly heralds a holiday's joy.

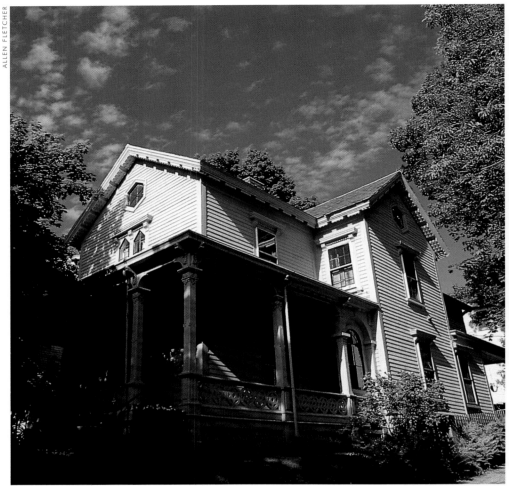

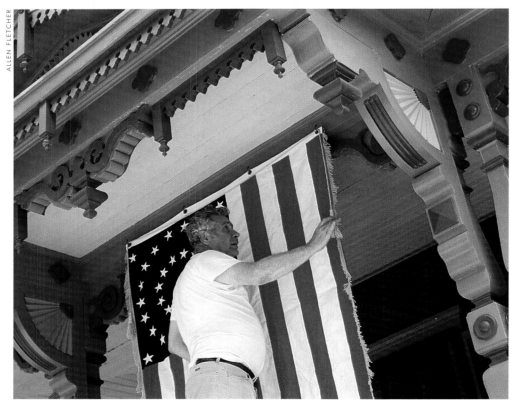

T he wonders of the region's habitats and their abundant diversity are a source of pride. Gables greet the morning sun, the flora and fauna of a graceful entrance, patriotism takes its place in a surround of gingerbread, triple-deckers face the twilight, federal designs stand at attention and a canine sentinel guards its domain.

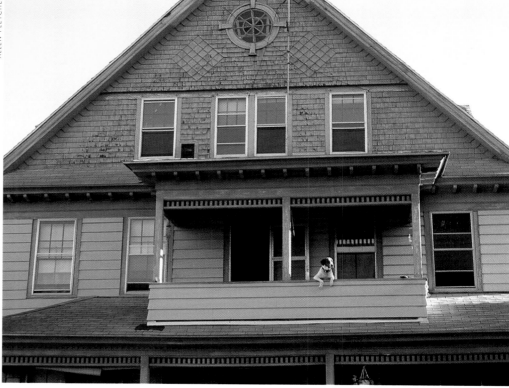

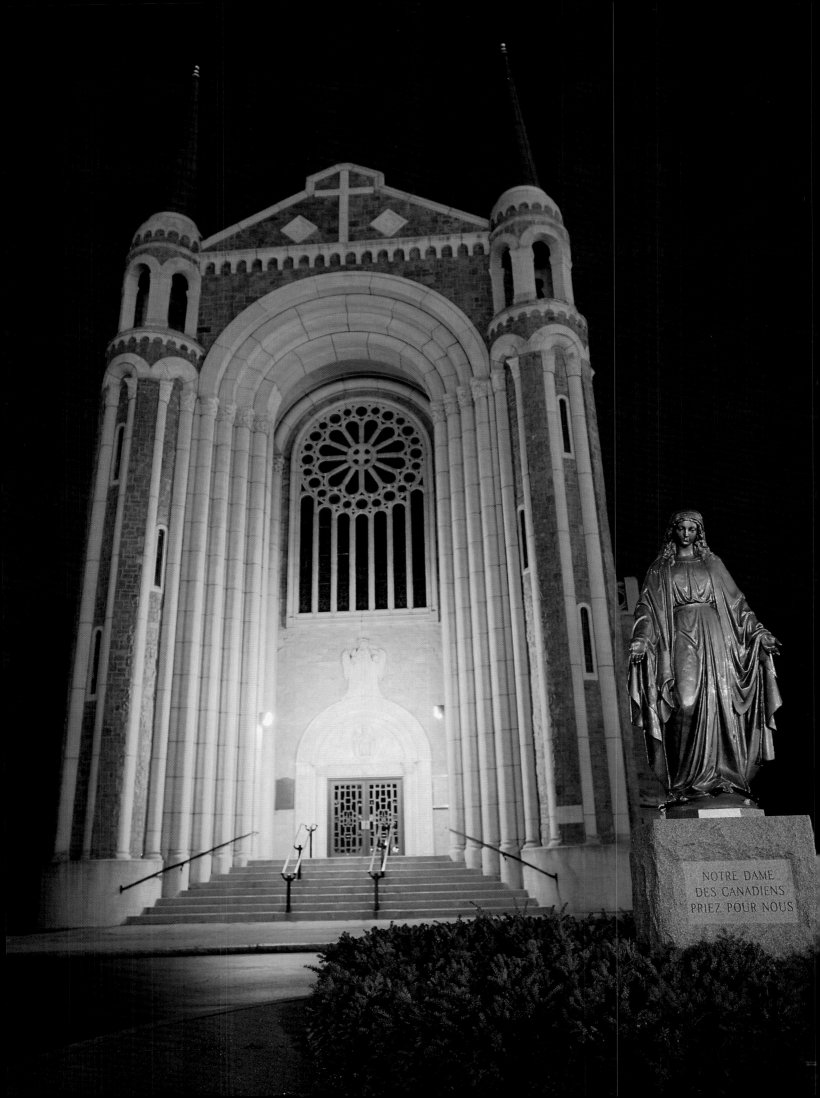

NOTRE DAME
DES CANADIENS
PRIEZ POUR NOUS

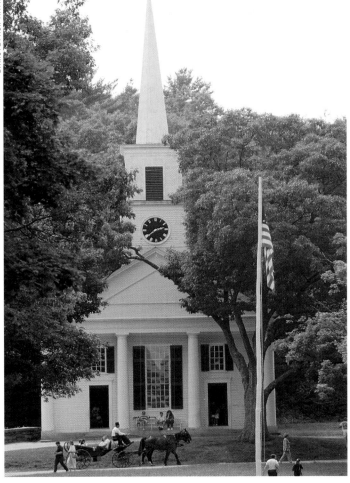

T he powers of the Almighty are rendered in many ways, as are the houses of worship they inspire. From simple to stately, baroque to Gothic, their purpose is universal.

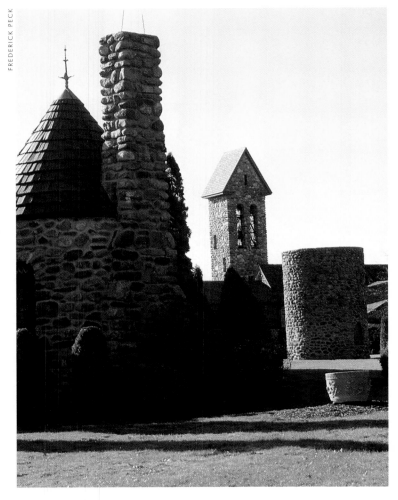

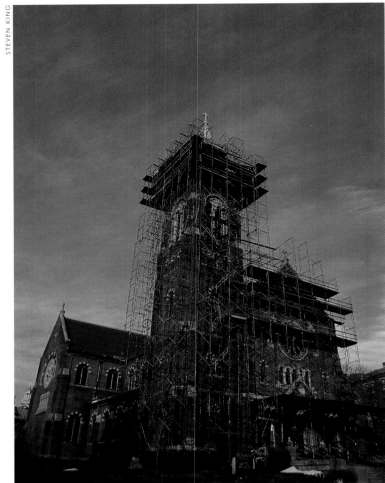

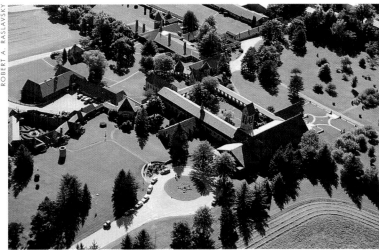

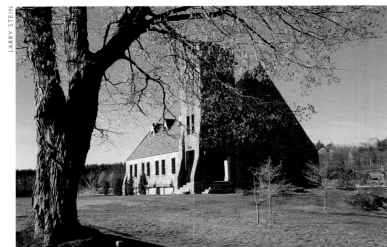

One message, multiple expressions: The simplicities of monastic life take on a grandeur of their own, scaffolding enshrouds God's house, a church of stone is warmed by daylight's gleam, colors play on oaken pews and enlightenment illumines the soul.

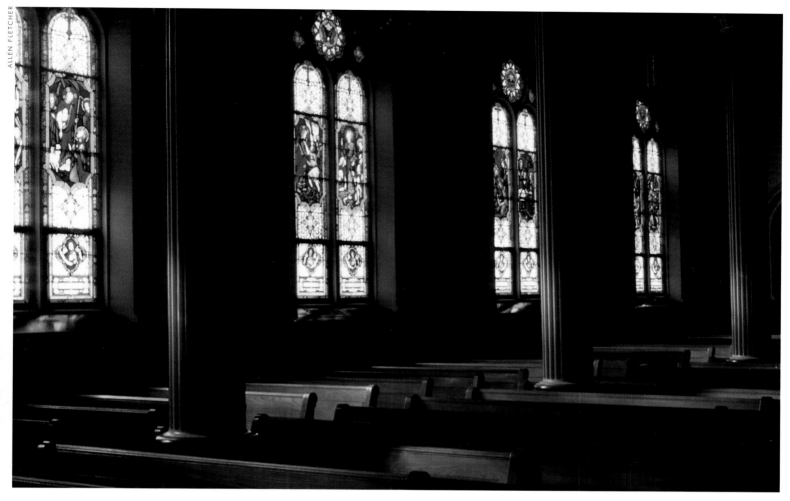

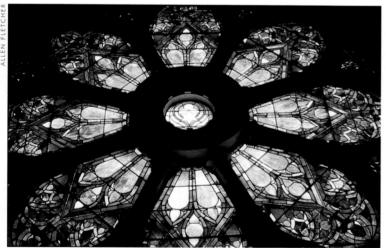

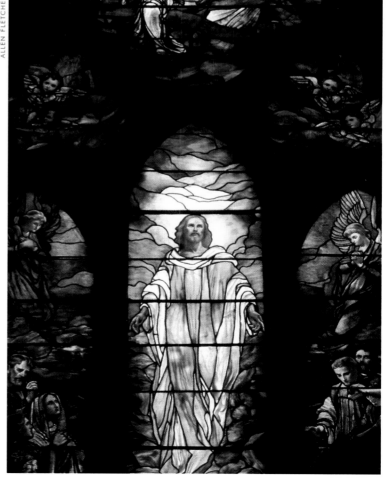

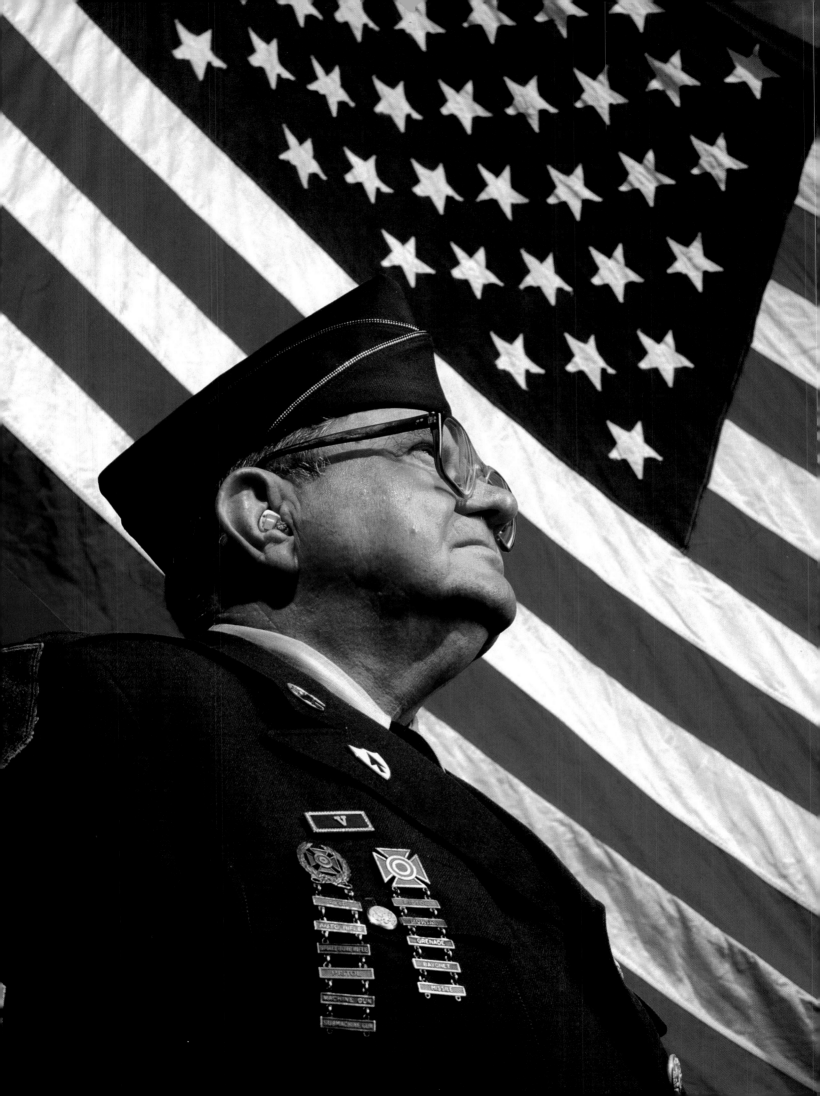

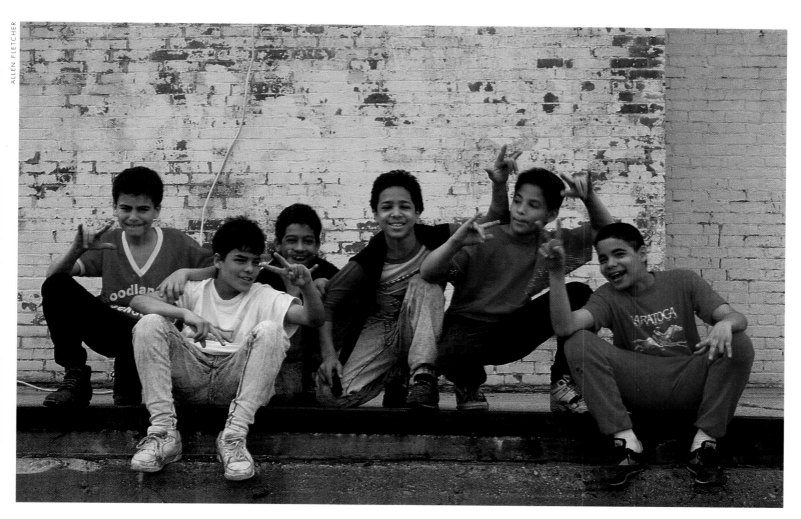

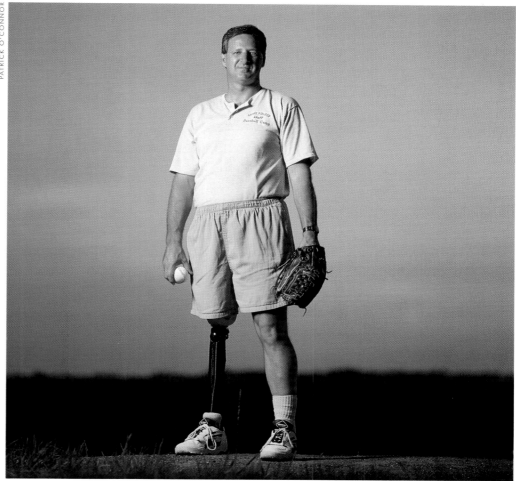

Beautiful buildings are everywhere, the elements are fickle no matter where you go and landscapes of breathtaking splendor can be found just around the corner or over the next hill. While these things are priceless, what makes them so is the ability of human beings to enjoy and treasure them. Perhaps the most defining characteristic of Central Massachusetts is its people. All shapes, colors and sizes, serious and silly, handsome and happy. Here we are!

FACING PAGE: PATRICK O'CONNOR

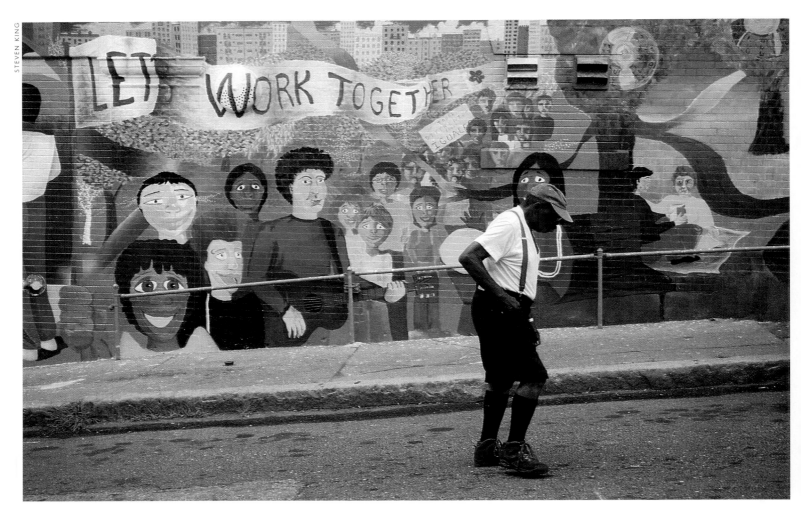

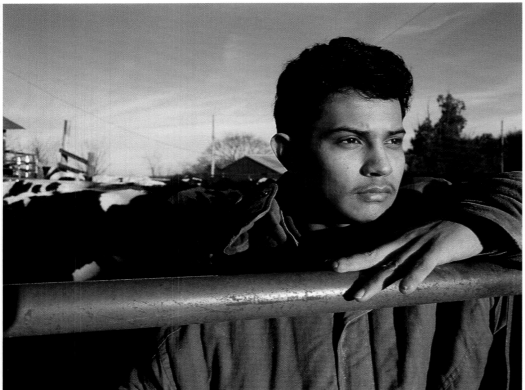

Indomitable spirit: Yesterday's struggle is an uphill journey to tomorrow's reward and the promise of the future beckons from beyond the barriers of today.

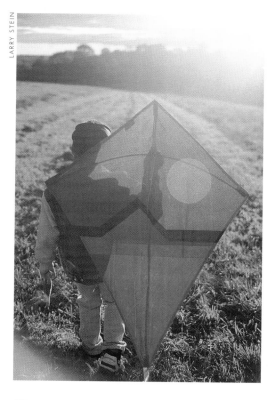

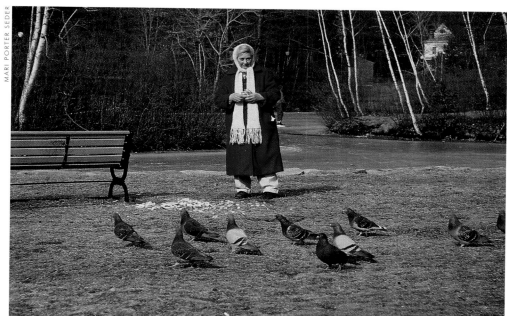

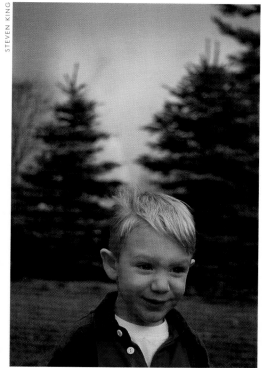

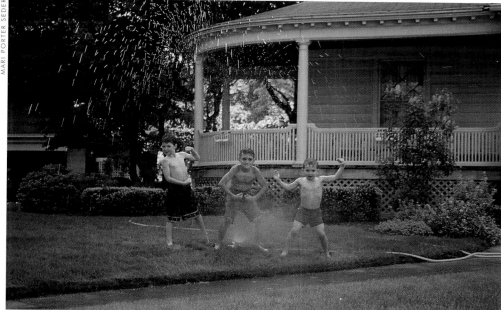

S un-streaked breezes cause the imagination to soar, a rainbow's hair of gold and smile of mischief, befriending feathered friends, youthful machismo in a summer sprinkler and the faith of a steadfast heart.

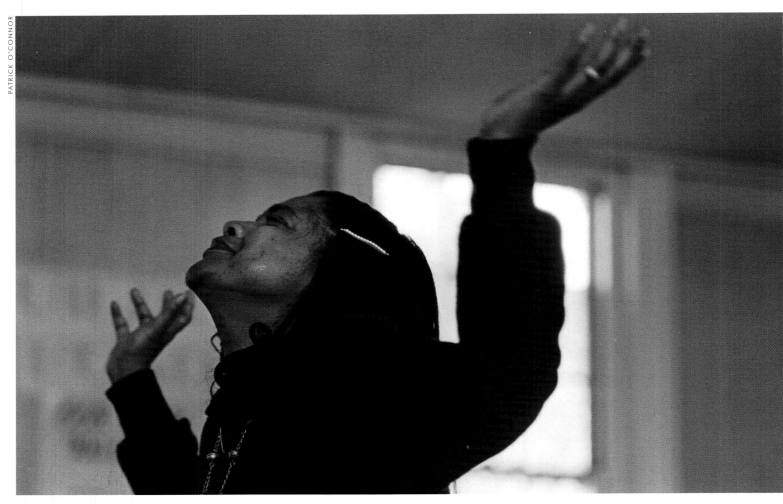

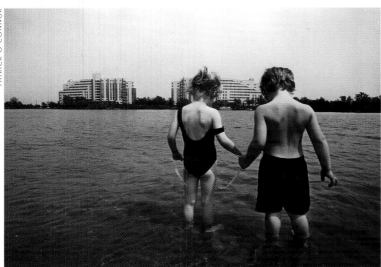

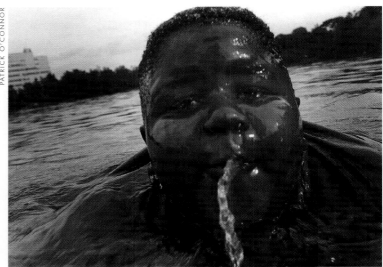

*P*assions: Rejoicing in the power of salvation, taking tentative steps in unknown waters, playfully conquering the deep and creating a masterpiece of epicurean proportions.

FACING PAGE: CHRISTOPHER NAVIN

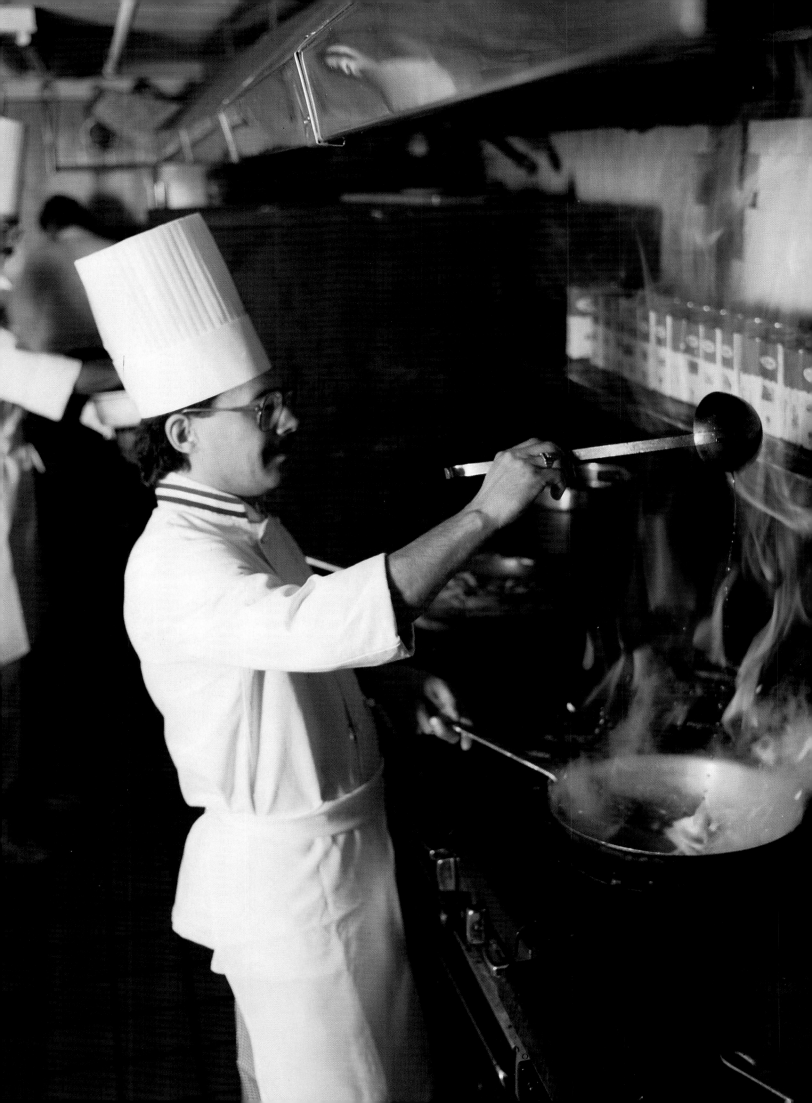

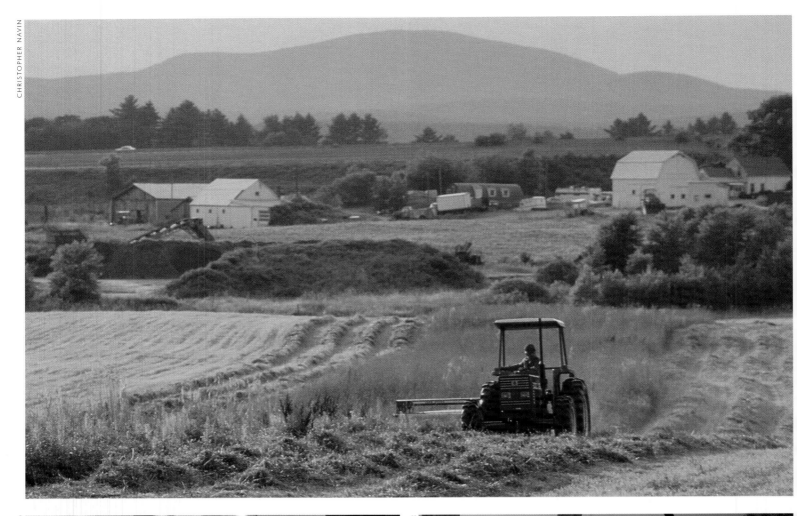

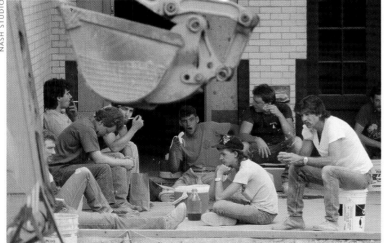

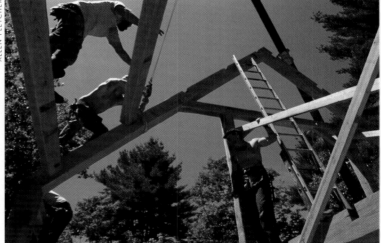

All in a day's work: Performing the ageless ritual of survival and sustenance by taming the land, taking a hard-earned break from their labors and raising the roof the old-fashioned way.

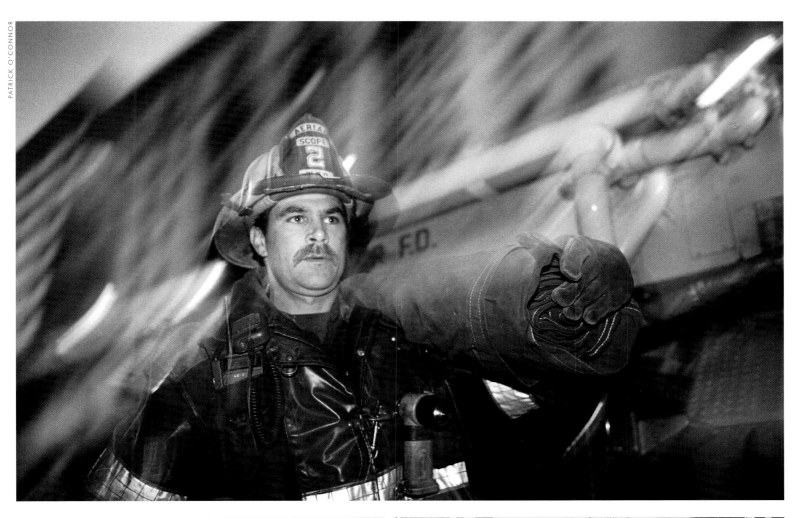

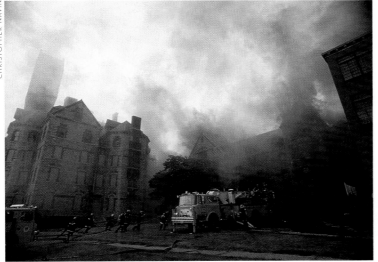

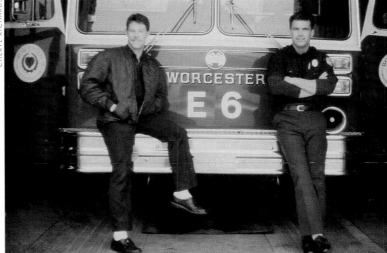

Heroes for our time: One man's courage, flames of destruction engulf a landmark, they also serve who wait and on-the-job training for the next generation of life-savers.

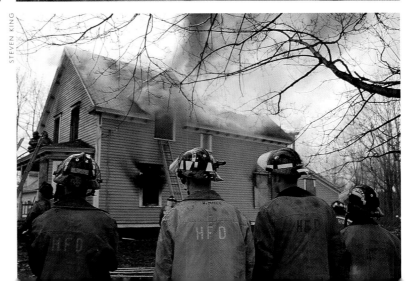

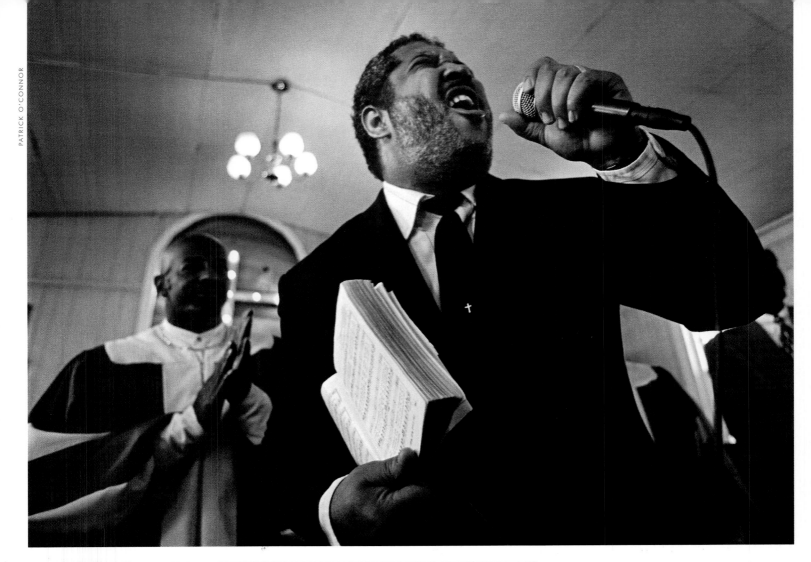

Minding their own business:
Singing praises, focusing
on tomorrow, missing the
bus, providing commentary and learning
the lessons of history.

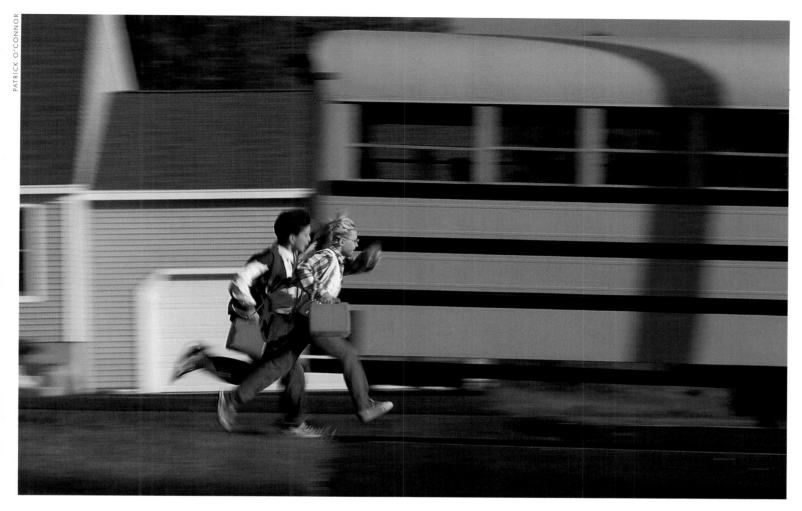

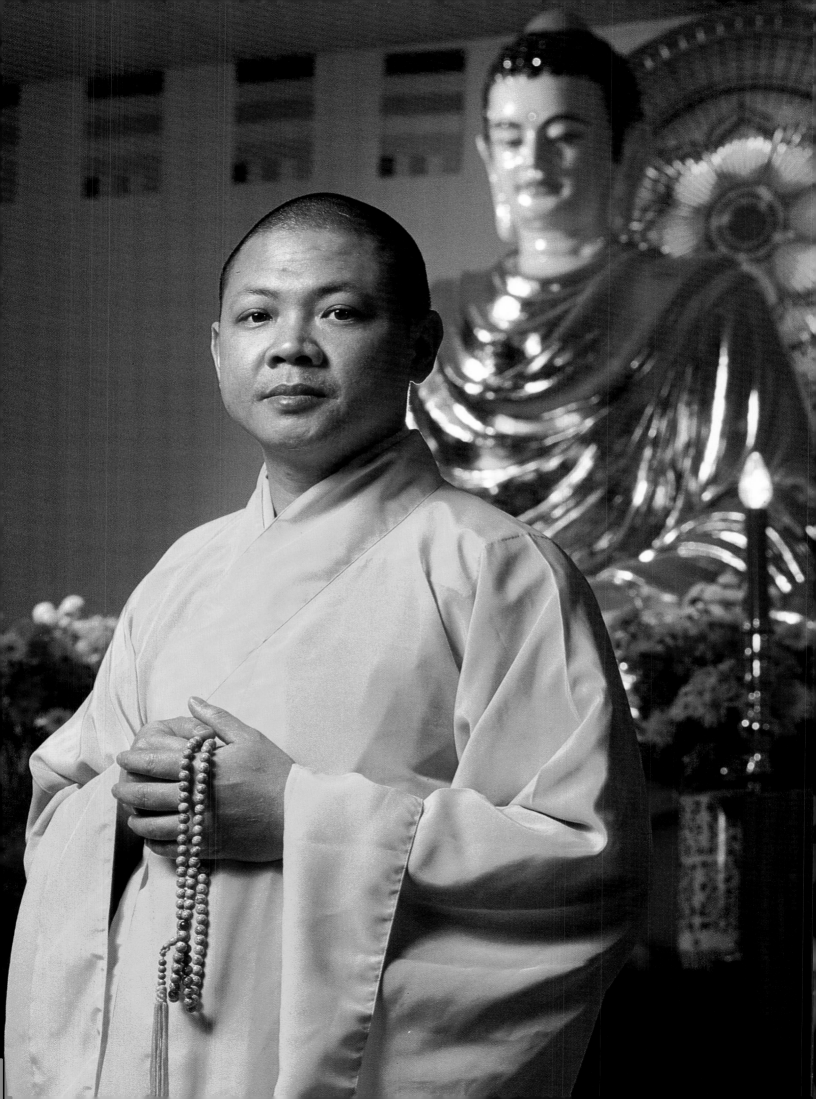

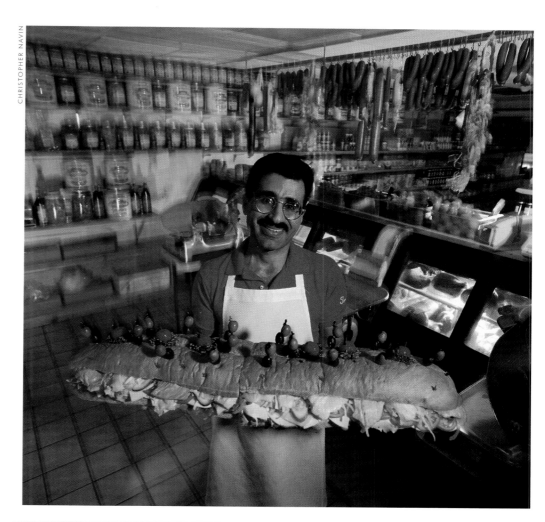

All in its own time: The peaceful lessons of the East find a home in our Northeast region of the West, an abundance of plenty and generations of bounty.

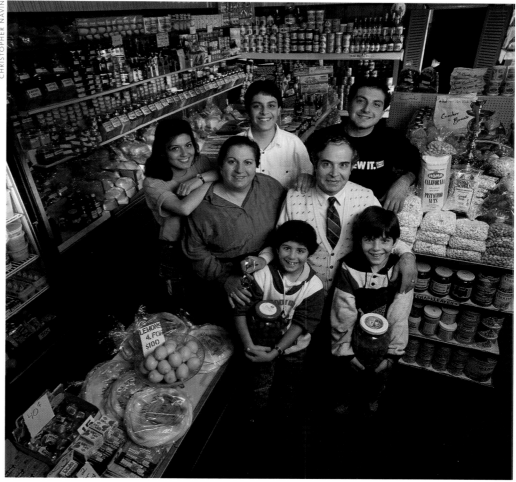

America is the land of new beginnings and plentiful opportunities. Here in Central Massachusetts, our strength of character and sense of purpose echo the journey of our ancestors.

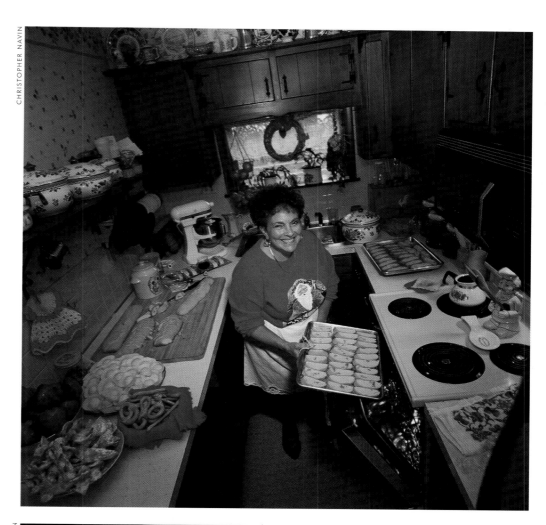

A new legacy in a new nation: Taking stock, pondering his next move, a culinary labor of love and the spirit of movement.

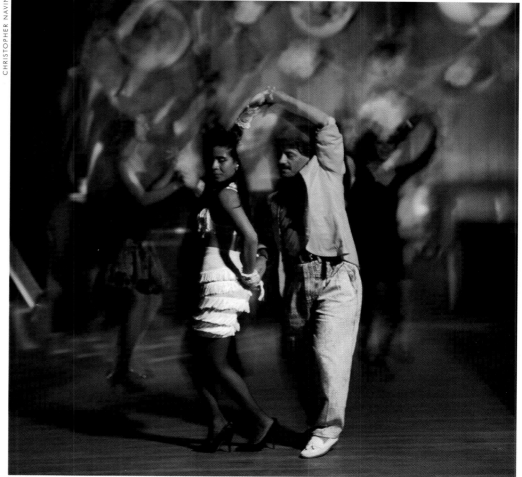

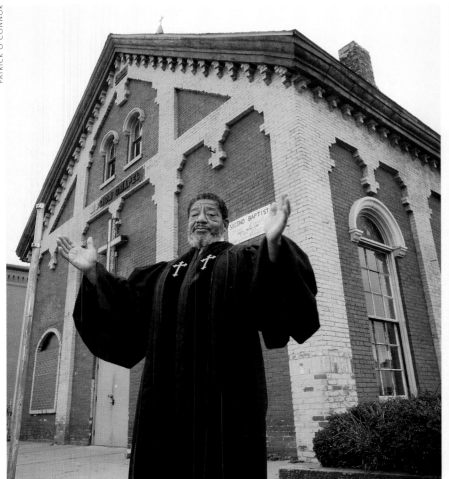

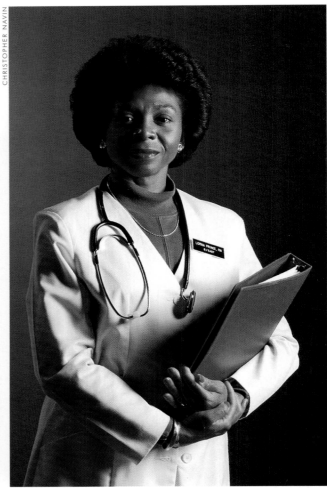

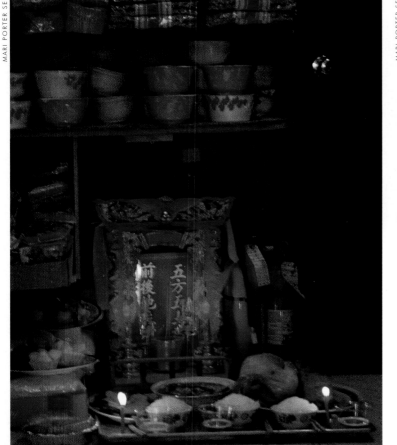

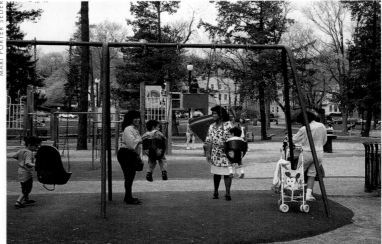

One book, many stories: A reverend's mission, a professional's poise, honoring the past, taking pleasure in the present, bubbling with enthusiasm, dog-play afternoon, hockey in the park and a veil of water highlights a skier's skill.

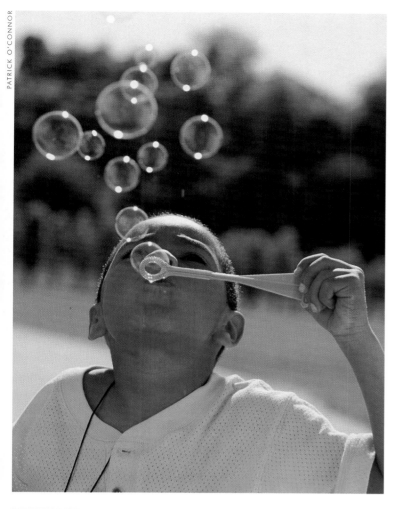

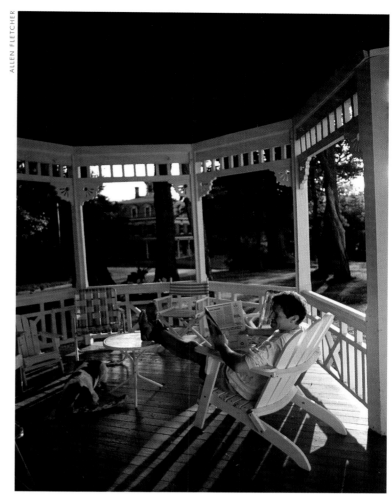

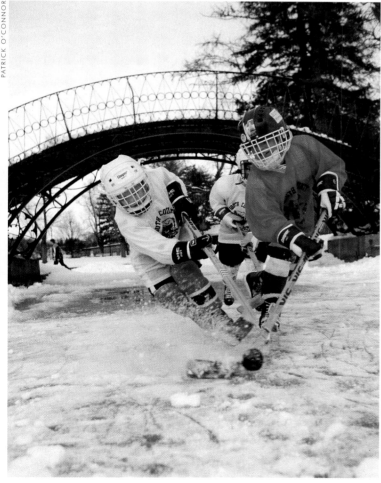

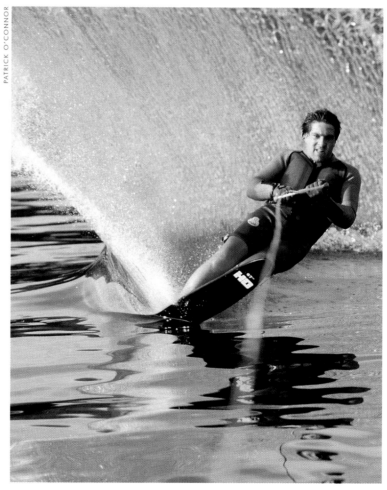

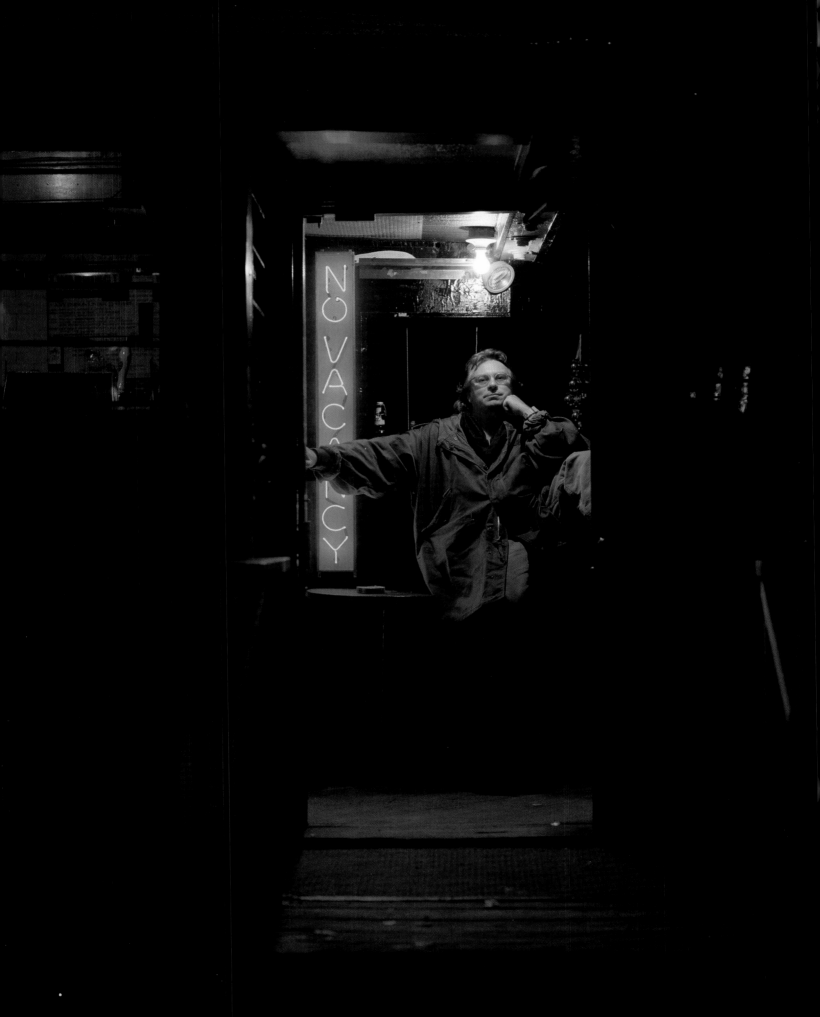

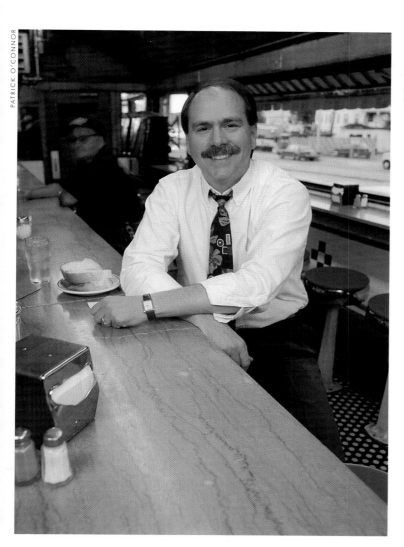

PATRICK O'CONNOR

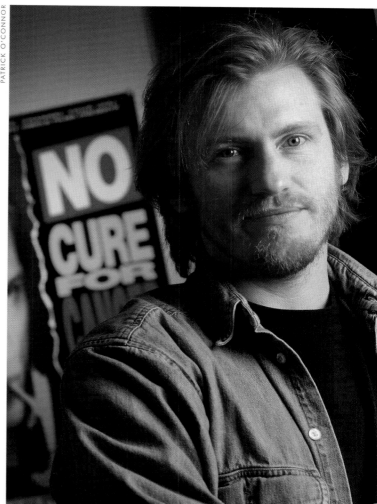

PATRICK O'CONNOR

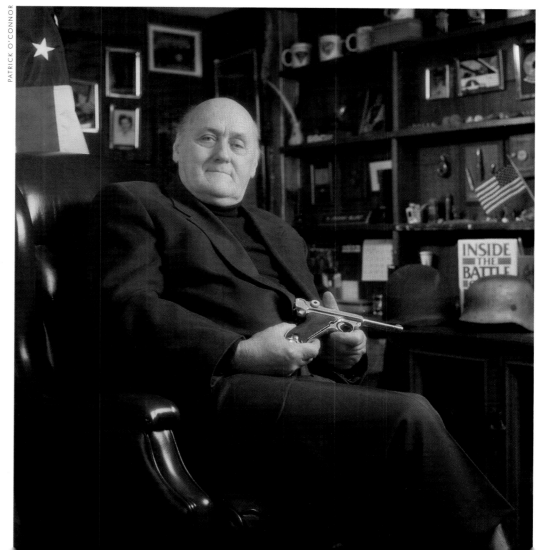

PATRICK O'CONNOR

It was George Orwell who said that all men are created equal, but that some were more equal than others. It is true that equality, respect and diversity are hallmarks of how New Englanders interact with each other. It is also true that there are those who have spent time among us, symbolizing us and what we aspire to. The people on these pages would be the first to say they're nothing special, but we disagree — they represent the best of who we are and what we can accomplish.

Ralph Moberly, impresario
Raymond Mariano, mayor
Denis Leary, entertainer
Rockie Blunt Sr., warrior

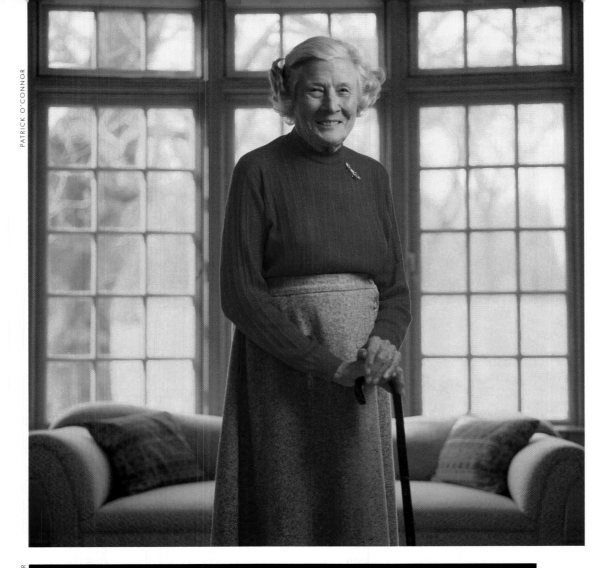

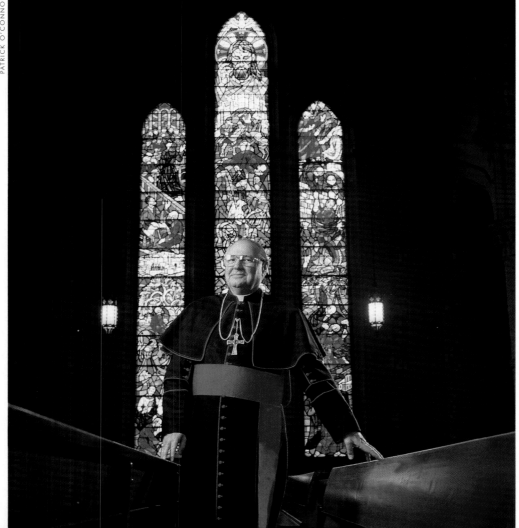

Alice Higgins,
philanthropist

Bishop Daniel Reilly,
shepherd

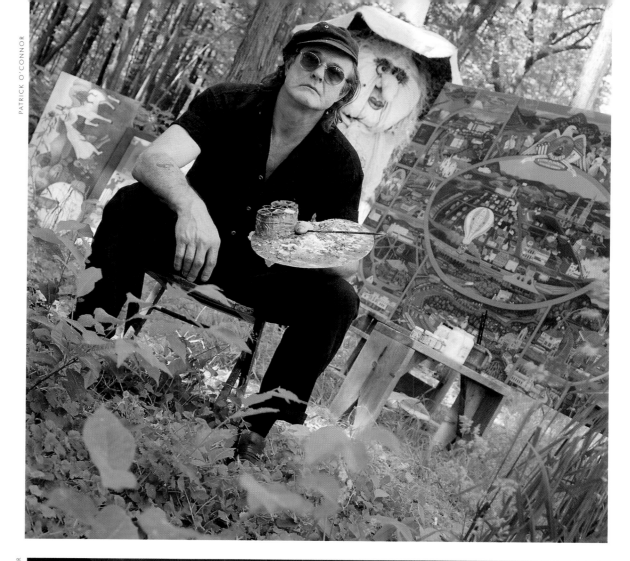

Jacob Knight,
artist

Bobby Harris,
pugilist

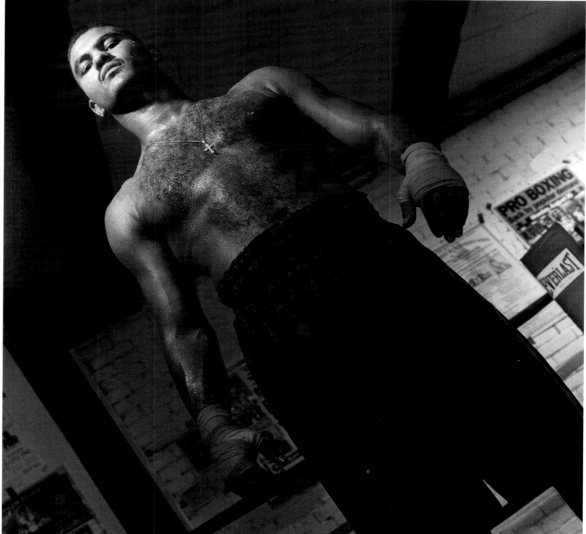

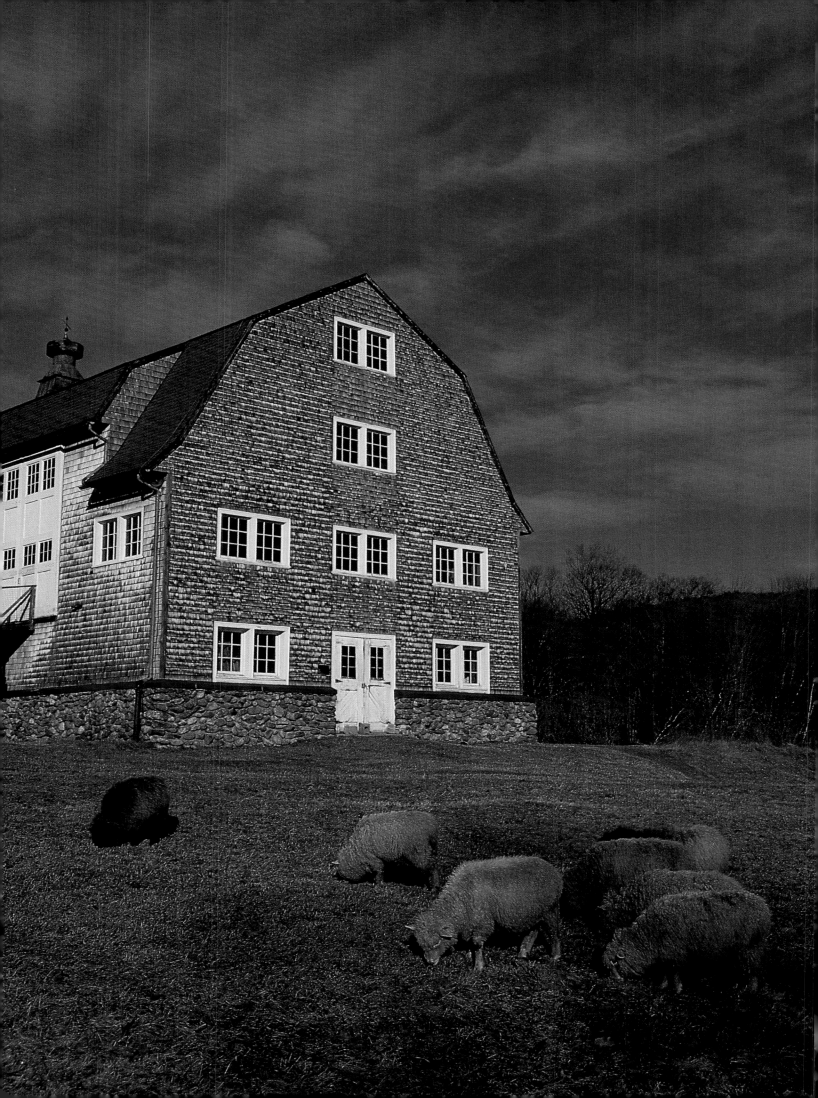

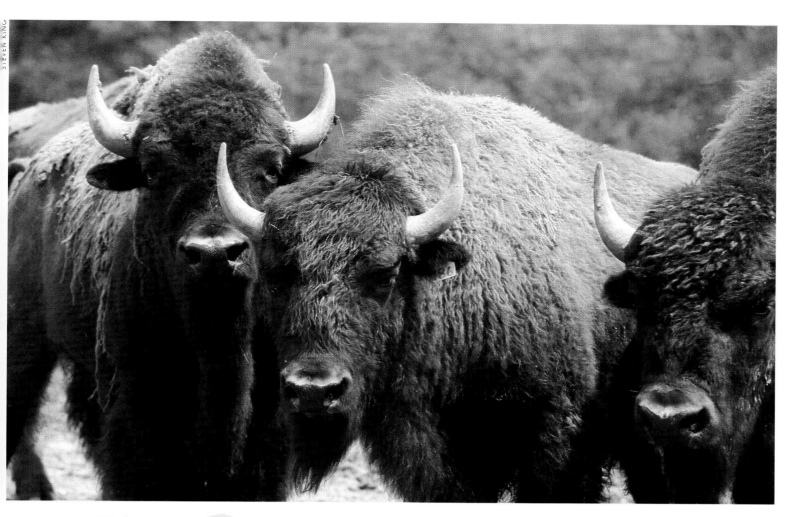

W e share our space on this planet with an amazing array of creatures, and this region is home to several species of the four-legged and feathered variety that enrich us by their presence.

Some animals are as common as sheep and others, like the American Bison, captivate us by their relative scarcity and intimidating power.

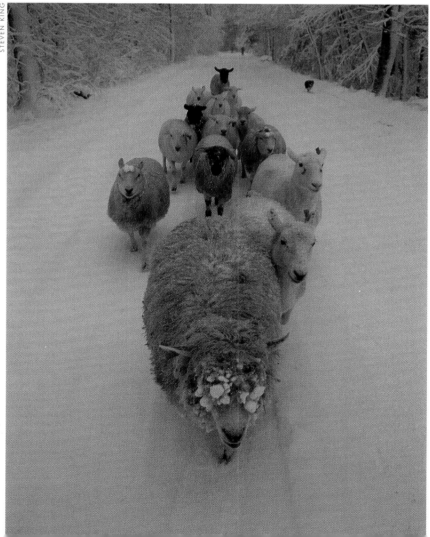

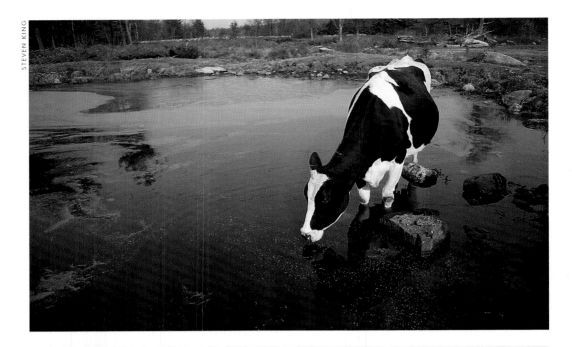

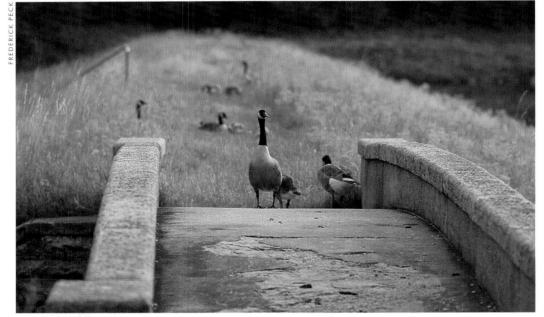

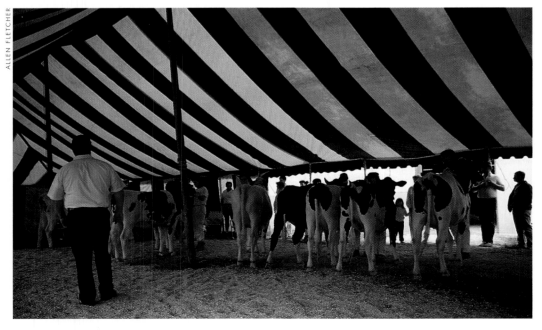

A cow becomes a player on nature's stage of beauty and contrast by simply slaking her thirst, a Canada goose takes a gander at who might be approaching and bovine beauty is in the eye of the beholder as judging commences at a county fair.

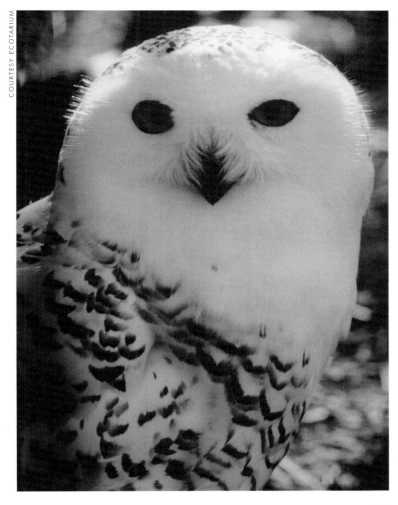

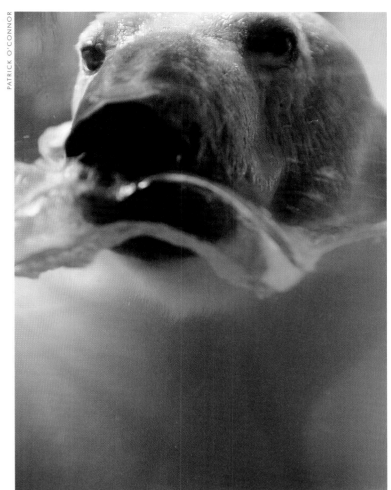

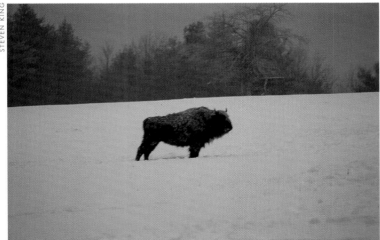

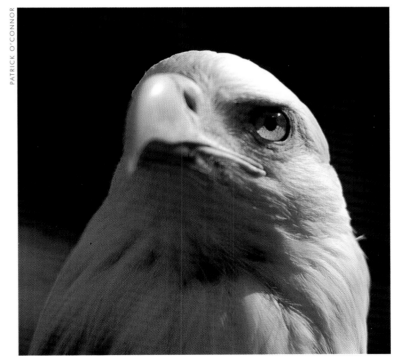

Snowy feathers and trusting eyes camouflage the heart of a predator, a lone sentinel stares down winter's blast, a national symbol surveys its domain and ursine pleasures allow a polar sovereign to beat the heat — bearly.

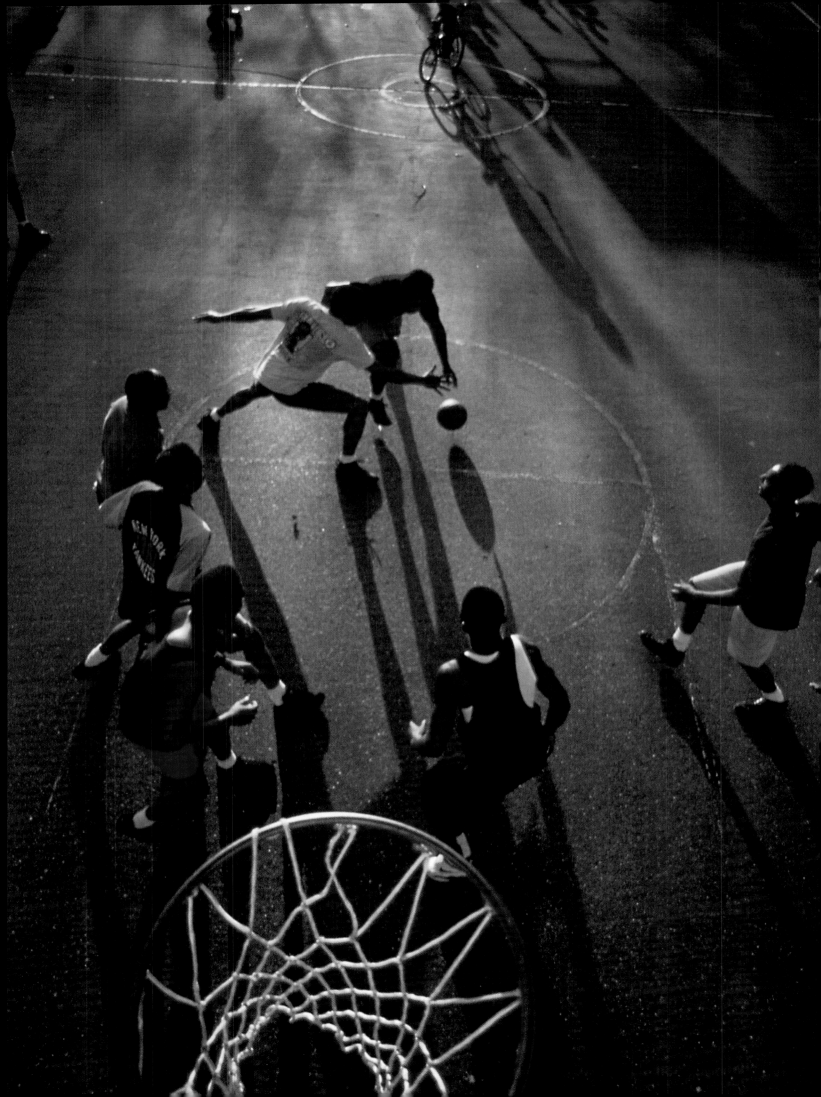

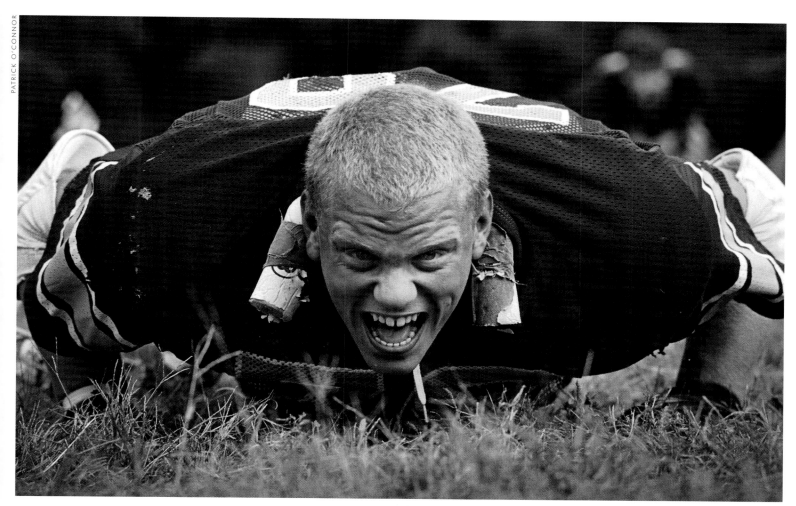

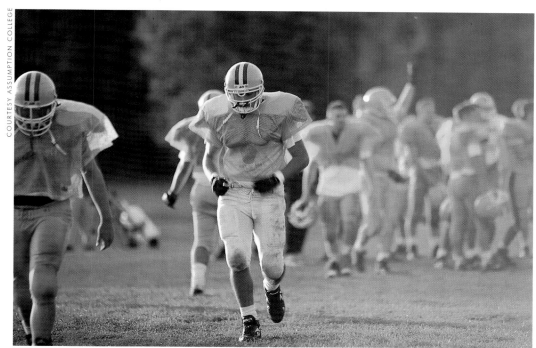

We work hard and we play harder, at least it seems that way when you attend a sporting event held just for the love of the game. No hefty salaries, no fancy equipment — just heart, muscle and determination — and plenty of it. Whether it is the speed and skill of a pick-up basketball game or the brutal grace of football, underneath it's all the same — no guts, no glory.

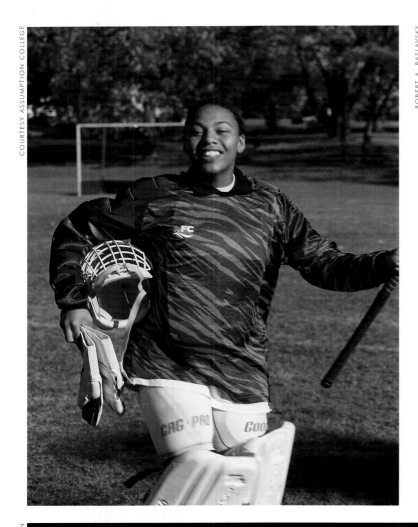

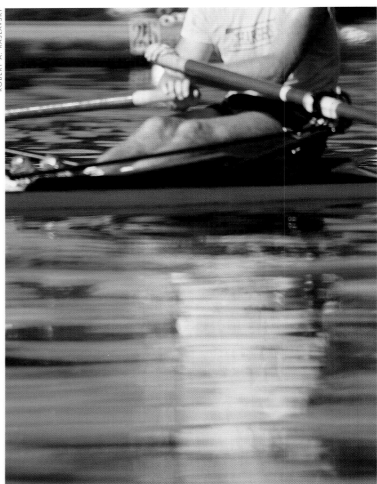

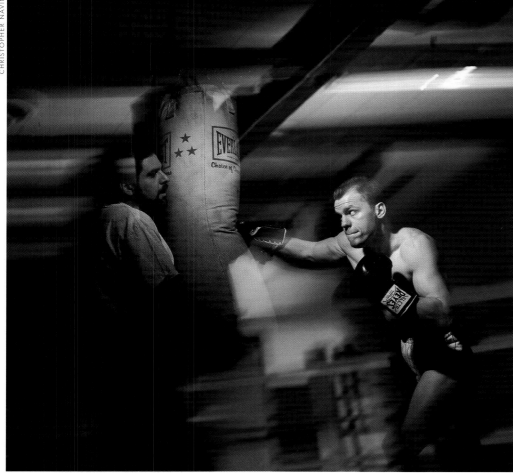

Faces of sport: The exultant smile of a lacrosse victor, members of a crew team disturb placid waters and the sport of kings courts a new prince.

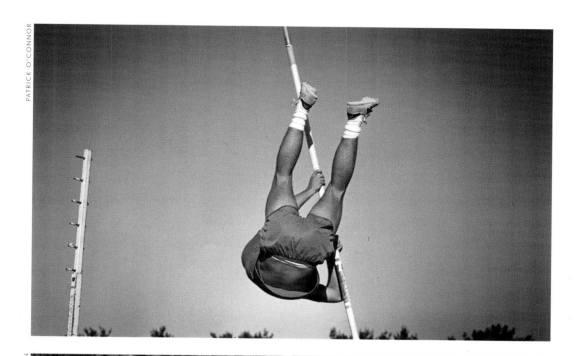

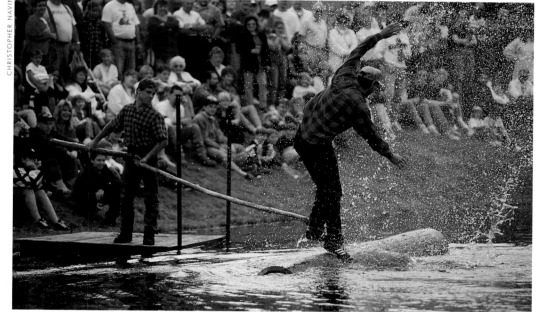

M uscles taut and toned, a pole vaulter heads back to earth, being "on a roll" is not as easy as it looks and a coxswain's call is obeyed through clenched teeth and straining bodies.

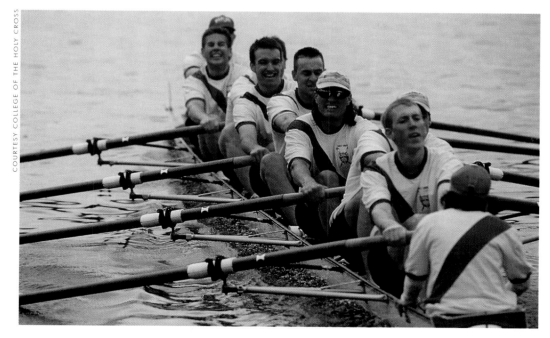

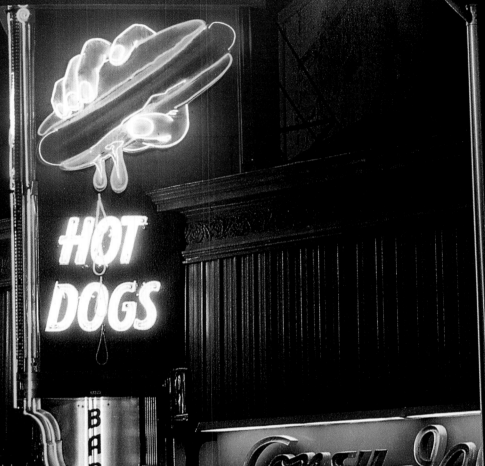

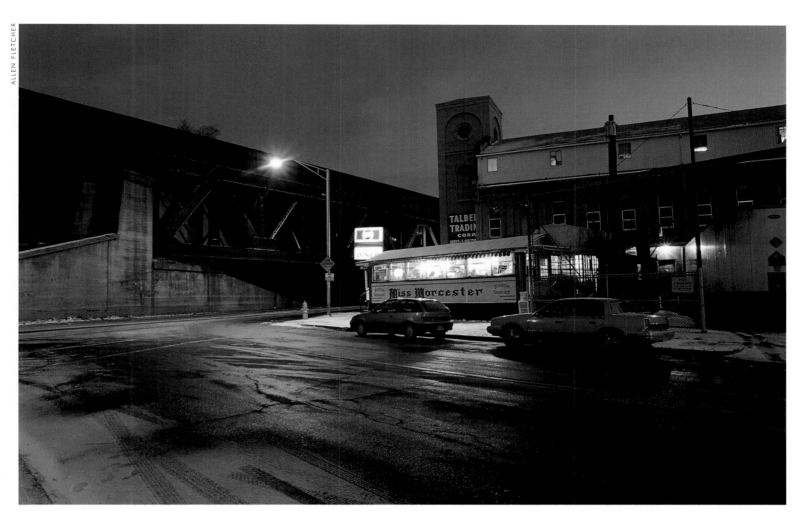

W orcester is known for its seven hills, its triple deckers and its diners, not necessarily in that order. Home to the nation's first lunch-car eateries, the city's surviving examples don't disappoint. There's Coney Island (though not technically a lunch car, it's still got class), the Miss Worcester and the Corner Lunch.

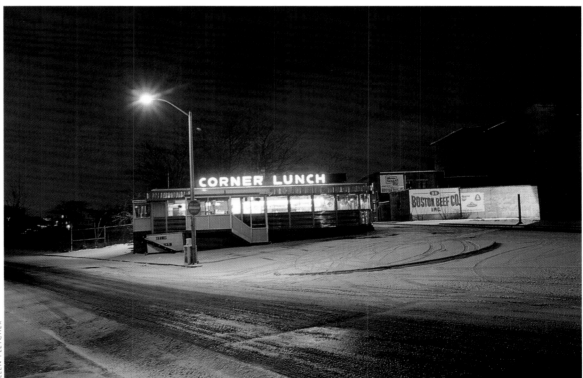

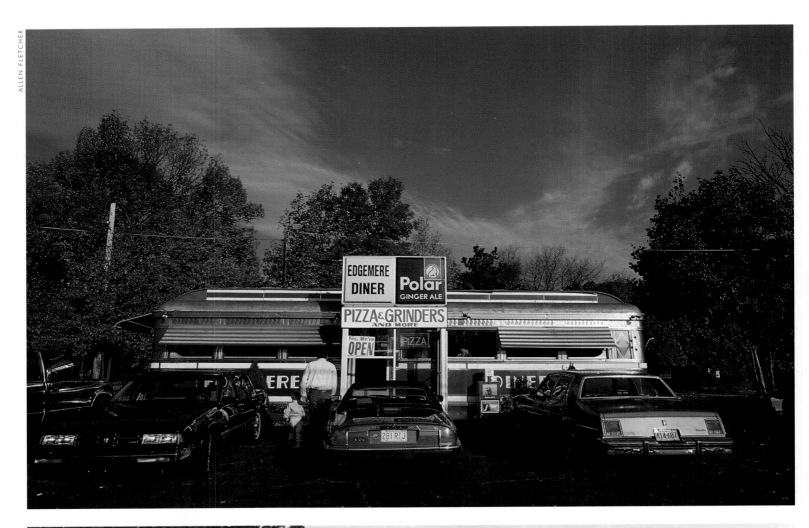

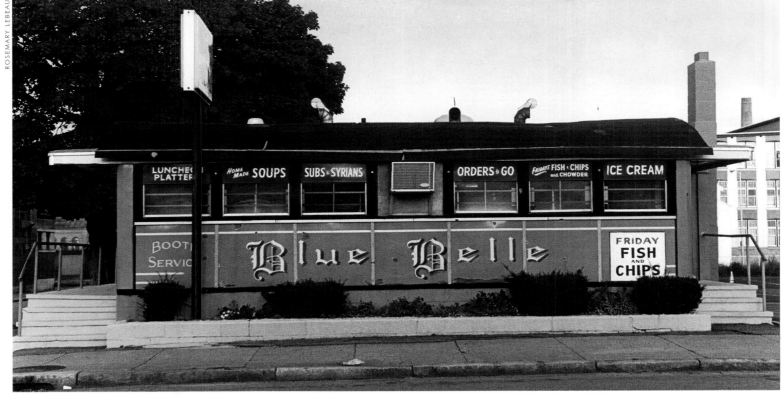

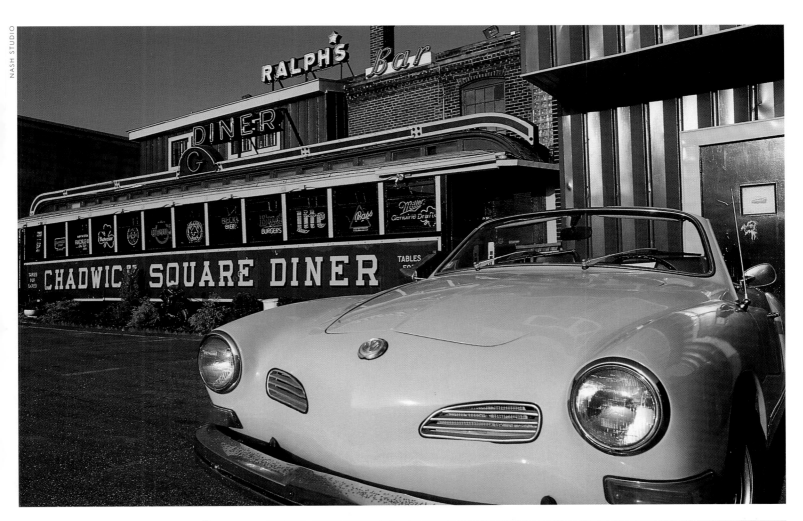

There are diners, and then there are diners: The Edgemere, the Blue Belle and Ralph's Chadwick Square Diner.

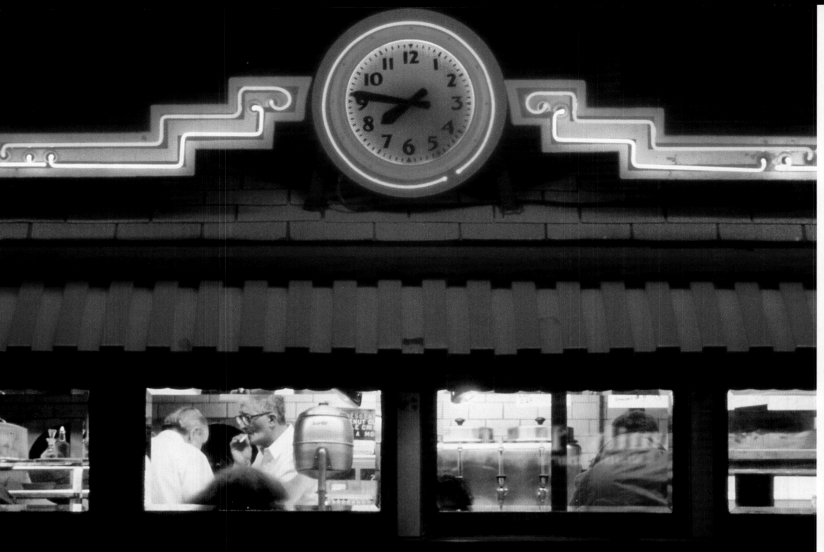

CHRISTOPHER NAVIN

ALLEN FLETCHER

Dining culture: A peek into the Boulevard beneath its neon halo, the Kenmore as seen under the overpass, marketing curious comestibles, a vendor's pride and twilight descends on a city thoroughfare.

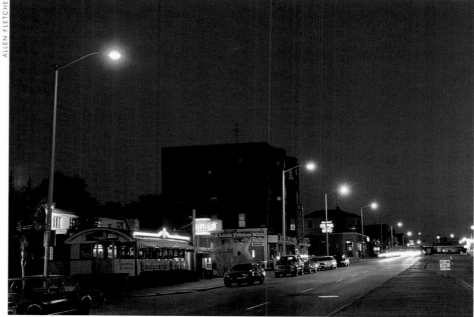

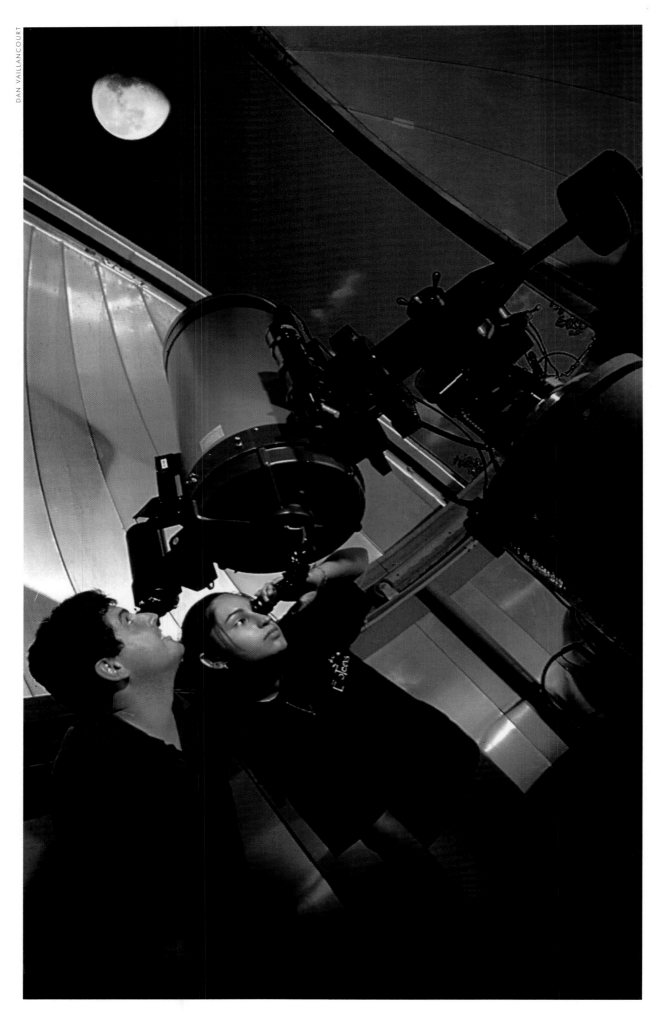

Under the stars, we're as one: Our curiosity has many avenues of exploration in Central Massachusetts. There's the observatory at the EcoTarium, where we can indulge our curiosity in heavenly bodies and pique our interest at the future and what may lie beyond. There is also the Higgins Armory, where a look to the past recalls a time when jousts, bravehearts and knights in shining armor were the order of the day.

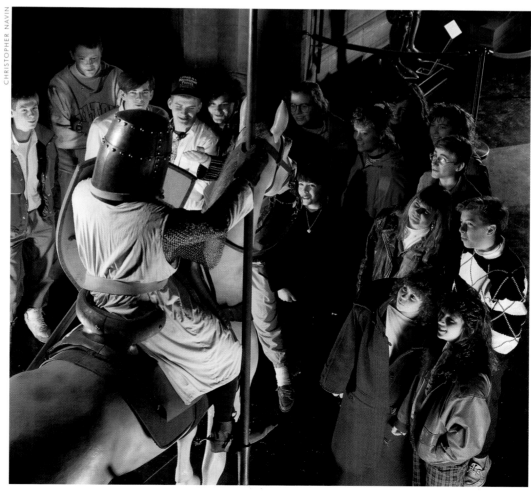

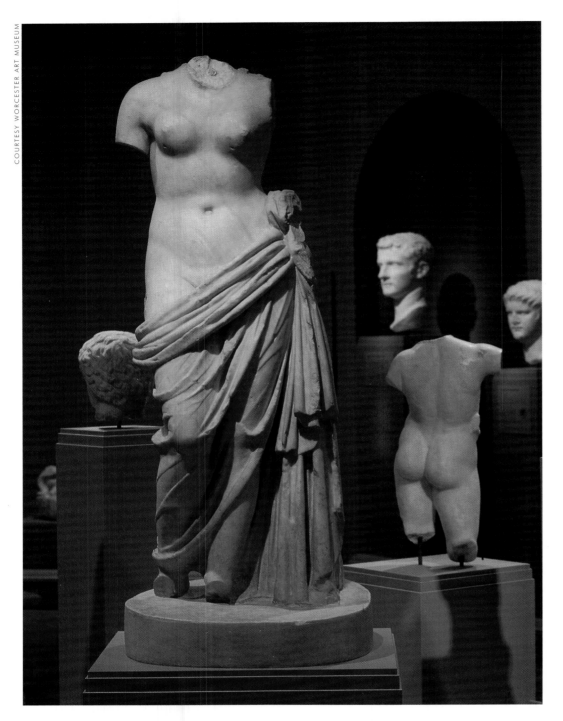

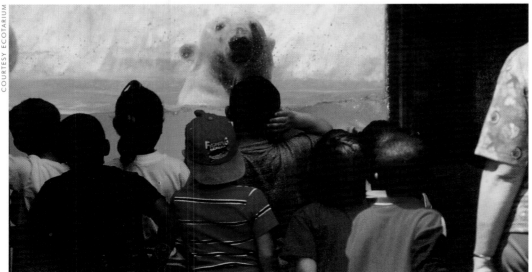

Antiquity beckons at the Worcester Art Museum, from Egypt to Greece to Rome and beyond — to the canvasses of Rembrandt, Monet and del Sarto.

Who's looking at whom? Is the frolicking polar bear the host or the guest of honor? Only visitors to the EcoTarium in Worcester know for sure.

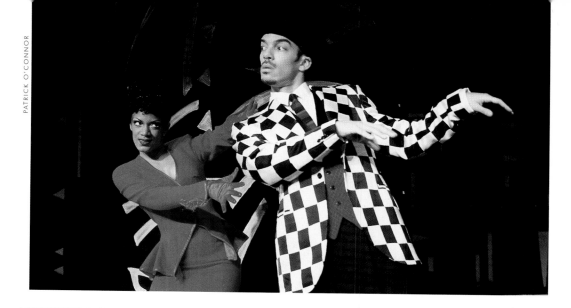

PATRICK O'CONNOR

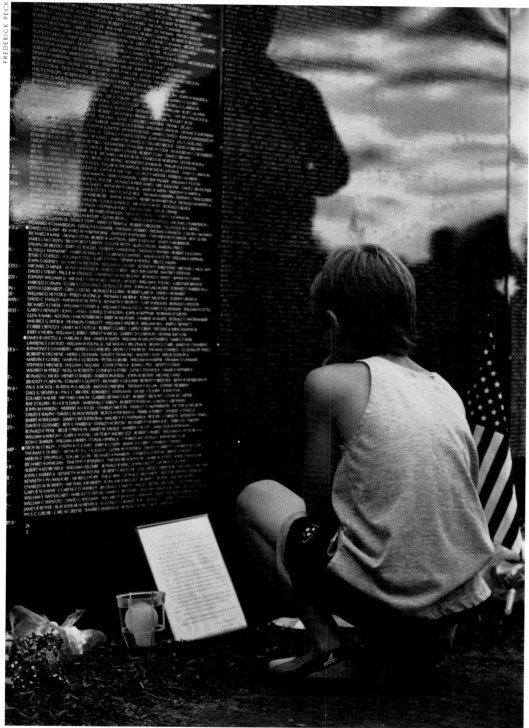

FREDERICK PECK

The lively dramatic arts in the region are ably represented here, in a production where the actors are definitely keeping the audience in check.

Pausing to reflect: A young visitor stops to read a tribute left at the Moving Wall, a replica of the Vietnam Veterans Memorial in Washington, D.C., on its visit to the College of the Holy Cross in Worcester.

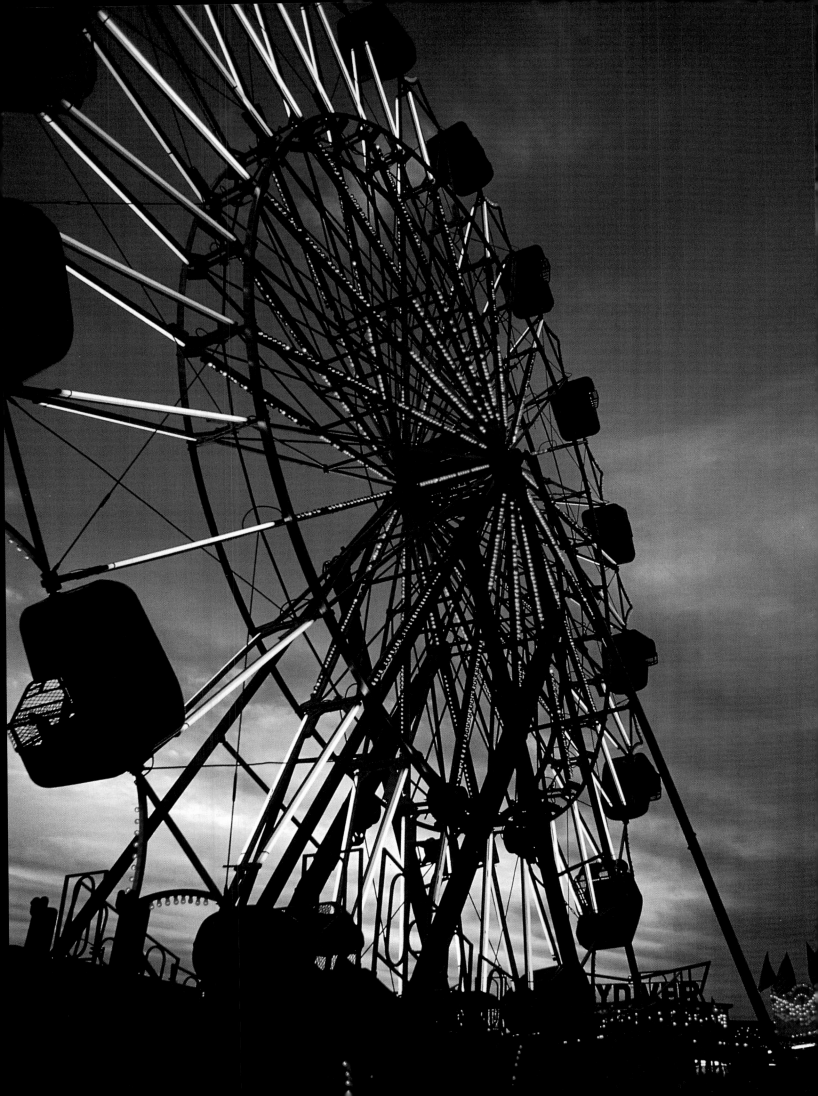

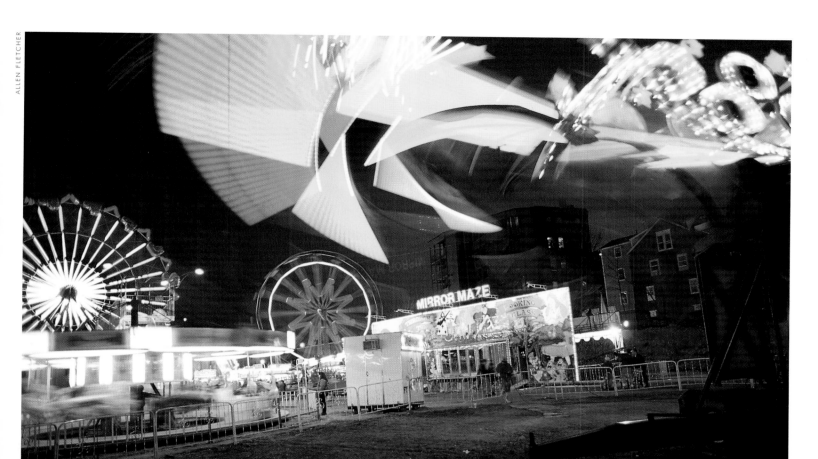

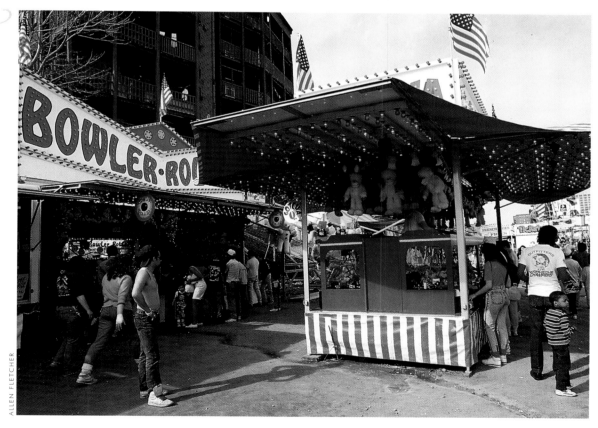

The sights and smells of a good, old-fashioned carnival last a lifetime. Bright lights, amusement rides, games of chance and food from the midway — it all adds up to a memorable summer evening.

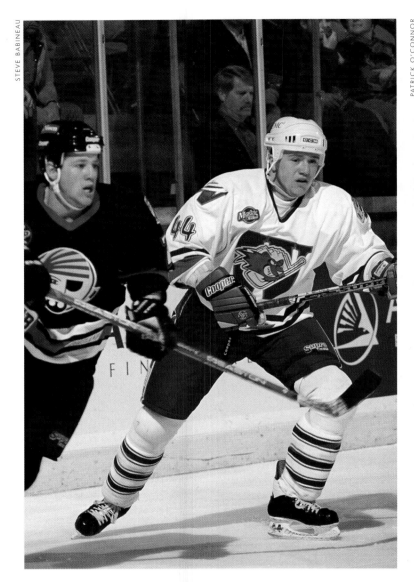

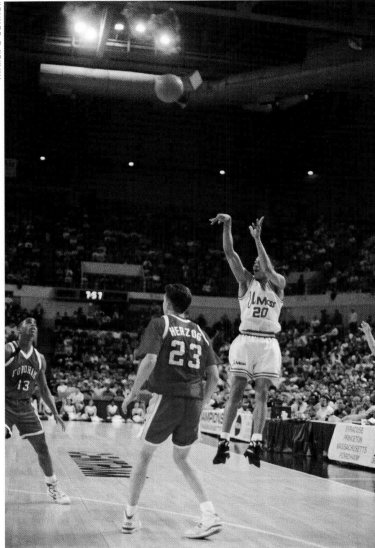

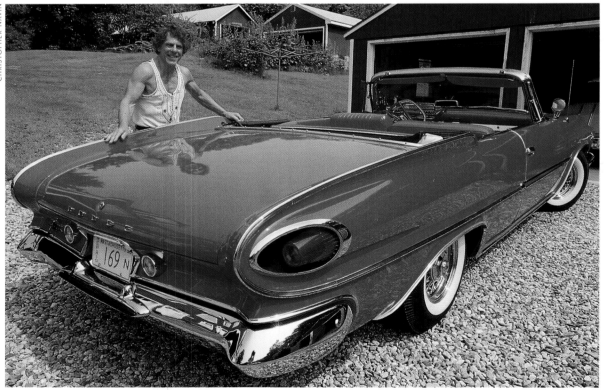

There is always something to do, indoors or out — no matter what time of year. The Worcester IceCats thrill their fans with the excitement of professional hockey, college basketball has a tremendous following, and what better way to appreciate the exhilaration of a New England summer than at the wheel of this fire-engine red '61 Dodge convertible.

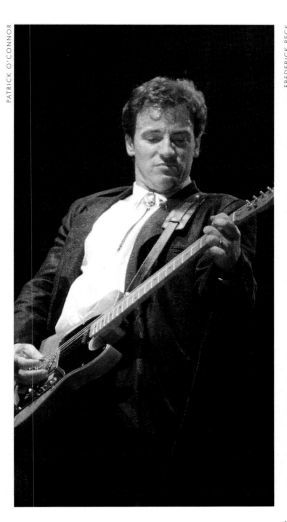

PATRICK O'CONNOR

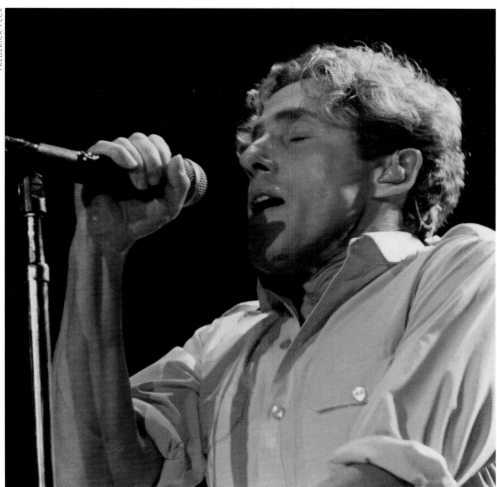

FREDERICK PECK

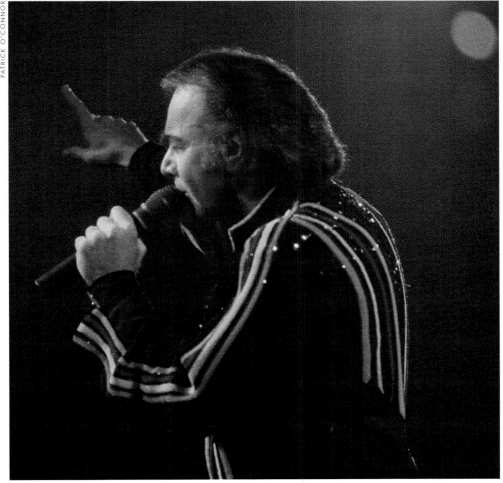

PATRICK O'CONNOR

Movers and shakers: Worcester is at the center of things, geographically and culturally. Since its opening in 1982, Worcester's Centrum Centre has played host to a galaxy of stars — among them Bruce Springsteen, Roger Daltrey and Neil Diamond.

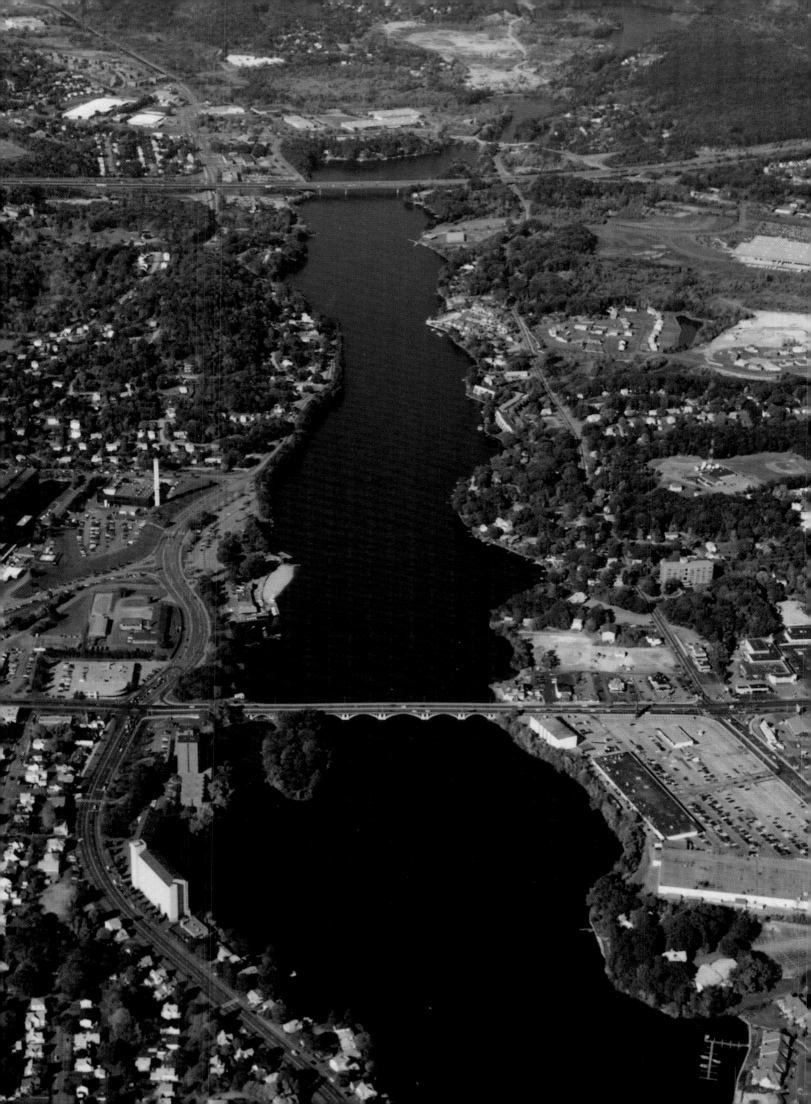

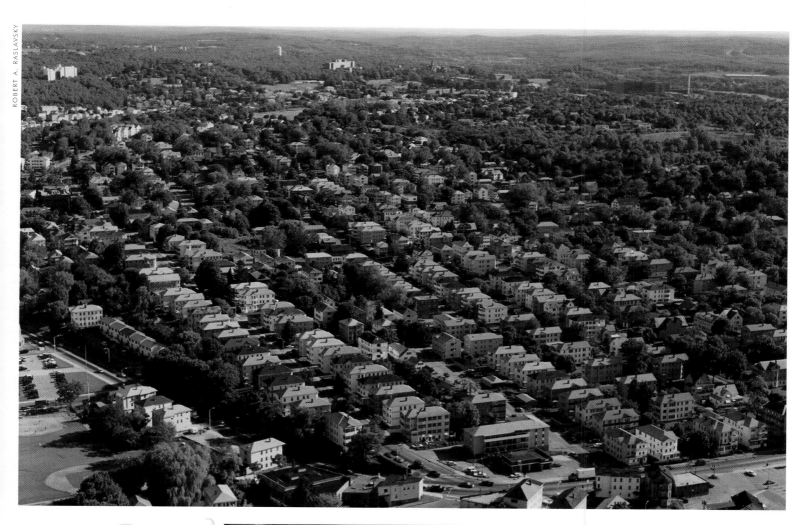

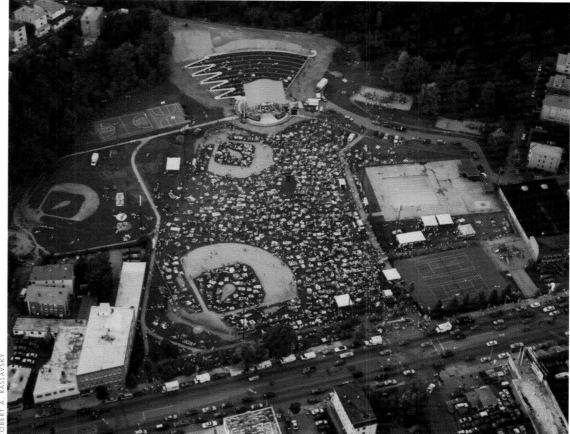

From the air: Worcester's landscapes take on a surreal quality when viewed from above. Lake Quinsigamond, row upon row of neatly stacked triple-deckers and East Park during a Fourth of July concert — all evoke a rich, diverse tapestry.

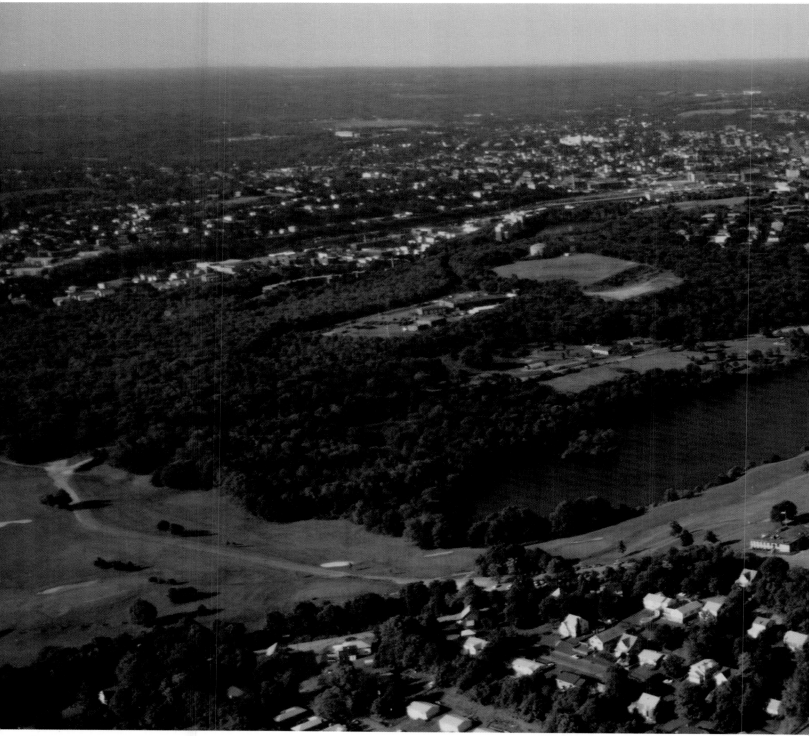

ROBERT A. RASLAVSKY

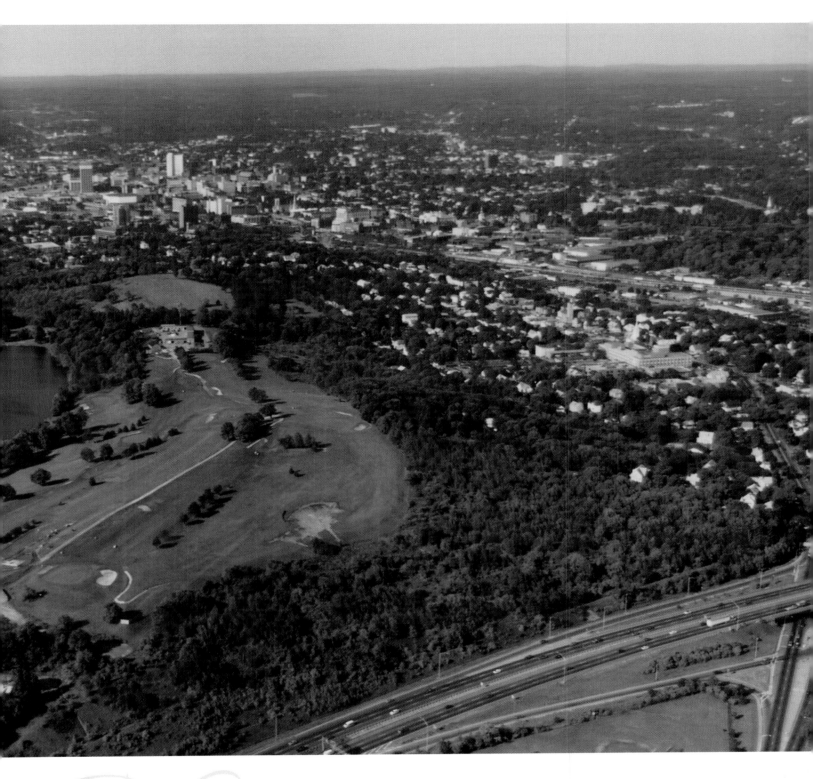

\mathcal{W}orcester's panorama, in the heart of the Commonwealth.

...RVM ET QVEM MISISTI JESVM ...

HISTORIA

SCIENTIA

MEDICINA

WORCESTER
Profiles of Enterprise

This is a close-up look at the corporations, publicly and privately held companies and institutions, as well as leading professional firms in the Central Massachusetts region, who have made this book possible. Their stories are arranged by their year of founding, and chronicle the commitment this region's business community has with its neighbors.

ALLMERICA FINANCIAL ❖ ANNA MARIA COLLEGE ❖ ASSUMPTION COLLEGE

BANKBOSTON ❖ BAY STATE SAVINGS BANK ❖ BOWDITCH & DEWEY, LLP

CLARK UNIVERSITY ❖ COLLEGE OF THE HOLY CROSS ❖ COME PLAY PRODUCTS

DATA GENERAL CORPORATION ❖ ECOTARIUM ❖ FAIRLAWN REHABILITATION HOSPITAL

FALLON CLINIC ❖ FLEET BANK ❖ FLETCHER, TILTON & WHIPPLE, PC ❖ FLEXCON

FITCHBURG STATE COLLEGE ❖ THE GITTO/GLOBAL CORPORATION

GREATER WORCESTER COMMUNITY FOUNDATION

GREENBERG, ROSENBLATT, KULL & BITSOLI, PC ❖ HEBERT CANDIES

THE HERLIHY INSURANCE GROUP ❖ HIGGINS ARMORY MUSEUM

JAMESBURY INC. ❖ THE LANDMARK ❖ LAVIGNE PRESS ❖ MIRICK O'CONNELL

MORGAN CONSTRUCTION COMPANY ❖ NICHOLS COLLEGE ❖ NYPRO INC.

QUINSIGAMOND COMMUNITY COLLEGE ❖ ROTMANS ❖ SHARFMANS INC.

SPAG'S ❖ M. STEINERT & SONS ❖ UMASS MEMORIAL HEALTH CARE

WEBSTER FIRST FEDERAL CREDIT UNION ❖ WEBSTER FIVE CENTS SAVINGS BANK

WORCESTER ART MUSEUM ❖ WORCESTER HISTORICAL MUSEUM

WORCESTER POLYTECHNIC INSTITUTE ❖ WORCESTER PUBLISHING LTD.

WORCESTER STATE COLLEGE ❖ WYMAN-GORDON

BANKBOSTON

BANKBOSTON HAS ENJOYED A DISTINGUISHED HERITAGE SINCE IT WAS ESTABLISHED IN 1784 AS THE MASSACHUSETTS BANK, FOUNDED BY A GROUP OF PROMINENT BOSTON BUSINESSMEN WHO DECLARED "IT WOULD BE BENEFICIAL TO THE PUBLIC IN GENERAL, AND TO ALL PERSONS ENGAGED IN TRADE, TO HAVE A BANK ESTABLISHED IN THIS STATE."

BankBoston maintains its Central Massachusetts headquarters at 100 Front St., Worcester (above), with more than 85 ATM locations and 30 branches throughout Worcester County

BankBoston continues to be a leader in banking technology offering faster, easier banking 24-hours a day, seven days a week with BankBoston ATMs – the largest ATM network in southern New England – telephone banking, PC banking and banking on the Internet

As the bank grew and prospered, it became a symbol of trust, community involvement and personalized banking. The bank entered a new era when it merged in 1903 with the First National Bank of Boston, founded in 1858. Taking full advantage of 100 years of financing international trade, the bank opened its first overseas branch in Argentina in 1917. By 1927, the First National Bank of Boston had also established offices in Cuba, London, Paris and Berlin, and had become known as "the neighborhood bank that serves the world."

Building on its rich legacy and financial strength, BankBoston has been a key financial partner for many Massachusetts institutions and businesses, furnishing the capital needed to grow, compete and provide jobs for tens of thousands of people. The recent merger of Bank of Boston and BayBank has created a consumer and corporate banking leader with deep regional roots and global reach. As the two companies combined, they also took on a new identity, BankBoston. The "new" BankBoston harnessed BayBank's world-class technology and consumer innovation with Bank of Boston's international franchise and sophistication in corporate banking.

BankBoston, with assets of $70.5 billion, is the 16th-largest bank holding company in the United States. BankBoston is constantly evolving to strengthen its Managing for Value strategy by organizing along the lines of its core business — retail, wholesale and global banking — to create value for its stake holders and build a winning company for the 21st century. To execute this strategy, BankBoston offers a full range of banking services to consumers, small businesses and corporate customers in southern New England, delivering sophisticated financial solutions to mid-sized and large corporations nationally as well as corporations and governments internationally, and providing full-service banking in leading Latin American markets.

BankBoston is the Worcester region's largest bank, serving the personal, business and investment needs of individual, institutional, corporate and governmental customers in Central Massachusetts through an unparalleled retail branch and ATM distribution network, middle market lending, small business lending, international trade services, residential mortgage division and The Private Bank in Worcester.

Today, BankBoston operates locally from its 20-story tower in the heart of Worcester's downtown district, providing an ever-increasing array of banking services crafted to meet the needs of its customers — whether they are young professionals, retirees or new immigrants from Europe, Asia or South America. "We are constantly examining our product lines to be sure they meet the customer's needs," says Richard Fates, regional president of BankBoston. "We are now offering products over the Internet, PC banking (for both

personal and business needs), supermarket banking and 24-hour banking through our ATM and telephone banking networks, which are the largest in southern New England."

Although BankBoston has developed a well-deserved reputation for its ability to serve large corporate customers, it continues to be a leading lender to small businesses as well. BankBoston has the special designation of "SBA Preferred" lender and is one of a few Massachusetts banks to offer the SBA's Fastrack program. BankBoston is committed to developing Worcester to its fullest potential by an aggressive presence in underserved communities through its First Community Bank and BankBoston Development Company subsidiaries, which help stabilize local economies, create jobs and accelerate personal wealth creation.

BankBoston's values are a powerful differentiator for the corporation and its key stakeholders: the employees, investors, customers and the communities it serves. Woven throughout the fabric of BankBoston, these values — teamwork, initiative, integrity and diversity — are at once a source of competitive strength and a force that propels BankBoston's support of the community. Sustaining growth and leadership requires the commitment and trust of a truly exceptional workforce. BankBoston engenders employee pride by supporting its employees on the job and off, promoting active dialogue with them, striving to help them achieve a balance between work and family, and respecting their interests, concerns and community service commitments.

BankBoston is also deeply committed to building and effectively managing a diverse workforce. The benefits of managing diversity are well-established — increased creativity and innovation, greater productivity, increased employee satisfaction and loyalty, larger market share and, ultimately, enhanced shareholder value. As Regional President Richard Fates says , "Bottom line, diversity is a business opportunity; and since people are the corporation's most valuable asset, in a world where both the talent pool and customer base is changing, we need to reflect that change in our workforce and harness the diverse talents and perspectives of all employees in our efforts to meet our business goals."

As one of the region's largest and most visible corporations, BankBoston has long provided a tangible return to the community with a focus on building partnerships and

relationships that will strengthen economic development, public education and related youth development. In this way, the bank is helping to build stronger, smarter, more inclusive and productive communities.

BankBoston and its employees have vigorously supported non-profit institutions, housing and economic development programs, public schools, arts and educational initiatives, and the United Way of Central Massachusetts. In recent years, the bank has returned more than half a million dollars annually to the community in direct donations and other philanthropic acts.

Going beyond this philanthropic focus, BankBoston's commitment to leveraging employee resources and encouraging employee involvement in community issues has been taken to the next level through the creation of the BankBoston Eagle Corps. The goal of the Eagle Corps is to expand the bank's impact for good in the community by encouraging and recognizing the bank's volunteers who work collectively on community projects. Its Charitable Foundation also has an employee matching gifts component, which allows employees to direct corporate dollars up to a certain cap each year to a variety of educational and cultural organizations.

BankBoston's commitment to playing a leadership role in the community is a key part of its business strategy. The bank takes pride in incorporating its values and principles throughout its strategy so it can do well by doing good and manage for value with values.

BankBoston demonstrates its corporate values through building and effectively managing a diverse workforce (above)

BankBostons's Eagle Corps team of volunteers spend countless hours annually on community projects in addition to supporting numerous programs for non-profit organizations such as Friendly House's summer camp (below)

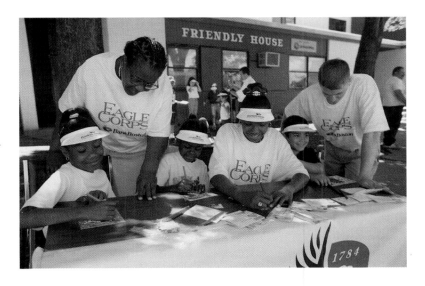

F
LEET FINANCIAL GROUP, THE PARENT COMPANY OF FLEET BANK, HAS REACHED NUMEROUS MILESTONES THROUGHOUT ITS 207-YEAR HISTORY, BUT NONE HAS BEEN AS SIGNIFICANT AS ITS TRANSITION FROM A LOCAL RHODE ISLAND BANK TO ONE OF THE LARGEST BANK HOLDING COMPANIES IN THE COUNTRY.

Fleet Financial Group, headquartered in Boston, is a diversified financial services company with $100.7 billion in assets and more than $80 million in assets under management. The nation's sixth largest commercial lender and New England's leading small business lender, Fleet Bank is the largest full-service provider of financial products in the Worcester community. Fleet's lines of business include consumer banking, government banking, mortgage banking, corporate finance, commercial real estate lending, credit cards, insurance services, cash management, equipment leasing and asset-based lending. Fleet also provides a wide array of investment management services for both individuals and institutional clients and operates the nation's third largest discount brokerage firm through its Quick & Reilly Inc. subsidiary.

Fleet stands behind its promise of convenience and exceptional customer service.

Across the Northeast, Fleet offers tremendous banking opportunities at its 1,200 branches and more than 2,400 ATMs. Fleet also provides 24-hour telephone banking as well as electronic banking services through the Fleet PC Banking Center.

Fleet delivers its services to customers through a variety of branches and products that are easy to use. The bank designs Web pages for its business clients and helps them conduct business internationally through strategic alliances the bank has forged overseas.

Through the efforts of a locally based team led by Fleet Worcester President and Worcester native John Merrill, Fleet offers its customers sophisticated big-bank products with a local touch. "We're local community people delivering state-of-the-art products. You take our commitment to the community, you take local knowledgeable people, and you take the

Showing their team spirit, from left are Kimberly Allen, Emanuel Giumarra, Beverly Harris, Christine Kempskie and Jennifer Leary

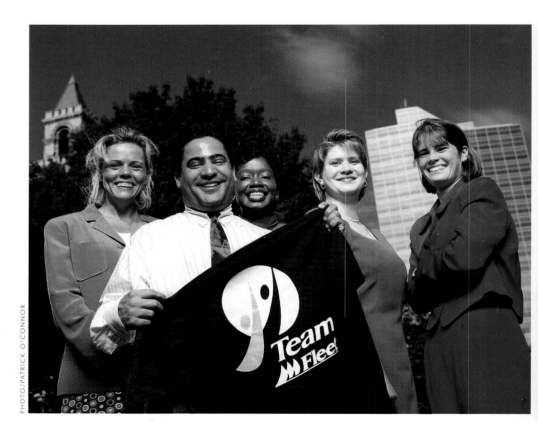

PHOTO/PATRICK O'CONNOR

power and resources of Fleet Bank, and you put those three resources together, and the synergies are just incredible," said Merrill.

Fleet has accomplished a great deal in bringing affordable housing and business development to the Worcester community. The Fleet INCITY program, which is organized into three initiatives — affordable housing, economic revitalization and community — is proof that Fleet can accomplish a great deal in the Worcester area. Fleet helps families in low- and moderate-income areas obtain mortgages for their first homes, revitalizes neighborhoods and helps entrepreneurs start new businesses.

Since February 1994, Fleet INCITY lending activity has totaled more than $6.7 billion, achieved through 223,500 loan relationships with low- to moderate-income families and small businesses in both rural and urban areas. Fleet takes great pride in its partnerships with the communities it serves and its role in helping individuals, families and small businesses achieve their dreams.

Fleet also has a long history of philanthropic leadership in the Worcester region and has supported more than 125 community-based organizations that are building and strengthening communities throughout Worcester.

Fleet has a long history of employee volunteerism as demonstrated by its Team Fleet program. This employee-directed and -driven program has organized groups of employees to work together on short-term, focused projects that benefit local non-profit organizations, such as Junior Achievement, Children's Friend and the ALL school. Fleet gives all employees two paid volunteer days per year that they can devote to volunteer services in their communities.

In 1997, the Fleet All-Stars program was introduced to Worcester County. This program challenges children to make a difference in their community through neighborhood beautification projects and other endeavors. In 1998, more than 2,000 children participated in Fleet All-Star community projects in Central Massachusetts.

As part of its corporate commitment to President Clinton's America's Promise initiative and to the Worcester Youth Summit, Fleet and the United Way partnered to open 25 Fleet tutoring centers throughout the Northeast, including one in Worcester. These centers provide a safe and structured environment for children to do homework, play sports and participate in arts and crafts activities.

"Our biggest assets and resources are our children," said Merrill. "An investment in our kids is an investment in the future of Worcester."

One of the truest measures of Fleet's success is reflected in the economic health and vitality of the communities it serves. By bringing its financial strengths to bear on communities in Central Massachusetts, Fleet is investing in the future of the region it calls home.

Built in 1974, Fleet Bank's headquarters in downtown Worcester

PHOTO/PATRICK O'CONNOR

NICHOLS COLLEGE

NICHOLS COLLEGE IN DUDLEY TRACES ITS ROOTS BACK TO 1815 WHEN AMASA NICHOLS, A WEALTHY INDUSTRIALIST, FOUNDED NICHOLS ACADEMY, A COEDUCATIONAL COLLEGE PREPARATORY SCHOOL.

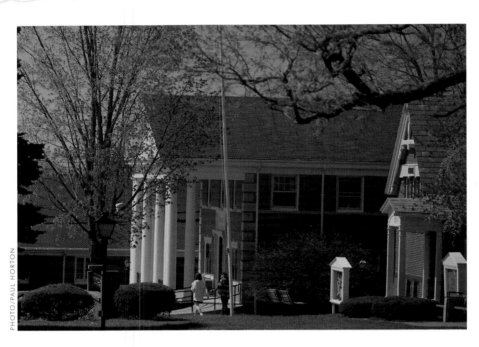

PHOTO/PAUL HORTON

In 1931, the institution became Nichols Junior College, a two-year business college for men, under the leadership of founder and first president James Lawson Conrad. In 1958, Nichols, still under the leadership of Conrad, grew into a four-year college offering the bachelor of science in business administration degree. In 1970, the college admitted women for the first time since academy days and a year later received authority to grant the master of business administration degree. In the 1980s, the college distinguished itself by being among the first in the nation to require all students to own a laptop computer.

Now toting smaller, lighter notebook computers, students can log onto the campus computer network and the Internet from any residence hall room or classroom. Many enjoy working off-line in the college snack bar, in a study lounge or even under a tree.

Today, over 80 percent of day students continue to pursue business degrees. Others study public administration

PHOTO/PAUL HORTON

or liberal arts. The college is actively developing academic programs for implementation in the near future.

In addition to its day programs, Nichols offers continuing education and MBA programs in the evening to another 800 adults. Evening courses are offered on Nichols' Dudley campus and at several off-campus and company sites.

In spring 1998, Nichols dedicated Kuppenheimer Hall, which provides suite-style, apartment-like accommodations for third- and fourth-year students. The college's largest residence hall, Shamie, offers a private shower in each room and individual heat and air conditioning controls. The college is committed to renewing its physical facilities to provide students with the best possible educational environment.

Half the students at Nichols play on a varsity sports team. Nichols also maintains its own nine-hole golf course adjacent to the campus. A wide range of student organizations and extracurricular activities add to an active social calendar. Internships and a semester-abroad opportunities provide further enrichment.

Nichols recently added student service advisors to its support network to ensure that first-year students enjoy a successful transition into their college careers. Combined with a tradition of small class sizes and student-focused teaching, Nichols seeks to embody all that is good about a small college experience — close personal bonds with classmates and professors that launch graduates into the working world with self-understanding and confidence. In recent years, 90 percent of Nichols graduates have found full-time professional employment within six months of commencement.

Nichols is accredited by the New England Association of Schools and Colleges and follows the curriculum guidelines of the American Assembly of Collegiate Schools of Business.

BEFORE GROUND WAS BROKEN FOR MECHANICS HALL, BEFORE THE FIRST STUDENT ENROLLED AT THE COLLEGE OF THE HOLY CROSS, BEFORE WORCESTER EVEN BECAME A CITY, A LEGAL INSTITUTION WAS ESTABLISHED IN WORCESTER THAT REFLECTED THE HONESTY, INDUSTRY AND CIVIC-MINDEDNESS OF THE CITY'S FOUNDERS.

That legal institution, now known as Fletcher, Tilton & Whipple, stands today as one of the premier law firms in Central Massachusetts. With a range of traditional and specialty practice areas, the firm has grown with and responded to the changing needs of its community and clients for nearly two centuries.

The law firm's roots reach back to 1822 when Ira Moore Barton, cousin of Clara Barton, started his law practice in Oxford. He relocated to Worcester in 1834, and in 1845, Barton joined with Peter Child Bacon to form Barton and Bacon, the first of many partnerships, mergers and name changes the firm underwent in its long evolution to Fletcher, Tilton & Whipple, PC.

Many of the firm's attorneys have offered distinguished service to their community and the nation. Barton served as a judge, state representative, state senator and presidential elector; William Swinton Bennett Hopkins commanded a regiment which saw action in the Civil War; Dwight Foster was appointed to the state Supreme Judicial Court in 1866; Thomas Hovey Gage Jr. served as counselor to Herbert Hoover in the National Food Administration and George Avery White became president in 1943 of what is now First Allmerica Financial Life Insurance Co.

This tradition of community service has continued through the years. Firm attorneys have served as district attorneys, judges, legislators, mayors of Worcester, chairmen of the Chamber of Commerce, and corporators, trustees and officers of a wide variety of civic groups, charities and commissions. "One of the true joys of a community-based practice such as ours is the unparalleled opportunity it affords us to have our clients and our friends be one and the same, much more as the rule than the exception," says Warner S. Fletcher, a director of the firm and trustee of several local foundations.

Fletcher, Tilton & Whipple, PC, is well-known for its traditional practices, but the firm also has developed specialized practice areas and business approaches. It serves as corporate counsel for more than 500 businesses and non-profit organizations, administers the region's largest estate and trust practice, and has full-service litigation, commercial lending and land use practices, as well as its own title company. Specialty practice areas include environmental, elder and health care, higher education, labor and employment, and immigration law. The firm has managed its growth to maintain a high level of personal attention and utilizes a large, expert paralegal staff to provide quality, cost-efficient legal services.

The practice of law and the city of Worcester have changed dramatically over the past 176 years and Fletcher, Tilton & Whipple, PC, has remained at the forefront of both. "We're more than just the oldest law firm in Worcester," says Fletcher. "We've established a history of integrity, leadership and excellence, and we are carrying that tradition into the future."

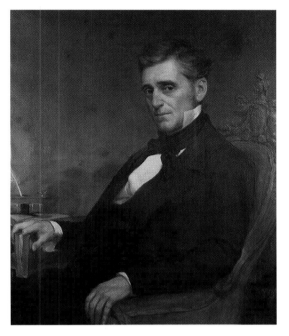

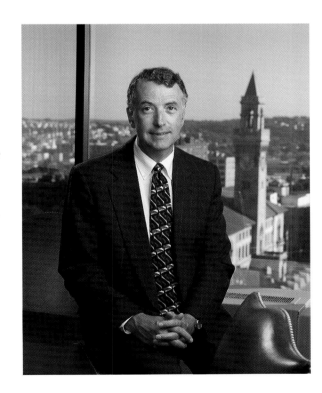

Ira Moore Barton, Esquire (above)

Warner S. Fletcher, Esquire (below)

F

OR MORE THAN 150 YEARS, ALLMERICA FINANCIAL HAS MAINTAINED AN UNWAVERING COMMITMENT TO ITS VISION: TO MAKE PEOPLE SECURE. THIS IS THE VERY REASON THE COMPANY EXISTS — TO HELP PEOPLE ACHIEVE THE KIND OF SECURITY THAT COMES FROM A SENSE OF FINANCIAL WELL-BEING. IT MEANS PROVIDING THE TYPES OF SERVICES AND PRODUCTS THAT PROTECT PEOPLE FROM WANT. IT ALSO CALLS FOR A MEASURE OF SELF-RESPONSIBILITY FROM THOSE WHO SEEK SUCH SECURITY. IT IS A PARTNERSHIP.

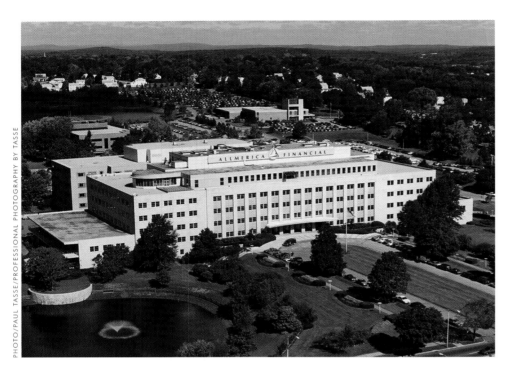

PHOTO/PAUL TASSE/PROFESSIONAL PHOTOGRAPHY BY TASSE

During its first 150 years, the organization pioneered many innovative services and developed a heritage of integrity. Allmerica was the first company to introduce the "10-Day-Free-Look" that now is a standard consumer protection within an insurance contract and the first to offer nonsmoker discounts for life and health insurance.

Today, the diversified group of insurance and financial services companies is headed by Allmerica Financial Corp., a Fortune 500 company whose stock is traded on the New York Stock Exchange under the ticker symbol "AFC."

In recent years, Allmerica has created and acquired companies and businesses to respond to emerging consumer demands and to capitalize on opportunities to expand its leadership position in the insurance and financial services markets.

Allmerica concentrates its business in two primary markets, risk management and asset accumulation. The risk management division consists of a growing property and casualty insurance business and a medical managed care business. The asset accumulation division includes a retail and an institutional retirement and life insurance business, as well as an investment management company.

Much of Allmerica's success over the years has been the result of the company's ability to anticipate and respond to changes in the marketplace.

During the 1990s, Allmerica embraced dramatic change, to compete more effectively in an increasingly competitive industry. Under the leadership of President and CEO John F. O'Brien, Allmerica was transformed from a traditional mutual insurance organization to a more customer-focused, competitive, stockholder-owned financial services organization.

Under Jack O'Brien's direction, Allmerica managed dramatic, positive change throughout the organization, from its corporate and

Allmerica Financial's national headquarters on Lincoln Street in Worcester (above)

John F. O'Brien, Allmerica Financial president and CEO (right)

A

llmerica Financial has been based in Worcester since 1844, when State Mutual Life Assurance Company of America (now First Allmerica Financial) was founded as the country's fifth mutual life insurer by former Massachusetts Governor John Davis.

operating structure, to its market and product focus, its distribution systems and its corporate culture. Allmerica's Service Company was created to provide superior service, to centralize back-office administration and to streamline costs. A far greater financial discipline was imposed. The company transitioned out of businesses that were not profitable or were not complementary to its core business strategies, and focused on variable life insurance, property and casualty insurance, and employee benefit plan coverages to capitalize on consumer needs.

While Allmerica refocused its marketing efforts under Jack O'Brien, it also greatly expanded its distribution capacity to complement its traditional networks, and invested heavily in improved technology, marketing and customer service. The organization applied marketing and service techniques successfully used by the best financial services companies, including telemarketing, financial service centers, seminar prospecting and worksite marketing.

In 1995, the company converted from a mutual insurance company to one owned by its stockholders. As a publicly owned company, Allmerica has enhanced significantly its access to capital and its financial flexibility. In the years following the conversion, Allmerica further improved its financial and industry leadership positions.

As Allmerica seeks to expand its reach in fulfillment of its vision to make people secure, the company is leveraging its historical competitive strengths with its more recently developed marketing skills. Soon after its conversion to a public company, Allmerica established itself as one of the fastest-growing variable product providers in the industry. Today, Allmerica is among the country's leading providers of variable annuities, variable life insurance and property and casualty coverages.

As individuals and businesses increasingly seek help planning for the financial challenges of the 21st century, Allmerica continues to emphasize variable life insurance products with the flexibility to accommodate changing markets and circumstances. The company also has broadened its asset accumulation focus to help clients plan to draw income from their retirement savings in a manner that will assure that they do not outlive their assets during retirement.

Allmerica is committed to making a difference in its home community as well. Just as

Allmerica helps its clients and shareholders build a strong financial foundation, it also has helped Worcester grow and prosper for more than 150 years.

While Allmerica has a comprehensive program of charitable giving and community involvement, it places special emphasis on youth, youth-at-risk and education. Allmerica helps all of the city's youth achieve their full potential and helps prepare the community for the future. The organization's commitment to Worcester, from the contributions of its charitable foundation to in-kind support such as free printing and the donation of surplus office furniture and equipment, helps make Worcester a better place to live and work. Efforts range from sprucing up a neighborhood school to financing a state-of-the-art athletic complex for city schools to providing the largest private contribution to the development of the city's convention center.

While Allmerica is highly adaptable and prepared to initiate further positive change to seize new opportunities, its vision for the 21st century is the same as it has been from the organization's inception — to make people secure. It's a commitment at the core of Allmerica's continued success.

Allmerica's employees continue to build on the company's heritage of integrity and its reputation for innovation (above)

Allmerica employees, family and friends give the thumbs-up sign as they prepare to participate in the annual Walk for Life to benefit AIDS Project Worcester. This is one of many community programs supported by Allmerica Financial and its employees (below)

PHOTO/D.C VANDAL/BLACK SWAN

C OLLEGE OF THE HOLY CROSS HAS BEEN A VITAL PART OF THE WORCESTER COMMUNITY SINCE ITS FOUNDING IN 1843. AS NEW ENGLAND'S OLDEST CATHOLIC COLLEGE, HOLY CROSS IS PROUD OF ITS REPUTATION FOR ACADEMIC EXCELLENCE.

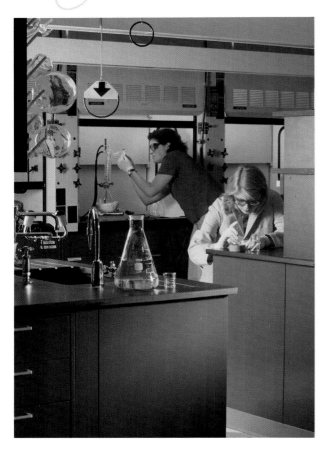

B ARRON'S PROFILES OF AMERICAN COLLEGES places the college in a select group of the nation's 50 "most competitive" colleges and universities. Over the past five years Holy Cross has been ranked among the country's top 25 liberal arts colleges by U.S. NEWS AND WORLD REPORT. The quality of the Holy Cross curriculum is grounded in the deep commitment of its faculty to professional excellence.

The Jesuit tradition of educating men and women to serve others is a major component of a Holy Cross education. While students are recognized for their long-standing commitment to service in the community, Holy Cross faculty are acknowledged for the development of several important outreach programs that allow them to work closely with teachers and students in the Worcester public schools.

Through the generosity of the Howard Hughes Medical Institute (HHMI), Holy Cross in 1991 initiated Youth Exploring Science (YES). During the grant period, 300 minority sixth-, seventh- and eighth-graders from the Worcester public schools participate throughout the school year in a multifaceted program designed to pique their natural interest in science. Holy Cross science faculty communicate their love for science, make science live and instill in students the conviction that the pursuit of scientific study and careers in science are real possibilities for them.

Under the HHMI grant, Holy Cross faculty also assist in the continuing education of science teachers from the Worcester public schools. Each year, Holy Cross provides free tuition for two to three teachers, who come to the college for year-long programs in science education. While these teachers attend the college, their classes are taught by recent Holy Cross science graduates. With their salaries and benefits paid for by the grant, many of these graduates have continued in long-term teaching positions.

In the college's International Ambassadors Program, Holy Cross students who have studied abroad share their experiences of different cultures and languages with students in Worcester public schools. Forty student ambassadors participate annually.

Thanks to funding from the Balfour Foundation, Holy Cross offers live-in summer institutes in creative writing for 15 Worcester public school teachers.

In addition, the Bell Atlantic Foundation assisted Holy Cross in offering Internet training workshops to more than 300 teachers and students in Worcester.

The Virtual Worcester Art Museum, a teaching tool and research database of artworks, texts and curatorial records, is being developed by Holy Cross librarians with a grant from the Davis Educational Foundation. It will enhance the teaching and learning of the arts and humanities at Holy Cross and in the Worcester public schools.

Holy Cross and Worcester have enjoyed a strong partnership for more than 150 years and, together, are looking to a bright future.

OR 140 YEARS, M. STEINERT & SONS HAS OFFERED ITS CUSTOMERS THE BEST PIANOS AT THE LOWEST PRICE CONSISTENT WITH QUALITY. THE FIRM HAS PROUDLY REPRESENTED THE PIANOS OF STEINWAY & SONS SINCE 1869 AND IS NOW THE SECOND-OLDEST STEINWAY DEALERSHIP IN THE WORLD.

As representatives of the most respected piano manufacturers in the world, the experienced staff at Steinert's are dedicated to helping customers find the "right" piano to fulfill their expectations and meet their unique needs. In seminars and workshops, M. Steinert & Sons counsels consumers about traditional acoustic piano construction as well as state-of-the-art digital pianos, MIDI and computer applications.

Steinert's full-time in-house service department performs complete piano rebuilding and restorations. Appraisals, tunings and other piano maintenance are also provided at the customer's request.

M. Steinert & Sons was founded in 1860 by Morris Steinert, who emigrated to New York City from Bavaria in 1831. After undertaking various business ventures, including teaching, performing and retail sales of musical instruments, Steinert opened his first music shop in New Haven in 1865.

On September 14, 1869, on his fourth try, Steinert was granted the rights by Steinway & Sons to sell Steinway pianos. In December of that same year Steinert Hall was built at 162 Boylston Street in Boston. Steinert Hall is the oldest music store in the nation and remains the company's headquarters.

Steinert opened a store on Main Street in Worcester in 1872. When this store was severely damaged by fire, Steinert's relocated to the Day Building on Main Street. People came to Steinert's not only to buy pianos and organs but also to hear concerts, buy music and take organ and piano lessons.

In the early 1980s, Steinert's moved to the Northworks Building on Grove Street and in 1990, to its currrent location at 1 Gold Star Boulevard in Worcester. In addition to its full line of instruments and sheet music, the store has a music school and offers music lessons for adults. Two full-time piano tuners are part of the staff at this location.

M. Steinert & Sons' current product line includes acoustic pianos by Steinway & Sons, Boston, Petrof, Weinbach, Kohler &

Campbell and Charles Walter. Its digital piano line includes Roland, Technics, Van Koevering and Viscount. Steinert's also represents Roland and Technics home organs. M. Steinert & Sons services all the instruments it represents, and offers its customers lessons on how to play them.

Believing that music and arts awareness programs nurture a love of music, Steinert's provides outreach programs with music schools. It also works closely with most of the major schools, colleges, universities and conservatories in Massachusetts, New Hampshire and Maine. Steinert's holds workshops with guest speakers to discuss the benefits of music.

Morris Steinert died in 1912 and left the company to his sons and Jerome F. Murphy, who joined the company as a clerk in 1897 and was made general manager in 1916. In 1936 Jerome F. Murphy took over the ownership of M. Steinert & Sons. When he died in 1961, he left the company in the hands of his two sons – Jerome Murphy III and Paul Murphy Jr. Today they still conduct business at Steinert Hall in Boston.

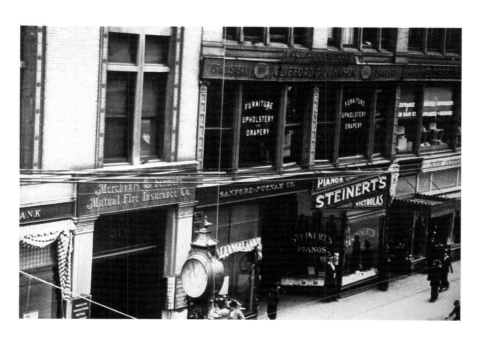

W PI AND WORCESTER HAVE GROWN UP TOGETHER. THE UNIVERSITY WAS FOUNDED JUST AFTER THE CIVIL WAR, A TIME WHEN THE CITY WAS TRANSFORMING ITSELF FROM A RURAL COMMUNITY TO A MIGHTY MANUFACTURING CENTER. IN THE SUCCEEDING CENTURY, WPI AND ITS HOMETOWN HAVE CHANGED DRAMATICALLY, AND EACH HAS CONTRIBUTED GREATLY TO THE OTHER'S SUCCESS.

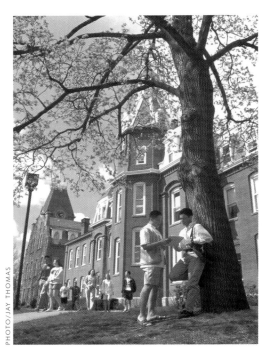

PHOTO/JAY THOMAS

The third-oldest private technological university in the United States, WPI was founded in 1865 as the Worcester County Free Institute of Industrial Science. It began as the dream of John Boynton, a successful tinware manufacturer from Templeton, Massachusetts. Foreseeing the impact the Industrial Revolution would have on life and work in New England, Boynton decided to establish a new type of school to educate young people to become leaders in engineering, manufacturing and commerce. He pledged his life's savings — $100,000 — to endow the institute if the people of Worcester would build it a campus.

Stephen Salisbury II, Worcester's most prominent business leader, gave the school 6.5 acres near Salisbury Street, the nucleus of what would become today's 80-acre campus. Salisbury also contributed to the fund to build Boynton Hall, the first of WPI's 31 major structures. The Washburn Shops is the oldest building in the nation used continuously for engineering education. The gift of Worcester industrialist Ichabod Washburn, it was a model manufacturing facility where future technological professionals could apply what they learned in the classroom. The balance

between theory and practice has been the hallmark of a WPI education ever since.

For the past 25 years, that balance has been embodied in an innovative curriculum that is focused on outcomes. WPI allows students to design their own programs to suit their interests and gives them the knowledge and the tools they need for rewarding and successful lives. They learn to lead, work in teams, communicate professionally, and approach and solve problems creatively and systematically.

At WPI, students learn by doing. They immerse themselves in the humanities and arts by conducting scholarly research, writing and performing original plays and musical compositions or developing exhibits for museums. They come to understand how science, technology and social issues intersect in today's world by tackling important problems for organizations and government agencies. And they see how problems are solved in science, engineering, management and other disciplines through original design and research experiences.

Believing that a global perspective is a necessity in today's interconnected marketplace, WPI has become the national leader in global technological education. It established its first off-campus project center in Washington, D.C., in 1974 and its first international center in London in 1987. Today, WPI maintains a network of project centers that spans the globe. About half of WPI's juniors and seniors travel overseas each year to complete professional-level projects with international corporations and organizations.

Overseas project work is a powerful learning tool for students and a valuable experience for project sponsors. Now WPI is bringing these benefits to its own backyard with the Worcester Project Center. Building on the success of projects conducted with the public schools, the court system, the University of

PHOTO/JAY THOMAS

Massachusetts Medical Center and other organizations, this new center serves as a focal point for projects that have the potential to benefit the entire community. The center will also consolidate and enhance the services WPI's students perform for the local community — through their projects and as volunteers.

WPI awarded its first advanced degree in 1893. Today most of WPI's academic departments offer advanced degree programs that can be pursued on a full- or part-time basis. Graduate courses and continuing education programs are offered at WPI and at branch campuses in Waltham and Westborough, Massachusetts. The growth of the graduate program has helped the university build research efforts that have earned increasing recognition in the scientific and engineering communities. WPI has created laboratories and centers for research in such fields as advanced materials processing, aerospace engineering, artificial intelligence, biochemical, biomechanical, biomedical and bioprocess engineering, fire science, fluid dynamics, holography and laser technology, machine vision, medical imaging, satellite navigation and wireless technology.

WPI's academic and research programs have benefited from the close relationship the university has enjoyed with local, national and international business and industry. WPI alumni founded many Worcester area companies and continue to be a mainstay of the region's industry. Corporations support WPI's mission by establishing research partnerships, donating equipment and facilities and supporting the university's academic programs and students. In return they have access to potential employees, to the expertise of WPI's renowned faculty and to educational programs that help build their employees' skills.

Through the years, WPI alumni have invented, designed and manufactured technologies that have changed our lives. They have founded and run companies, designed and erected buildings, dams and bridges, and fashioned great networks of railways, highways, waterways and power lines. They have made scientific discoveries and explored uncharted territory – both physical and metaphorical. With their ideas, their knowledge, their creativity, their indomitable spirit and their sweat and tears, they helped build the world of the 20th century, and they are at work right now on the world of tomorrow.

A WPI WHO'S WHO

In its 13 decades, WPI has graduated many scientists, engineers, business people and educators whose achievements are world-renowned. They include Harry P. Davis, Class of 1880, who helped establish the nation's first commercial radio station and became the first chairman of NBC; Elwood Haynes, Class of 1881, who built one of America's first automobiles; Robert H. Goddard, '08, inventor of the solid-fueled rocket and widely regarded as the father of the Space Age; Arthur Nutt, '16, a member of the Aviation Pioneers Hall of Fame, who designed the engines that powered 90 percent of the world's commercial aircraft in the 1920s and 1930s; Burton Marsh,'20, the nation's first full-time traffic engineer, who contributed greatly to highway and pedestrian safety in the United States; Harold Black, '21, inventor of the concept of negative feedback, now a fundamental principle of electrical engineering and the social sciences; K. Blair Benson, '41, who was part of a team at CBS that won the Emmy in 1956 for the invention of videotape; and Richard T. Whitcomb, '43, who formulated the area rule, a fundamental principle in the design of high-speed aircraft; Carl Clark, '45, inventor of the first practical airbag safety system; Paul Allaire, '60, chairman and CEO of Xerox Corp.; and Ronald Zarella, '71, president of General Motors' North American operations.

A S RARE AS IT MAY SEEM, THERE IS A BANK THAT STILL BELIEVES IN SUPPORTING LOCAL NEIGHBORHOODS, WHILE PROVIDING PERSONAL, ONE-ON-ONE SERVICE TO LOCAL RESIDENTS. IT'S CALLED WEBSTER FIVE CENTS SAVINGS BANK.

Richard C. Lawton, president and CEO of Webster Five Cents Savings Bank (above)

Webster Five Cents Savings Bank main office at 136 Thompson Road, Webster (below)

Since 1868, Webster Five has provided vital banking services to the area. For more than 130 years, it has not only served the community but been a vital part of it.

Financial growth has been steady throughout the history of the bank and indicates the confidence area residents have always shown in Webster Five. Today, the bank has assets in excess of $255 million, and in 1998 Bauer Financial Reports Inc. issued it a five-star rating, the best a bank can receive among its peers.

On August 10, 1868, Webster Five opened for business with 20 deposits made at its first location in the J.F. Hinds Store in Spaulding's block of Main Street, Webster.

Two years and 710 depositors later, the bank moved to larger quarters in the Dresser Block building. In 1954, its headquarters became the attractive red brick building at 290 Main Street, and in 1980, the bank opened its present corporate headquarters on Thompson Road, Webster.

Many area residents came to Webster Five for mortgages, loans and savings accounts during the post-World War II housing boom. Local businesses, flourishing in the postwar era, also relied heavily on the institution during this time of commercial and community growth.

To better serve the needs of surrounding communities, Webster Five opened branches in Oxford and Dudley during the 1960s and 1970s. And now in the 1990s, Auburn and Worcester are part of the 6-location branch network.

Today, supported by its solid history and secure financial base, the bank has developed a reputation for outstanding personal service, community support and fiscal strength. In addition, its expanded branch network and computer technology have made it more convenient than ever for area residents to bank with Webster Five.

While one-on-one service from Webster Five may be reminiscent of years past, the products and services it provides are anything but old-fashioned. The bank's ATM system is considered among the most advanced in the area. And in 1997, Webster Five introduced its Value Checking Package, which combines free checking with free debit card transactions, free ATM use and free Tellalink 24-hour phone banking.

Committed to reinvesting its profits into the community, the bank has developed the Webster Five Foundation, a non-profit fund to serve various community-related causes. From 1996 to 1998, Webster Five distributed more than $185,000 in charitable contributions to non-profit organizations. Webster Five also participates in the Massachusetts' Savings Makes Cents Program, a statewide educational program to teach the principles of banking in the classroom.

As it plans for tomorrow, Webster Five will continue the tradition of serving the banking needs of local residents and businesses. The record speaks for itself: Webster Five always has been, and always will be, an involved and important contributor to the community, delivering guaranteed personal service and attention beyond the expected.

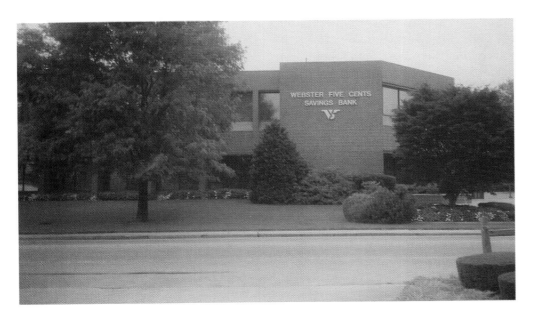

SINCE ITS FOUNDING IN 1887, CLARK UNIVERSITY HAS NURTURED A PIONEERING SPIRIT. VISIONARIES SUCH AS PSYCHOLOGIST G. STANLEY HALL, PHYSICIST ROBERT H. GODDARD AND INTERNATIONAL RELATIONS PIONEER GEORGE BLAKESLEE THRIVED IN THIS UNIQUE AND LIBERATING ENVIRONMENT.

Clark continues its tradition of attracting scholars who have the courage to take risks, the imagination to tackle problems from new perspectives, and the confidence to work beyond the frontiers of their disciplines. Founded as a graduate school, the second-oldest in the country after Johns Hopkins, Clark has awarded more graduate degrees in geography than any other institution. Undergraduates can major in 27 different academic programs, including a psychology program that continues to champion new scientific trends. Sigmund Freud's only visit to America was in 1909 to deliver the "Clark Lectures" in which he introduced his theories of psychoanalysis to the United States.

Clark is the smallest research university in the country, yet its faculty successfully compete against the best universities in the nation for research funding. An 11:1 student-faculty ratio means that Clark's 2,000 undergraduates receive the research advantages of a university without losing the highly personalized teaching attention of a college.

Clark students are noted for being diverse, with a highly international character. Fifteen percent of Clark's students come from countries other than the U.S., a higher percentage than all but three other colleges in the country. Internationalism pervades the curriculum as well, and faculty research touches every part of the world.

Students are socially engaged, and that spirit is supported by the Clark community. Clark's innovative University Park Partnership, a neighborhood revitalization effort, is receiving national attention for its success in building community spirit. The University Park Campus School, a Worcester public school on the Clark campus, benefits from Clark's facilities, faculty and student volunteers.

Many alumni credit Clark with changing their lives — inspiring them to achieve beyond their expectations, providing outlets for exciting research and academic discoveries, and launching them on interesting and fulfilling careers. Clark's 27,000 alumni live all over the world and represent every profession imaginable.

Clark leads the academic community in areas such as international relations, environmental sustainability and Holocaust and genocide studies. Clark's Center for Holocaust Studies is the first and only institute to establish Holocaust history as a field of study in its own right. The nation's first full-time, fully endowed chair in Holocaust history was created at Clark in 1995, and a second was added in 1997.

In 1987, Clark geographer Ronald Eastman created Idrisi, an inexpensive software that maps and analyzes geographical data by pulling together millions of pieces of data with unprecedented speed. Idrisi has become one of the world's most popular Geographic Information System software programs, used in 130 countries by more than 20,000 registered users.

Most recently, Clark faculty were instrumental in organizing a forum in Asia for business, government, and academic and community leaders worldwide to explore the benefits of incorporating environmental concerns into mainstream business development strategies.

These are just a few examples of the result of Clark's lively intellectual exchange and openness to new ideas. Clark will continue to champion a pioneering spirit with innovative programs exploring the world's most pressing issues.

Jonas Clark Hall (above)

The Robert Hutchings Goddard Library (below)

OR 125 YEARS, WORCESTER STATE COLLEGE HAS BEEN HELPING PEOPLE MAKE THE CONNECTION BETWEEN WHERE THEY ARE AND WHERE THEY WANT TO BE. WHILE SOME OF THE TOOLS FOR THE EDUCATIONAL JOURNEY MAY HAVE CHANGED OVER THE DECADES — FROM CHALK BOARDS AND INK WELLS TO SATELLITE LINKS AND INTER-ACTIVE VIDEOS — THE GOAL OF THIS COMMUNITY-GROUNDED COLLEGE REMAINS THE SAME, TO PROVIDE INDIVIDUAL ENRICHMENT AND ADVANCEMENT FOR STUDENTS FROM ALL WALKS OF LIFE.

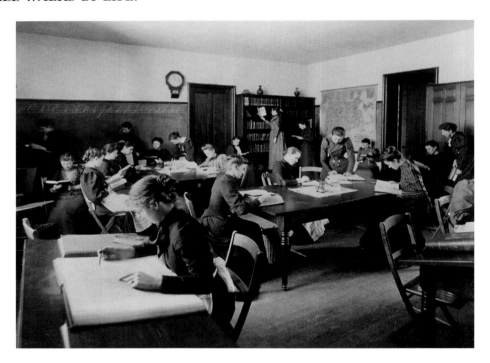

It all started in 1874, when the state Legislature resolved to create a college that would educate women to become teachers. Worcester State College also served as a bridge for the Worcester area's many immigrants to gain skills and launch careers in their new homeland. The college began as a single building on St. Ann's Hill. With its successful evolution from normal school to four-year teachers' college by the 1920s, Worcester State began to outgrow its splendid Gothic building. The city responded to its campaign for a new home, purchasing 20 acres for a new campus in a residential area on the West Side. In 1932, Worcester State moved to a new building at Chandler and May streets, its current location. The original graceful, white-columned brick structure now serves as the college's Administration Building.

Today, Worcester State College is committed to educational programs that lead to self-

enrichment through the liberal arts and to careers in the professions, government, business and industry. While continuing its tradition of serving the residents of the Commonwealth, the college has earned a reputation for an affordable education through quality teaching by dedicated faculty in classes of moderate size. As the needs of the community and of society have changed, Worcester State College has evolved to offer degrees in nursing, communications, health services, speech disorders, occupational therapy and more. In response to the region's burgeoning role in biotechnology, it offers undergraduate and graduate studies in that cutting-edge field.

Worcester State College seeks a more comprehensive role in the community it serves by reaching beyond the traditional realm of college education with its many programs to fit an array of student needs at various stages of their lives. Nearly half of the 5,700 students who pass through the halls of its stately brick buildings are non-traditional students. Many are looking to pursue new career focuses or to improve skills in their current professions. Working professionals come here to gain special accounting or communication skills. Adult students can also pursue graduate degrees evenings and weekends in such subjects as nonprofit management or biotechnology. Local businesses and institutions can also use Worcester State's resources to structure on-site programs tailored to their individual needs.

Traditional students attending Worcester State enjoy a full array of collegiate activities and a chance to work in the community through its many outreach programs. Students work with the public schools to provide such services as screening for speech and

hearing problems. They can also get hands-on experience through a variety of internships with local businesses and institutions. Significantly, most of Worcester State College's students are from the Central Massachusetts region and most remain here after graduating. In fact, three quarters of the college's alumni live in the greater Worcester area.

The college's 58-acre campus provides a rural atmosphere in an urban setting. It is in the residential West Side of the city, accessible by the public bus line and only six minutes from downtown Worcester. Always striving to meet community needs, Worcester State College facilities accommodate everyone from dance troops and local opera companies to state and local politicians. It actively seeks opportunities to work with local schools, businesses, cultural and social organizations.

Worcester State College is committed to embracing the latest technology to help students reach their learning goals and to expand their educational horizons. "Smart classrooms" with specially designed computer consoles let instructors bring in satellite images and use the latest audio, video and interactive tools. Students at off-campus locations can interact electronically with on-campus classes. Student dormitories are wired to the Internet and feature e-mail. What's more, Worcester State is in the process of building a four-story, $22.5 million Science and Technology building with state-of-the-art technology to serve its health services, science and biotechnology programs. The new facility, expected to be open in 2000, will provide laboratories for communication disorders, occupational therapy, physical therapy, physics, computer science, biology, biotechnology, chemistry, geography, natural sciences, health science and nursing. Also included in the plans are 65 faculty offices, academic computer facilities and a multi-media auditorium.

Programs at Worcester State College even bridge the gap to other countries and continents. Students can spend a semester at the college's sister institution in Worcester, England, not far from Stratford-on-Avon. English students, in turn, come here to study. The college just recently established sister relationships with two Chinese colleges as well.

Whether it's helping working professionals advance their skills or launch new careers in biotechnology, Worcester State College will

continue to strive to meet the changing needs of the community it serves. Biomedical and health sciences will be key focuses as it prepares students for the 21st century and beyond. However, as it celebrates it 125th anniversary, helping to create outstanding teachers remains its hallmark. Nine of the last 11 teachers recognized by the City of Worcester as Teacher of the Year have been Worcester State College alumni.

T

THROUGHOUT ITS 115-YEAR HISTORY, WYMAN-GORDON CO. HAS BEEN A LEADING SUPPLIER OF FORGED METAL PARTS TO INDUSTRY. FORGING IS THE BLACKSMITH'S ART OF HEATING METAL AND FORMING IT THROUGH HAMMERING, EXTRUSION, ROLLING OR PRESSING.

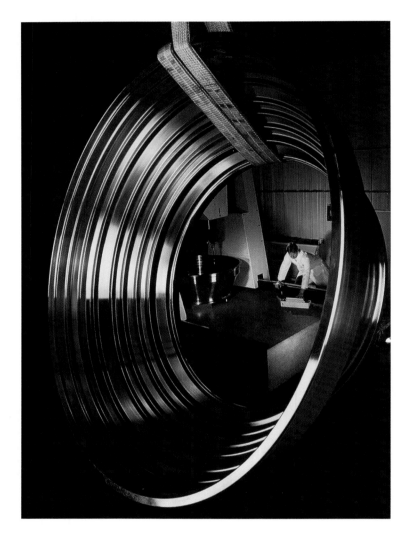

These nickel alloy turbine cases for the Pratt & Whitney PW4000 engine are representative of Wyman-Gordon's heavy press forging and advanced machine capabilities (above)

The history of Wyman-Gordon Co. mirrors the history of the transportation industry. Early forged products included sprockets and cranks for bicycles. The company then moved into forging copper rail bonds for electric trolleys. In the late 1800s, the company forged steel knuckles that joined railway cars. The company's greatest growth spurt occurred in the early part of the 20th century when it began to manufacture forged crankshafts for the automotive industry. Crankshafts remained a major product line for the company for many decades.

In 1903 the Wright Brothers made their first flight, and since that time aerospace has grown to be the main market for the company's products. Wyman-Gordon forgings were on the Spirit of St. Louis when Charles Lindbergh made his epochal flight from New York to Paris in 1927. Today, every commercial airline flying uses Wyman-Gordon parts. Although the company expects that airplane travel will remain its principal market for many years to come, it has also produced parts for the space shuttle program. If space travel ever becomes a reality, Wyman-Gordon will be there.

Since 1887, when George Fuller joined the company, and 1911, when Harry G. Stoddard joined, the Fuller and Stoddard families have been inextricably linked with Wyman-Gordon. George Fuller, Harry Stoddard and his son, Robert Stoddard, served successively as CEOs of the company from 1915 through 1972 — a span of 58 years during which the company experienced unprecedented growth. Through the Fuller Foundation and the Stoddard Charitable Trust — funded largely with Wyman-Gordon stock — as well as the Wyman-Gordon Foundation, the Worcester community has received generous financial support for a great variety of charitable causes.

In 1994, at the nadir of the aerospace cycle, Wyman-Gordon acquired Cameron Forged Products Co. in Houston. The combination of the two leading aerospace forging companies has resulted in a stronger organization that has

Forging imparts strength to metal so that lighter weights can be used — a critical advantage in aerospace, which is the company's major market today.

The company — initially called Worcester Drop Forge — was founded in Worcester in 1883 during the height of the American Industrial Revolution by H. Winfield Wyman and Lyman F. Gordon. The men were lifelong friends and graduates of the Worcester Free Institute of Industrial Science — now Worcester Polytechnic Institute (WPI). Their principal customer in the early days of the company was the Crompton & Knowles Co., which required forged shuttles for its weaving looms.

been better able to serve customers such as General Electric Aircraft Engines, Pratt & Whitney, Rolls-Royce, Boeing and Airbus Industrie S.A. Wyman-Gordon's principal product line consists of forged rotating parts such as disks, spools, shafts, cases, seals and spacers that it sells to major jet engine manufacturers. The company's line of aerostructural products includes landing gear, landing gear support beams, bulkheads and wing spars. Wyman-Gordon manufactures its forgings out of high-temperature nickel alloy and titanium and steel alloys.

The company's plants in Houston, Buffalo and Livingston, Scotland, all have the capability of extruding seamless pipe. The company can produce pipe as long as 60 feet with outside diameters of up to 48 inches and wall thicknesses of up to 4 inches. These pipes serve the nuclear power generation and chemical processing industries and are also used in petroleum production, where the company's corrosion-resistant alloy pipes have advantages, particularly in deep sea oil and gas production.

In the late 1980s, the company entered the investment castings business. Casting, a process developed in China more than 5,000 years ago, involves producing a wax pattern of a part, encasing the pattern with a ceramic shell, melting the wax to create a cavity, and pouring molten metal into the mold to achieve a finished shape. Casting is a precise manufacturing process in contrast to forging, which produces larger parts with greater metallurgical strength. Wyman-Gordon's castings business operates in plants in Groton, Connecticut; Tilton and Franklin, New Hampshire; Carson City, Nevada; San Leandro, California and Albany, Oregon. The principal market for the company's casting products is the aerospace industry, but the company serves the biotechnical, automotive, food processing and power generation markets as well.

Through its Scaled Composites and Scaled Technology Works subsidiaries, Wyman-Gordon is engaged in the development of prototype composite aircraft constructed out of fiberglass and other fibers bonded together with high-performance resins.

Wyman-Gordon currently operates in Worcester and in North Grafton, where its headquarters are located. In Worcester, it conducts isothermal forging, a process in which the die tools are heated to the same temperatures as the metal which is formed inside them. Because of these elevated temperatures, the dies oxidize and thus isother-mal forging is conducted in a vacuum or inert gas environment.

At its North Grafton location, the company forges aerostructural parts on heavy presses which are capable of applying forces of 50,000 tons, 35,000 tons and 18,000 tons. These presses were installed by the U.S. Air Force after World War II as part of a national defense preparedness effort. Until 1982, when the company acquired the North Grafton plant, the plant was owned by the government and operated by Wyman-Gordon. The 50,000 ton press is listed as a National Historic Mechanical Engineering Landmark, and there is only one equivalent press in the United States.

Today, Wyman-Gordon employs 4,000 people at 13 plants in the United States and one in Scotland. From its beginnings as a small forge shop on Bradley Street in Worcester to a multinational corporation, Wyman-Gordon has always been here and is proud to be part of the Worcester community.

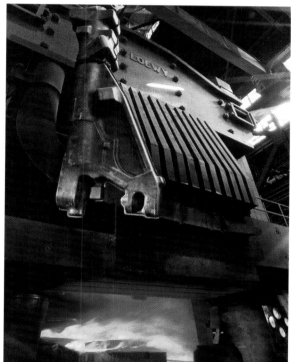

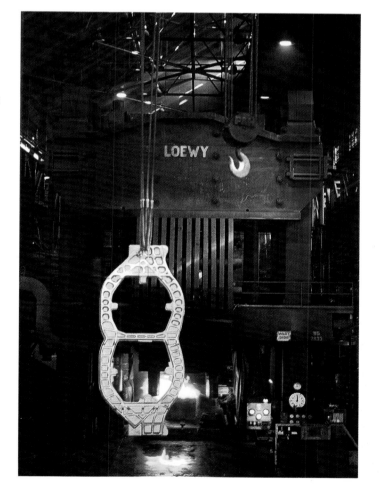

Wyman-Gordon's 50,000-ton forging press located in North Grafton is the largest press in the United States (above)

The bulkhead for the F-22 advanced tactical fighter made by Wyman-Gordon is the largest titanium closed-die forging ever made (left)

MORGAN CONSTRUCTION COMPANY IS WELL KNOWN, NOT ONLY TO THE WORCESTER COMMUNITY, BUT ALSO TO A VITAL AND SPECIALIZED SEGMENT OF THE INTERNATIONAL BUSINESS COMMUNITY.

Shown are Morgan Construction Company's two Worcester facilities – its headquarters building on Carbon Street at Lincoln Square (above), and its manufacturing facilities on Crescent Street (below), about a mile away alongside Interstate 290

Established in 1888, the company's principal business is the design and manufacture of bar and rod mills. During the past 110 years, Morgan has built a strong reputation for technical innovation and quality products for the worldwide rolling mill business.

The company was founded in Worcester by Charles Hill Morgan, an engineer and inventor who designed the first successful continuous rolling mill ever built in the United States. Based on his ideas and commitment to research, Morgan's products have become the worldwide benchmark for technological leadership, reliability and performance.

Today, Morgan is one of the world's leading designers and manufacturers of high-quality steel and copper mills and related equipment, and the only American company of its type still in operation.

Morgan, which is ISO 9001-certified, has designed

and installed more than 450 continuous rolling mills in more than 30 countries throughout the world. Its determination to innovate and its commitment to research and development are evident in the fact that Morgan currently has more than 1,500 patents in effect throughout the world.

In addition to its bar and rod mill business, the company, through its MORGOIL® Bearing Division, has become the world's dominant supplier of a patented line of load-carrying bearings, equipment that is used in the production of flat-rolled steel and aluminum products.

Morgan family members have always played leading roles in the success of the company. Currently, President Philip R. "Flip" Morgan is the fifth generation of his family to serve in that capacity. He succeeded his father, Paul S. Morgan, who retired as president in 1986 but continues to maintain an active role as chairman.

In Worcester, where the majority of its 650 employees are located, Morgan operates a headquarters building at Lincoln Square and a five-acre facility at Crescent Street that is one of the largest "machine shops" in the area.

Its Central Massachusetts presence was increased earlier this year when Morgan opened a new facility in Auburn, which houses the company's Spares and Guides Division. Formed in 1993, this division provides products and field service to customers who need replacement parts and service for their mills.

To support and provide better service to its domestic and international customers, the company has 11 subsidiaries in eight countries. In the United States, three offices operate in Pittsburgh and one in Chicago; throughout the world, Morgan maintains subsidiary and sales offices in Brazil, China, England, France, India, Japan and Taiwan.

As it looks toward the beginning of a new millennium, Morgan Construction Company has committed itself to continuing as the world's preeminent designer and manufacturer of products for the different markets it serves.

THE HISTORY OF FITCHBURG STATE COLLEGE BEGINS IN 1894, WHEN THE FITCHBURG NORMAL SCHOOL WAS ESTABLISHED BY THE MASSACHUSETTS LEGISLATURE TO EDUCATE AND TRAIN TEACHERS FOR THE REGION'S SCHOOLS. THE CAMPUS CONSISTED OF A SINGLE BUILDING, THOMPSON HALL, IN DOWNTOWN FITCHBURG.

By the time of its centennial in 1994, Fitchburg State had become a sprawling 30-building operation with more than 3,000 students, 500 employees and total revenues of $30 million. A liberal arts institution, Fitchburg State College offers 32 undergraduate degree programs in 20 academic fields and extensive graduate and continuing education programs. The college serves 3,000 students in its day division and another 4,000 students in its evening and graduate programs. The average class size is 25, and the overall student-teacher ratio remains low at 15:1.

Under the leadership of President Michael Riccards, who joined Fitchburg State in 1995, the college has earned acclaim for a series of innovative new initiatives, including a three-year baccalaureate program, internship opportunities, an extensive merit scholarship program, and a guarantee to employers that its graduates will possess the skills they need to succeed in their chosen fields.

Fitchburg State recently instituted the most rigorous admissions standards among the Massachusetts state colleges. With higher academic standards, Fitchburg State offers an affordable alternative to the selective but expensive private colleges in the state. "Our intent is to solidify the college's reputation for providing a low-cost, high-quality education," says President Riccards.

The college has been designated "The Leadership College," and is engaged in a series of efforts aimed at preparing leaders for the 21st century. A new Leadership Academy will offer a special curriculum for honors students.

The college has long been a leader in the education of future teachers, and operates a laboratory school where undergraduates earn teacher certification. Its education program is one of just 10 programs (out of 60) in the state accredited by the NCATE.

In recent decades, Fitchburg State has earned a reputation for excellence in other fields. Its nursing and industrial technology programs are often cited by practitioners as being among the best in the state.

Fitchburg State has also been expanding its graduate degree programs, adding a master of business administration and masters of science in criminal justice and nursing.

Fitchburg State was among the first to have a fiber-optic network and now operates 14 computer laboratories, some general, some focused specifically on such fields as graphics, business, nursing, technical writing and geography.

Students, faculty and staff are now totally "wired," thanks to the completion of an extensive $2.75 million technological overhaul. Every classroom, residence hall and office is linked to an electronic communications network that delivers Internet access, electronic mail, voice mail and other services.

In addition, a new $12 million recreation center is now in the design stage. That project is the capstone of a successful town-gown effort to renovate the college neighborhood and link the college with Fitchburg's downtown area.

Following its recognition of "a century of achievement," Fitchburg State College now looks with eagerness toward its second hundred years. Despite its accomplishments, there remains a strong sense that what has gone before represents just a beginning.

BAY STATE SAVINGS BANK IS A FINANCIALLY SOUND MUTUAL SAVINGS BANK FIRMLY COMMITTED TO MEETING THE CHANGING NEEDS OF ITS CUSTOMERS AND REMAINING SENSITIVE TO ITS DIVERSE COMMUNITIES.

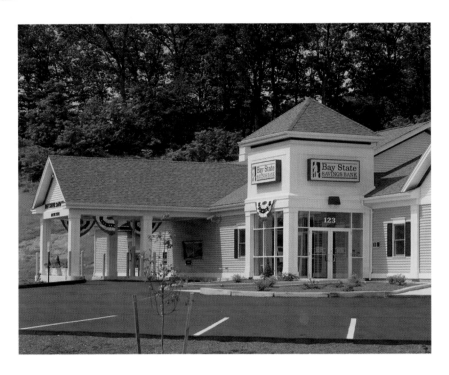

The Auburn office (above) –
Bay State Savings Bank's newest
branch – opened in June 1998,
at Minuteman Plaza in Auburn

The doors of Holden's permanent
office (below), opened September
1997, replacing a temporary
office that had operated on an
adjacent site since January 1997

Bay State has a Worcester banking history that dates back more than 100 years. Bay State Savings Bank opened for business on May 16, 1895, in Worcester under the leadership of a group of public-minded citizens who were committed to the availability of banking services for all members of the Worcester community.

Patricia A. Naumnik, the bank's president and CEO, says: "As a local community bank, Bay State Savings Bank is unique to the Worcester market. Our independence and our mutual charter mean that all decisions, whether related to day-to-day operations or strategic issues governing the bank's future, are made in Worcester by local management and a local Board of Trustees. The U.S. Supreme Court has defined a mutual savings bank as 'an institution in the hands of disinterested persons, the profits of which, after deducting the necessary expenses of conducting the business, inure wholly to the benefit of the depositors, in dividends or in a reserved surplus for their greater security.' (96 U.S. 338) We are the sole embodiment in Worcester of that definition."

Bay State has assets in excess of $140 million, with a proportionate capital strength that is unmatched by any other financial institution in the community. As the world approaches the millennium, Bay State looks forward to continuing a tradition of superior personal service as Worcester's only mutual savings institution and the community's only true local provider of financial services.

The bank provides a broad services package, both on the commercial and retail side, with emphasis on mortgage and home equity lending, as well as a full array of commercial services including business, real estate and SBA lending, and commercial checking accounts. Bay State Savings Bank ranks ninth among all Massachusetts banks in overall SBA lending and third in SBA lending to minorities, activities which have earned it SBA Certified Lender designation. The bank tangibly practices its belief that small businesses make the difference in the economic viability of their communities and is firmly committed to lending in this market segment.

"We acknowledge our heritage with great pride," Naumnik says, "but remain firmly committed to offering a full package of financial services that responds to the changing needs of our customers and is delivered, using superior technology, by a professional staff. Our people – customers and staff – are our future."

The bank's main office is located at 28 Franklin Street in downtown Worcester. Branch offices are located at 378 Burncoat Street and 247 Mill Street in Worcester, 628 Main Street in Holden, 123 Auburn Street in Auburn and a school banking facility is available at Auburn High School. An additional suburban office is planned for 1999.

ASSUMPTION COLLEGE IS A FOUR-YEAR, PRIVATE, COEDUCATIONAL, CATHOLIC LIBERAL ARTS AND SCIENCES COLLEGE, FOUNDED BY THE AUGUSTINIANS OF THE ASSUMPTION AND GUIDED BY RELIGIOUS VALUES AS WELL AS A STRONG SENSE OF ECUMENISM.

The college provides an educational atmosphere that allows its students to develop perspective – to hone lifelong reasoning, creativity, communication and problem-solving powers, and to find their niche. Assumption's General Education Curriculum includes both the great works of the past and current breakthroughs in philosophy, business and theology, the humanities and social sciences, mathematics and natural science, foreign languages and writing. These valuable core subjects are combined with innovative academic major and minor programs offering unique courses and projects.

A full range of undergraduate, graduate and continuing education programs are offered. The faculty's primary focus is teaching, and they make themselves available for extensive office hours. The ratio of students to faculty is 14:1. Students are provided with many opportunities to expand their educational experiences beyond the Assumption College campus: additional academic offerings through the Colleges of Worcester Consortium, internships in their majors, and study-abroad programs.

Assumption College is continually upgrading its programs and facilities to provide an excellent learning, self-discovery and physical environment for its students. The Living/Learning Center is a residence hall designed to be especially conducive to creative group learning. Recently added facilities include a comprehensive library, a state-of-the-art recreation center and a well-equipped multimedia center. The entire campus is wired for the Internet and cable television. This gives students additional academic advantages, connecting them with extensive resources, both on and off campus. A new science and technology center will expand the college's laboratory and classroom facilities, and provide additional space for use by the greater Worcester community.

Athletics at all levels – intercollegiate, intramural and recreational – are recognized as an important part of students' lives, and contribute significantly to building teamwork and

leadership skills that students carry on in their lives after college.

Community-oriented, Assumption, through its Reach Out Center, is known for the extensive contributions of time and service of more than 500 student volunteers to more than 50 Worcester-area schools and human service agencies. These experiences build leadership skills and broaden understanding. Many students also participate in service internationally and nationally, through the college's Mexico Mission, Hell's Kitchen and Philadelphia projects. Multiple partnership programs with the Worcester public schools provide mutual benefits.

Assumption hosts the French Institute, the Worcester Institute for Senior Education, the Worcester Municipal Research Bureau and the Interdisciplinary Environmental Association, among others.

The campus, with its picturesque duck pond and beautiful landscaping, is located on 150 rolling wooded acres in the Westwood Hills section of Worcester, an attractive suburban area. The college's neighbors are encouraged to use the campus as a park, and the college's HUMANARTS series is free to the public, as are many other excellent cultural, academic and athletic events throughout the year.

Learn. Achieve. Contribute. These simple words embody Assumption College's mission – to provide excellent academic opportunities, a feeling of accomplishment, and an understanding that it is important to give back to our society.

THE PRESSES HAVE BEEN ROLLING AT **LaVigne Inc.** FOR MORE THAN **100** YEARS, TURNING OUT EVERYTHING FROM EDUCATIONAL BROCHURES TO CORPORATE ANNUAL REPORTS. THROUGH THE DECADES, THE FAMILY-RUN COMPANY'S STATE-OF-THE-ART PRINTING WORK HAS LENT CLARITY AND COLOR TO THE HISTORY OF BUSINESSES AND ACADEMIC INSTITUTIONS THAT THRIVE IN **CENTRAL MASSACHUSETTS.**

The days of setting type by hand (above) are gone – today, LaVigne Press is at the forefront of industry excellence

LaVigne Inc. stands on its own as a classic example of entrepreneurship. Back in 1898, a determined 21-year-old from a large Worcester family began a career as a printer earning $2.50 per week. Narcisse J. LaVigne – whose family traces its lineage back to the Napoleonic Wars in France when they were banished to Canada – worked for a dozen years for other companies in Worcester's printing business. Then he bought out his original employer to establish LaVigne Press. Four generations later, Narcisse LaVigne's legacy continues to make its mark as one of the oldest and most successful printers in Central Massachusetts. It is at the heart of a business that is one of the region's key industries.

LaVigne's modern plant, located at Worcester Regional Airport, operates 24-hours-a-day, six days a week. The company's clients range from individuals seeking special-ty brochures to international advertising agencies and investment firms requiring runs of 50,000 to 60,000 pieces. LaVigne's 45,000-square-foot facility features a full electronic pre-press department with extensive comput-

er capabilities including scanning, image manipulation, digital proofing and direct digital plates. It has a wide array of offset and digital equipment for two to six-color and four to six-color processes. With a well-equipped bindery in-house and its own fleet of delivery vehicles, LaVigne can meet all of its clients' printing needs at one location, maintaining complete control over quality and turn-around time.

The company is now headed by Toby LaVigne, Narcisse LaVigne's great-grandson, who joined the family business in 1991 after attending Colby College. Toby LaVigne worked in sales at the company for several years, attained an MBA in 1995 and was appointed CEO in 1997, replacing his father, Thomas P. LaVigne in that capacity. Thomas LaVigne then became chairman and treasurer.

Like the printing industry itself, LaVigne Inc. has gone through many physical and technological changes in the past century. It began as a modest existing print shop on Federal Street in downtown Worcester. It moved to Foster Street in 1932, several years after Narcisse LaVigne's son, Robert G. LaVigne, took over the company following his father's death. A fire forced the company to relocate yet again in 1950 to Main Street, where it stayed half a dozen years before moving to Mechanic Street. In 1966, the Worcester Redevelopment Authority took that site by eminent domain, in order to build the Worcester Center Galleria, and LaVigne Press moved to Jackson Street.

As the company expanded and the printing industry evolved, the Jackson Street building proved inadequate to accommodate the large and heavy color printing presses brought into the operation. LaVigne purchased nine acres of land at the Airport Industrial Park and in 1983, moved into the modern 30,000-square-foot plant where it remains. LaVigne recently completed a 15,000-square-foot addition to the facility and has plans to eventually expand to 90,000 square feet.

In response to a changing technological environment, LaVigne became one of the first printers in the area to establish a digital printing division. Through this computerized process, materials are printed directly from a computer disk or screen. Gone are the old paste-up layouts once so central to the printing business. This high-tech printing advancement allows the company to cater to specialized printing needs, enhancing its

ability to print small quantity, custom orders economically. In the quickening pace of the printing industry, high-tech equipment also allows the company to turn out thousands of pieces of material in a few days' time.

LaVigne is committed to remaining on the cutting edge of its industry's advancements as well as maintaining the entrepreneurial values pioneered by Narcisse LaVigne a century ago.

The presses of the future are at LaVigne right now (above) – a far cry from how printing was done in the past (below)

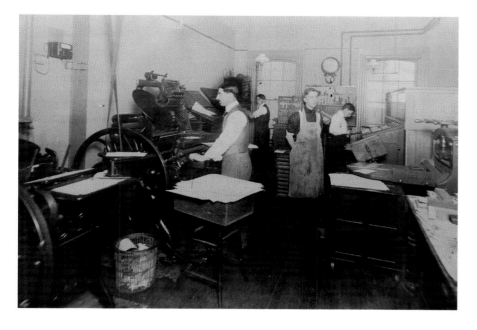

BOWDITCH & DEWEY, LLP IS A BUSINESS LAW FIRM WITH CENTRAL MASSACHUSETTS ROOTS, A NEW ENGLAND FOCUS AND A GLOBAL PERSPECTIVE. ITS ATTORNEYS HAVE HELPED GUIDE NEW ENGLANDERS AND THEIR BUSINESSES THROUGH PERIODS OF CONFLICT AND CHANGE SINCE 1914.

Bowditch & Dewey's Worcester Office (above)

The Bowditch & Dewey Management Committee, shown from left, Michael P. Angelini, Michael D. Brockelman, Joseph P.J. Vrabel, Jane V. Hawkes and George W. Tetler III

It has helped clients in virtually every industry throughout the region expand their opportunities, protect their investments and deal with changing circumstances. In the process, the firm and its clients have grown far beyond Central New England and far beyond the limitations of traditional law firm approaches. Today, with clients in 33 states and several countries, and with a practice well-versed in complex litigation and innovative transactions, Bowditch & Dewey has become a firm of broad perspective and uncommon versatility.

Every aspect of the firm's practice is designed to help clients effectively and efficiently achieve their objectives. Strong management, integrated technology and a professional staff with diverse experience and unusual open-mindedness allow the firm's practice groups and support personnel to develop innovative solutions to client needs.

Steering a successful, long-term course through constant change is a challenge for any organization. Bowditch & Dewey is comfortable helping clients meet these challenges because the firm itself has done this. While anchored by an uncommon stability, the firm has always kept pace with change. This ongoing evolution has helped it serve its clients with increasingly strong business and financial representation, and with extended capabilities in emerging practice areas. It is among the region's leaders in higher education, environmental, ERISA, health care, intellectual property and international law.

Whether representing clients in litigation, negotiation and other advocacy proceedings, serving the banking community or facilitating international initiatives and transactions, its services make a difference.

Bowditch & Dewey helps its business clients with their own growth and evolution by providing a wide range of business services. These include: advice on organizational issues, obtaining venture capital, licensing and protection of intellectual property, the structuring of benefit programs, public offerings, mergers, acquisitions, liquidations, bankruptcies and workouts, as well as support and representation in the full range of employment, environmental, real estate, securities and tax matters.

Along with its service to the business community, Bowditch & Dewey continues to operate one of New England's largest and most respected trust and estate practices. Its commitment to the needs of families, non-profit organizations and community groups has been unwavering throughout its long history. The firm is proud of its long-standing service to families and charitable causes and of the strong performance achieved by portfolios under its management.

As litigators, advocates and advisors, the attorneys of Bowditch & Dewey have always been, and will continue to be, client-driven, forward-looking, results-oriented professionals.

HEBERT CANDIES IS THE STUFF CHILDHOOD MEMORIES ARE MADE OF — A MANSION DEVOTED ENTIRELY TO CANDY! VISITORS MAY WATCH CANDY PRODUCTION, SAMPLE THE RESULTS, AND KIDS AND ADULTS CAN MAKE THEIR OWN ICE CREAM SUNDAES DRIZZLED WITH THEIR FAVORITE TOPPINGS. IT'S ALL PART OF AN 81-YEAR TRADITION THAT IS HEBERT CANDIES.

Hebert Candies is still a family-run business with seven unique retail locations throughout New England, including its landmark Candy Mansion and manufacturing facility in Shrewsbury and stores in Bolton, Natick, Sturbridge, Sterling, West Springfield, and Kittery, ME.

For four generations, the Hebert family has taken great pride in creating, manufacturing and selling quality candy under the family name. The tradition started in 1917, in Fitchburg, when Frederick E. "Pepere" Hebert purchased his first production equipment — a table, knife, thermometer, copper kettle, stove and a marble slab — for $11.

For many years, Mr. Hebert manufactured his candies and sold them in small neighborhood stores. In 1946, he purchased a Tudor stone mansion on Route 20 in Shrewsbury. The building became the home of Hebert Candies and the landmark known as the Candy Mansion. Hebert's Candy Mansion was the first roadside candy operation in the country and marked a new direction in candy marketing. Over the years, Hebert Candies has achieved many other confectionery milestones, including the introduction of white chocolate in the United States.

"Pepere" passed on a special tradition of candymaking to his sons, and each generation has learned the art of retail manufacturing the Hebert way. Every piece of candy leaves the building with the Hebert stamp of approval. Many of the same proven candy recipes are still used. Only the finest ingredients go into making Hebert candies.

Family-oriented special events make coming to Hebert Candies more than just a shopping trip — it's an adventure! The Haunted Candy Mansion, where children are invited to trick-or-treat, has become a family Halloween tradition. Visits with the Easter Bunny and Santa Claus provide great holiday fun.

Today, Hebert Candies proudly makes community service a key focus of its special events and activities. In 1997, the company celebrated 80 years of candymaking with a weeklong schedule of festivities. In the spirit of giving back to the community, Hebert Candies donates throughout the year to the Performing Arts School of Worcester, the American Red Cross, the MSPCA, and for 25 year has sponsored fundraisers for MDA.

Today, the third and fourth generations of the Hebert family continue the overall experience of fun events and quality products that have defined Hebert Candies for more than 80 years.

THE LAW FIRM OF MIRICK O'CONNELL WAS FOUNDED IN 1916, ALTHOUGH MUCH OF THE FIRM'S GROWTH HAS TAKEN PLACE RELATIVELY RECENTLY. IN THE LAST 20 YEARS, THE FIRM HAS MORE THAN QUADRUPLED IN SIZE, AND TODAY ONE OF NEW ENGLAND'S OLDEST IS ALSO ONE OF CENTRAL MASSACHUSETTS' LARGEST LAW FIRMS.

Mirick O'Connell was founded by Worcester native George Hammond Mirick. Mirick attended Harvard Law School, began practicing law in 1909, and started his own firm in 1916. His practice included real estate, corporate law and estate law – practice areas that are still important to the firm today. The firm's second namesake, Paul Revere O'Connell, joined the firm after graduating from Harvard in 1930. Gardener G. DeMallie joined the firm in 1936 after graduating from Harvard and Lawrence H. Lougee, a 1935 Harvard graduate, joined the firm in 1955 as a partner. The firm was known as Mirick, O'Connell, DeMallie & Lougee until 1997, when the name was shortened to Mirick O'Connell.

Over the years, Mirick O'Connell's clients have included many major companies with a national or international presence, yet Mirick O'Connell has always made its home in Worcester. In 1970, when the Mechanics National Bank Tower was completed, Mirick O'Connell became its first tenant. Today the firm occupies three floors of what is now called the BankBoston Tower.

Mirick O'Connell earned its strong reputation as a comprehensive business law firm and has continued to expand its leadership in this arena. During the 1970s, Mirick O'Connell was involved in some of the largest corporate divestitures as well as in one of the country's first leveraged buyouts.

Today, Mirick O'Connell combines leadership, depth of experience and enterprising young attorneys in a firm that is unsurpassed in Central Massachusetts. With offices in Worcester and Boston, Mirick O'Connell serves clients throughout New England and across the country, and meets the diverse needs of large corporate clients, entrepreneurs, research pioneers, public and private school systems and individuals.

In addition to practice groups in corporate and business law, tax and estate planning, labor and employment law, land use, litigation

and municipal law, the firm offers cross-departmental and intradepartmental practice groups in areas such as creditors' rights and bankruptcy, high technology, health law, banking and environmental law. The firm also aggressively recruits and trains the best attorneys and continually adds to its expertise by expanding its practice areas.

The firm believes it is crucial to keep abreast of changes, not only in the legal community but in other areas that affect the well-being of its diverse clients. To that end, the firm participates in local and regional bar associations, and is committed to ongoing training, communication and continuing legal education. The firm regularly conducts a series of free topical seminars and its attorneys are published in a wide variety of media. THE MIRICK O'CONNELL REPORT, a client newsletter, recounts recent cases and topics of interest.

While Mirick O'Connell is large enough to provide the depth of legal services needed in today's complex legal environment, the firm continues to recognize the importance of close, personal service. The firm's client focus is central to its philosophy.

Reflecting this philosophy, Mirick O'Connell attorneys believe that the one-on-one attorney-client relationship is the foundation of strong and effective legal representation. To maintain open lines of communication between lawyers and clients, each client works with an attorney who serves in the role of client manager. Attorneys take the time to learn about their clients, developing a base of knowledge that ranges from clients' immediate plans to their long-term goals. This unique continuity of representation has proven to be the most efficient and effective way to provide quality legal representation.

Administrative responsibilities are handled by an executive director who oversees a sophisticated support staff using state-of-the-art technology. This approach frees attorneys to concentrate on their clients, and gives Mirick O'Connell the ability to build highly focused legal teams on a moment's notice.

Mirick O'Connell is focused not only on its clients but also on its community. Among the firm's attorneys are officers, trustees and directors of civic and charitable organizations, coaches, scoutmasters and members of many educational and cultural groups. The firm co-sponsors annual environmental awards and has donated legal services to many nonprofit organizations and, in particular, contributed significant time to the planning and

creation of the Massachusetts Biotechnology Research Park.

The firm's attorneys have also taken leadership positions in the many revitalization and redevelopment efforts ongoing throughout Worcester County. Active in the legal community as well, Mirick O'Connell lawyers have served as presidents, vice presidents and treasurers of the Worcester Bar Association and as appointees to the Secretary of State's Task Force on Massachusetts Securities Regulation.

Today, Mirick O'Connell is a growing full-service law firm dedicated to uncompromising client service. Building on its traditional strengths, Mirick O'Connell has embraced the emerging health care, biotechnology and environmental fields. Mirick O'Connell's unique commitment to its clients and to the community has been consistent throughout the firm's history and will remain consistent as the firm continues to grow into the next century.

GREENBERG, **R**OSENBLATT, **K**ULL & **B**ITSOLI, PC, PROVIDES A FULL RANGE OF AUDITING, TAX, ESTATE AND FINANCIAL PLANNING, MANAGEMENT ADVISORY AND INFORMATION SYSTEMS CONSULTING SERVICES TO BUSINESSES AND INDIVIDUALS.

The firm has roots in Worcester dating back to 1921, when Hyman Brodsky opened an office of public accounting at 390 Main Street. In 1956, Nathan Greenberg cofounded the partnership now known as Greenberg, Rosenblatt, Kull & Bitsoli, PC. Today, the firm has offices in Worcester and Springfield.

From its beginning as a small local practice, the business has expanded to become one of the region's largest firms. It is large enough and has the capability to offer the services required for virtually any business — but is small enough to offer clients the personal attention needed to enhance their success. The key to GRK&B's client relationships is devotion to quality service. It is the intensity, continuity, diversity and flexibility of that service which is the hallmark of GRK&B.

The firm's diversified client list ranges from individual proprietors to corporations representing a broad spectrum of activities: health care, manufacturing, leasing, retailing, distribution, education, construction, printing and publishing, professional services and not-for-profits. For many clients, the performance of

an audit is one of the principal services provided by GRK&B. Audits are performed in conformity with professional standards adopted by the American Institute of Certified Public Accountants (AICPA). As the concluding factor in the audit, the firm makes recommendations for improving operating procedures. For other clients, the firm also prepares the appropriate reports in the form of a compilation or review.

In 1997, the firm received an unqualified report — the highest possible ranking — in an independent peer review of its accounting and auditing practices. GRK&B's participation in voluntary triannual reviews demonstrates its commitment to maintaining and improving the quality of its practice. In addition, the firm is actively involved in the AICPA and the Massachusetts Society of CPAs, and members of the firm have consistently held major positions of responsibility in these organizations.

A multitude of tax services are performed for clients by GRK&B, including tax planning and forecasting; effective year-end financial planning; analysis of potential investments, mergers and acquisitions; estate planning; corporate reorganization approaches and preparation of appropriate tax returns. In addition to these basic services, the firm provides many others depending on the particular needs and circumstances of its clients.

Those doing business with GRK&B benefit greatly from the firm's experience and expertise in the complicated but extremely important area of estate planning and administration. The firm assists the client in developing a long-term financial plan. After preparing a formal estate analysis, GRK&B proposes recommendations for proper planning and possible gifting programs. Estate administration extends to include carrying out all necessary accounting functions in accordance with the terms of the will and provisions of any trust agreements.

Augmenting the auditing, accounting and tax services offered by GRK&B are its management advisory and financial consulting

services. As the firm discovers problem areas for the client, it proposes solutions or alternatives, and assists in the application of various remedies. By identifying management problems, the firm helps its clients develop more effective management and increased profits.

Greenberg, Rosenblatt, Kull & Bitsoli, PC, is the New England representative of Jeffreys Henry International, a worldwide association of independent accounting firms founded in 1975. Member firms provide a major service to clients by offering the combined members' expertise in a wide range of business practices and professional assistance throughout the world.

At Greenberg, Rosenblatt, Kull and Bitsoli, PC, concerned citizenship is more than just a high ideal — it is a working principle. Within the firm are many energetic and dedicated individuals who volunteer a significant portion of their time to community projects. Their talents have enabled them to make meaningful contributions to civic, economic and charitable activities. Some of the programs which employees are involved in include: civic and social agencies, charitable organizations, philanthropic fundraising, educational and research institutions, religious organizations, children's athletic activities and recreation programs. The firm soundly supports and encourages participation in such activities to maintain and increase its employees' commitments and responsibilities to society.

Melvin M. Rosenblatt, CPA, chairman (top)

Leatrice D. Kimener, CPA, manager (center)

Nathan Greenberg, CPA, founder (left)

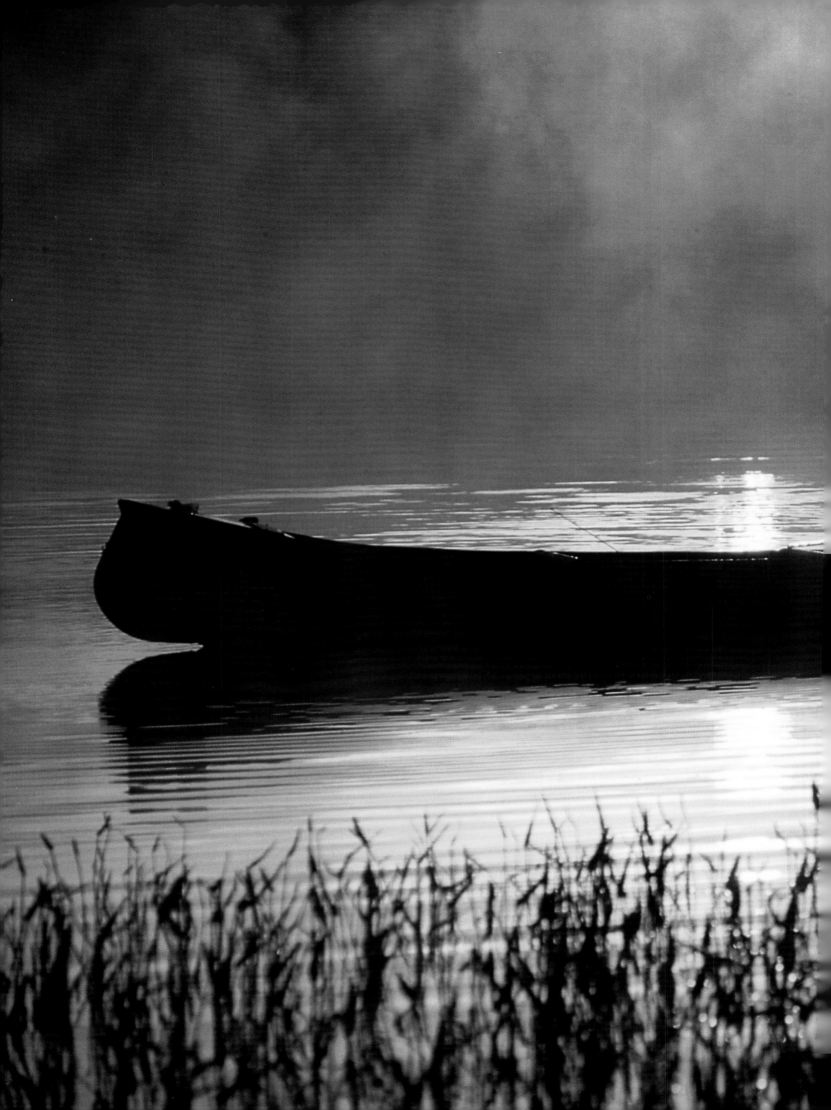

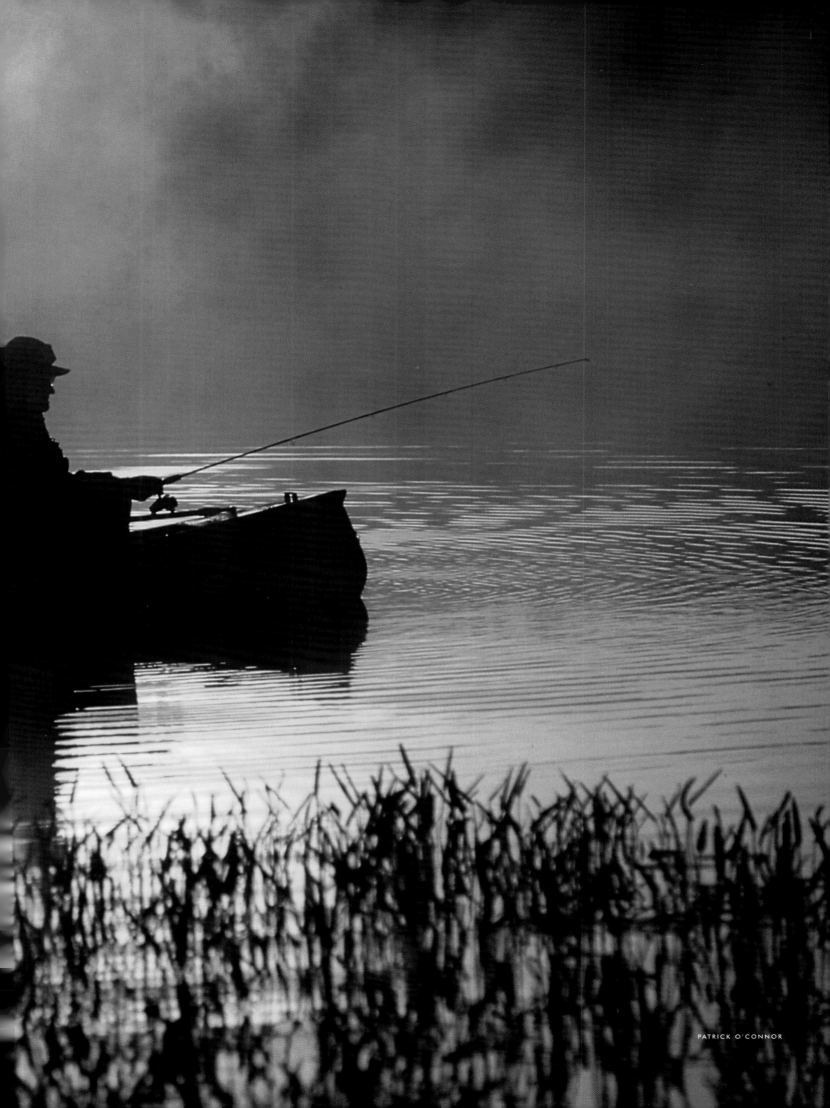

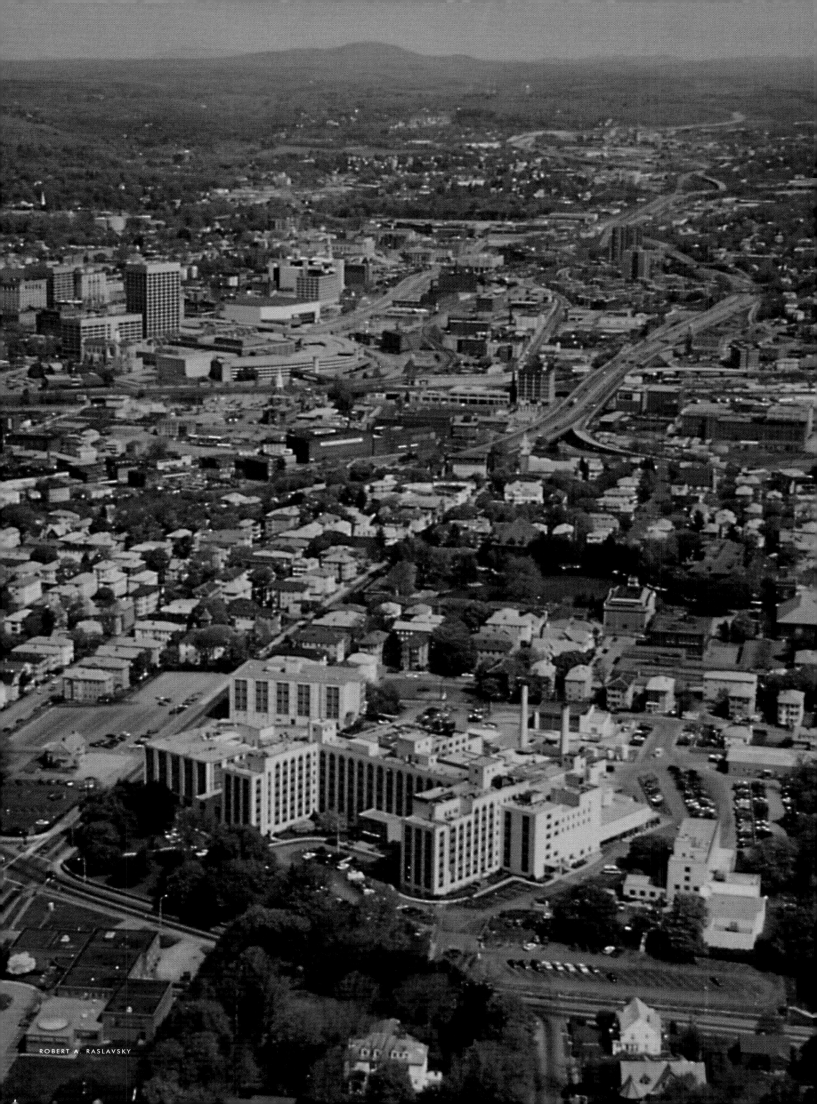

ONE AGENT. ONE OFFICE. ONE INSURANCE COMPANY. A LOT HAS CHANGED SINCE THE FIRST DAYS WHEN JIM HERLIHY STEPPED OUT ON HIS OWN IN 1927 AND BEGAN A COMPANY KNOWN TODAY AS THE HERLIHY INSURANCE GROUP.

The growing company's headquarters were on the ninth floor of the then-modern Slater Building, located at 390 Main Street in Worcerster. In its early days, Herlihy represented a single insurance carrier, Aetna Property & Casualty Co., and primarily provided property and casualty coverage.

Today, The Herlihy Insurance Group is an independent brokerage insurance agency that provides comprehensive insurance solutions for commercial clients and businesses. Its goal is to implement and manage its clients' overall insurance needs, including property coverages, workers compensation, professional liability, employment practices, commercial automobiles and employee benefit programs.

With a staff of more than 20 insurance professionals, The Herlihy Insurance Group is structured into specific units that serve particular industries. Through this approach, it is able to provide a specialist who works with a company and provides meaningful recommendations and viable solutions.

Specialization has been a key ingredient to the agency's success over the past 70 years. In particular, The Herlihy Insurance Group has built a strong reputation for serving medical professionals, the construction industry and manufacturers. Specialists who offer services for these niche markets are involved in their industries' association groups and are aware of the developing trends and needs specific to each of these groups.

The Herlihy Insurance Group has a unique approach to working with clients because it does not offer quotes. From the outset, the company establishes a working relationship contract that outlines the responsibilities of the firm and establishes the client's expectations. Because Herlihy represents more than 20 insurance companies, it always offers competitive rates. It concentrates on the needs of the client and focuses on developing its role as an insurance advisor. This untraditional approach has served clients well, and The Herlihy Insurance Group looks forward to continuing this success.

Today, the company is headquartered at 65 Elm Street in Worcester, three blocks from its original location, in a neighborhood that reflects the city's prominent history and business tradition. From a one-person business, the company has grown into a multimillion dollar organization with three office locations and more than 6,000 clients in Massachusetts.

O N JANUARY 20, 1928, THE WEBSTER CREDIT UNION BECAME A REALITY, FORMED BY A SMALL GROUP OF THRIFT-CONSCIOUS MEN OF POLISH ANCESTRY WHO WERE DEDICATED TO ESTABLISHING A THRIFT INSTITUTION THAT WOULD ACCUMULATE AND INVEST THE SAVINGS OF ITS MEMBERS AND PROVIDE LOANS TO THEM FOR PROVIDENT PURPOSES.

When the first office opened at 207 Main Street in Webster, the bank had 20 depositors and a capital outlay of $350. Over the decades, Webster Credit Union steadily grew and prospered. On November 10, 1995, Webster Credit Union changed its charter and became Webster First Federal Credit Union. By changing its charter, the credit union was allowed to offer more products and services. In 1967 the credit union moved to its present location at 1 North Main Street in Webster. The bank now has eight branch locations in Webster, Dudley, Douglas, Worcester, Whitinsville, Charlton and Spencer. Plans are underway for drive-up windows in both the Worcester and Whitinsville locations, as well as for construction of a 16,000-square-foot building to house the new Spencer branch.

Today, the bank has more than 57,000 members and more than $243 million in assets. The credit union is committed to meeting the financial needs of its members by offering exceptional personalized member service and a wide range of consumer and business products. The credit union offers savings and NOW accounts, business checking, personal loans, auto loans for new and used cars, MasterCard and VISA credit cards, mortgages, home equity lines of credit, second mortgages, IRA accounts, direct deposit, ATM access and commercial business services including small-business loans. Most recently, the credit union has added overdraft protection and audio response account access, allowing its members access to their accounts 24 hours a day, seven days a week.

As a business and community leader, Webster First Federal Credit Union knows the importance of building strong communities and assisting in the education of future leaders. "Community involvement at the credit union means working to enhance the quality of life with our neighbors by giving back to the community in which we work and live," says

Michael N. Lussier, president of Webster First Federal Credit Union. Each year, the credit union awards scholarships to local graduating students, makes donations to non-profit organizations and programs for the elderly, and sponsors various Little League teams. Other efforts have included packaging donated food items for the homeless, an "angel" Christmas tree and team participation in its program for the American Cancer Society.

The history of Webster First Federal Credit Union has been marked by steady growth. The credit union's strong heritage and commitment to members is the foundation on which Webster First will continue to grow, prosper and build a promising future marked by strength, stability and wisdom.

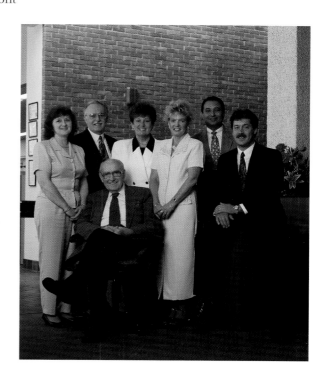

FALLON CLINIC

FALLON CLINIC, A GROUP PRACTICE WITH MORE THAN **250** DOCTORS LOCATED THROUGHOUT CENTRAL MASSACHUSETTS, HAS GROWN INTO ONE OF THE MOST DYNAMIC AND PROGRESSIVE HEALTH-CARE ORGANIZATIONS IN THE COUNTRY.

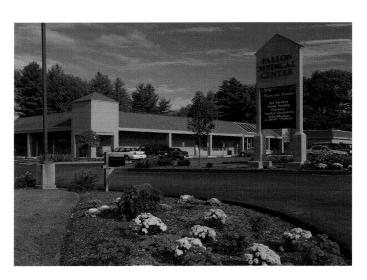

Fallon Medical Center, Charlton (above)

Thirty-eight Fallon Medical Centers are conveniently located throughout Central Massachusetts (below)

Practicing at 38 medical centers in the region, Fallon Clinic primary-care physicians and specialists serve nearly 1 million patients every year.

Its medical staff includes some of the most talented and dedicated physicians in medicine. Fallon doctors are graduates of some of the best medical schools in the United States and have served their residencies at top-rated hospitals. They keep abreast of the latest advances in medicine, are active in education and medical research, and offer the most advanced medical treatments available anywhere in the country.

People today demand quality, compassion and affordability from their health care. With nearly 70 years of experience, Fallon Clinic knows how to successfully deliver on those demands. In fact, Fallon Clinic has raised the stakes of what health care is expected to do—to not only provide affordable quality health care to people when they are sick, but to give them the programs and services that keep them healthy.

Fallon's patients can take advantage of a wide range of support services at its many convenient locations. Fallon Clinic's continuously growing selection of educational programs, support groups and community services further illustrates its commitment to the overall health of Central Massachusetts residents. Fallon believes it has a responsibility to offer creative solutions to health-care problems.

As a group practice, Fallon can direct more resources to patient care. Its concern for affordable care is reflected in low administrative costs and true value for every health-care dollar. With its focus on excellence, Fallon has earned a national reputation for quality that is supported by extensive research and scientific data.

What enables Fallon Clinic to deliver such high-quality care? Fallon is based on the philosophy that a group of doctors working together can be more effective and more efficient because of their team approach. A group practice allows for freer exchange of ideas and information. Specialists and primary-care physicians work closely together, readily sharing their knowledge and helping one another treat a wide variety of conditions and illnesses. The caring attention of a single doctor is great — but multiply that by the number of doctors in Fallon's group practice and the product is a vast resource of compassion and experience, ready to serve each patient. As a result, Fallon's patients benefit from better quality and more comprehensive health-care services.

As Fallon moves forward into the new millennium, it promises to remain an organization that is physician-directed and focused on the highest-quality care and service to its patients.

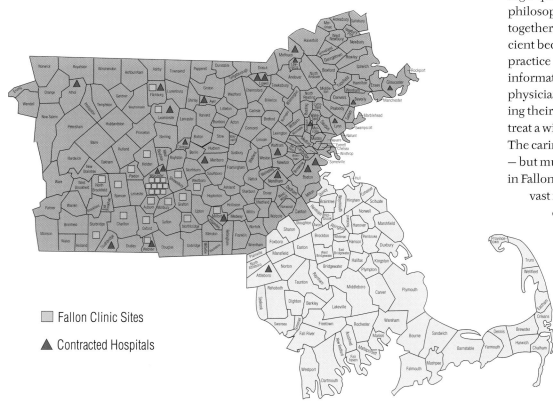

☐ Fallon Clinic Sites

▲ Contracted Hospitals

SPAG'S IS COMMITTED TO OFFERING ITS CUSTOMERS THE BEST VALUES AND
SERVICE POSSIBLE AND TO BEING A GOOD CORPORATE CITIZEN, SUPPORTING
LOCAL INSTITUTIONS AND CORE CUSTOMERS TO MAKE LIFE BETTER FOR
EVERYONE IN THE COMMUNITY.

Spag's is that old general store of times past but just a little bit bigger! A family owned and operated business, Spag's was established in 1934 by Anthony Borgatti, the son of Italian immigrants. After graduating from Shrewsbury High School, Borgatti, nicknamed "Spag" (short for spaghetti) by his classmates, opened his store in the corner of a family property located on Route 9 in Shrewsbury. He stocked his store with products that reflected the wants and needs of his customers. The store kept growing, its contours reflecting the adjacent pieces of property that became available. Throughout the 1970s and '80s, Spag's continued to expand, acquiring and renovating adjacent buildings.

In 1940, Spag married Olive Lutz. When the store was incorporated in 1966, Olive Borgatti was named president and Spag remained treasurer.

For decades, Spag's has supported the community through numerous contributions to projects ranging in scope from church bazaars and high school fundraisers to the research efforts of the former Worcester Foundation for Experimental Biology in Shrewsbury, now part of UMass Memorial Health Care. Spag and Olive donated the first bookmobile to the Town of Shrewsbury, and offered after-funeral receptions for their employees and all Shrewsbury residents, a program that continues today. They also established three funds, which serve the community in perpetuity, at the Shrewsbury Public Library, the Greater Worcester Community Foundation and Worcester State College, Olive's alma mater. Most recently, Spag made available $750,000 to the Town of Shrewsbury for the purchase of a large tract of land in the center of town to maintain that land as recreational space for the community.

Spag's discounted before discounting became a way of life, leading to something called "the Spag's mentality" in Central Massachusetts — an approach to shopping that insists on maximum value for money

spent. SPAG-TACULAR is the term the store coined for its prices, variety, quality and shopping experience.

In today's marketplace, where people can buy the same products in the same way in the same stores in every city and town, Spag's remains ruggedly individualistic, selling everything from Indian River oranges (in season only) to Oriental rugs. Hundreds of people shop daily at Spag's for hardware (customers can still buy nails by the pound) and associated plumbing and electrical products, groceries, lawn and garden supplies, plants, paint, sporting goods, clothing, toys, office supplies, automotive products and many other goods. As its customers say, "If Spag's doesn't have it, you don't need it!"

Carrying more than 200,000 different items in 80,000 square feet, Spag's is still family owned and operated by Carol Borgatti Cullen, president; Jean Borgatti, executive vice president; and Sandy Borgatti Travinski, treasurer.

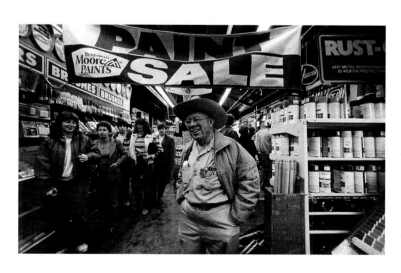

SHARFMANS INC.

PHOTO/PATRICK O'CONNOR

For generations, families have come to rely on Sharfmans for their fine jewelry and gift needs. Whether helping a young man choose a sterling silver bracelet for his girlfriend or assisting with the selection of that all-important diamond engagement ring, Sharfmans is committed to long-term customer service. Customers know they can count on Sharfmans to reset or repair family heirlooms and to help them purchase jewelry and gifts that will be treasured for future generations. Fathers who purchased a diamond from Sharfmans thirty years ago often send their sons here when they are shopping for a diamond for their brides.

Founded in 1937 by Nathan Sharfman and his son Norman, Sharfmans is one of the few remaining independent jewelry stores in the region. It is located in the Worcester Common Outlets where it moved in 1971 from its original Main Street location.

In 1986, a group of five long-time employees of Sharfmans bought the family business, retaining its name and its philosophy of service, quality and value. Today, three members of that group — Richard Johnson, James Joslyn and Francis Paquette, all Worcester natives — remain at the helm of Sharfmans. Their commitment to forging lasting relationships with their customers isn't just a slogan. It is evident in their own long associations with the business. Richard Johnson has worked at Sharfmans for more than 31 years, since he was 16. James Joslyn, now company president, has 36 years tenure with the company. And Francis Paquette served as controller at Sharfmans for 18 years.

Like the family they learned the business from, the three partners personally select their hand-crafted jewelry from manufacturers around the world. Sharfmans strives to offer a unique selection of jewelry with traditional styling. It also strives to offer something in every price range, from a $15 pair of sterling silver earrings to a $30,000 diamond bracelet.

Customers will find cultured pearls, Italian gold, fine watches and every conceivable gem stone. Sharfmans extraordinary settings include 18-karat gold and platinum as well as 14-karat gold and sterling silver. Its staff will work with customers to create custom jewelry. When it comes to diamonds, Sharfmans' seasoned sales people, many with 10 to 25 years experience, are committed to helping customers gain the knowledge needed to feel secure in their selection.

Beyond their jewelry, Sharfmans has an outstanding collection of fine gifts from around the world, and a convenient bridal registry. It is the place to go in the Worcester area for fine crystal, including such makers as Baccarat of France, Waterford of Ireland and Orrefors of Sweden. It features Lladro porcelain figurines from Spain, Lenox china and Reed & Barton sterling flatware and hollowware.

Underlying each sale at Sharfmans is the philosophy that if they do it right the first time, customers will be back for years to come. Or, as the partners put it, Sharfmans is in it for the long run.

PHOTO/PATRICK O'CONNOR

Sharfmans 1998 Worcester Ornament

Worcester Regional Airport

A

NNA MARIA COLLEGE IS A PRIVATE, CATHOLIC COEDUCATIONAL COLLEGE LOCATED JUST EIGHT MILES FROM DOWNTOWN WORCESTER. FOUNDED IN 1946 BY THE SISTERS OF SAINT ANNE, THE COLLEGE IS DEDICATED TO HOLISTIC EDUCATION IN THE JUDEO-CHRISTIAN TRADITION.

As a Catholic institution of higher education, the college recognizes its obligation to serve its immediate community, the Commonwealth of Massachusetts, the nation and the world through the provision of education, the preservation of learning and the sponsorship of research. The mission of the college is to foster in its students intellectual involvement, career preparation, social awareness, dedication to justice and peace, religious and moral sensitivity, and a lifestyle capable of balancing and sustaining these values.

Today, Anna Maria College offers a combination of liberal arts, career preparation and the values orientation of a Catholic college to a population of more than 1,700 undergraduate and graduate students, and boasts an alumni population of more than 11,000. The college offers undergraduate degree programs in art, art therapy, criminal justice, music therapy, psychology, paralegal studies, social work and nursing, as well as graduate degree programs in biology, business administration, criminal justice, counseling psychology, education, and occupational and environmental health and safety. In addition, Anna Maria College is the first in the nation to offer a Master of Science in Emergency Planning and Response.

Initially located on a temporary campus at Saint Anne's Academy in Marlborough, Massachusetts, the college relocated in 1952 to its present campus — a fine colonial estate surrounded by 180 scenic acres in Paxton, Massachusetts. The beautiful campus has 13 buildings including Socquet House, an 18th-century Federalist-style farmhouse that is now the residence for the Sisters of Saint Anne, and the Fuller Activities Center, which houses a gymnasium, basketball courts, a volleyball court, and an aerobic fitness and weight training center. Over the years, athletic teams at Anna Maria College have compiled an excellent record at the NCAA Division III level. The college hosts events in the St. Luke's Gallery of the Moll Art Center, the Zecco

Performing Arts Center, which is home to the New England Theatre Company, and the Payer Concert Room, as well as offering conferences through the Mortell Institute for Public Safety.

On the cutting edge of technology, the college is fully wired with 500 computer hookups which link classrooms, offices, residence halls, the academic computer center, computer mini-labs and the library. Its students, faculty and staff enjoy access to vast resources, from CD-ROM databases to worldwide networks via the Internet.

Anna Maria College looks forward to continued innovation and prosperity. In 1996, the year Anna Maria celebrated its 50th anniversary, the college appointed Bernard S. Parker, Ph.D., as its seventh president. He is the first lay person to hold this position, ending a long tradition of appointing a member of the Sisters of Saint Anne. Parker has proposed a strategic plan to move the college through the next century. His goals are to increase the college's full-time undergraduate body, improve the quality of the college's academic programs and implement a 20-year campus master plan to rejuvenate the physical plant and strengthen the endowment.

A S EARLY AS 1948, THE PHILOSOPHY AND IMPLEMENTATION OF EQUAL OPPORTUNITY EMPLOYMENT HAD ESTABLISHED ITS ROOTS HERE IN CENTRAL MASSACHUSETTS. WITH THE END OF WORLD WAR II AND THE RETURN OF VETERANS FROM FOREIGN SOIL, THERE WAS AN UNANTICIPATED GAP IN JOBS AND CAREER OPPORTUNITIES FOR THOSE AFFECTED AND AFFLICTED WITH NON-RECOVERABLE INJURIES.

Worcester born Robert Freelander, as a result of injuries he sustained on the shores of Okinawa, recognized these potential issues related to returning veterans. Upon his return to the States and throughout his continued education, Freelander spent most of his time exploring alternative venues that had successfully addressed job opportunities for those who had been historically unemployable.

Using the structure established by the Industrial Home for the Blind in New York City, he developed a similar format here in Worcester. Come Play Products was started in 1948 and hired its first employees from the Worcester State Mental Hospital. That employee base consisted of a deaf mute alcoholic, and a blind deaf mute. Though these employees were not afflicted with handicaps directly related to war injuries, they still fell well within

the target category that Freelander had first envisioned. The company began producing brooms and mops for the U.S. Army and Navy, and soon expanded its production to generate the same products for children, which were sold to the F.W. Woolworth Co. Over the years, Come Play continued to expand its employee base by hiring from other local institutions such as the Massachusetts Employment Services and the Worcester Area Association for the Retarded.

An interesting story that defines the times and limited vision of the general public in the early 1950s occurred soon after Freelander hired several blind, deaf and wheelchair bound individuals. The Fire Department had concerns that this unique operation was a potential fire trap. Their worries were soon put to rest after fire officials had the opportunity to observe Come Play's established emergency procedures. The system consisted of lights and buzzers, as well as a coordinated "buddy program" whereby a deaf person would push a wheelchair and lead a blind person through the facility and out an exit door within a prescribed amount of time.

In order to utilize and train many individuals who fell into the category of being physically and mentally impaired, Freelander helped found the Worcester Occupational Training Center, which is still in existence here in Central Massachusetts.

Over the years, programs such as the Barrier Free Access Law have been established with the help of Freelander, who was chairperson of the President's Committee on Employment of the Handicapped that eventually set this law into place.

Freelander's involvement in the Worcester area has had a significant impact on many of its local agencies. His commitment to the betterment of society is most recognizable through his historical roles and responsibilities related to community service over the years. Robert Freelander has served on more than 35 boards of directors for such agencies as the Worcester Area Association for Retarded Children, the Youth Guidance Center, Anna Maria College, Worcester State College, the University of Massachusetts Memorial Foundation, the Genesis Club and the National Conference (of Christians and Jews), to name a few.

Over the past 50 years, as Come Play has matured and grown, a smaller percentage of its workforce is handicapped. This is mainly due to the many programs that have now been incorporated since the government has taken action to assist those in similar need.

Being a family run business, Freelander's son, Michael, assumed the responsibilities of president and owner of Come Play Products in 1991. The company continues to grow with the development of unique products within the toy trade. Recognized items include shopping carts, bowling and basketball sets, as well as many seasonal products such as Halloween pumpkins, sleds and Easter baskets filled with eggs.

With its home office situated in Worcester, Come Play employs more than 350 associates. The company now sells more than 200 different styles of merchandise throughout the United States to companies including Wal-Mart, KMart, Target Stores, Toys R Us and Kaybee Toys. It also distributes to 27 countries in the global market.

In 1993, Come Play expanded its operations to include a centralized manufacturing facility in the Midwest, and the company recently established a manufacturing base for proprietary merchandise produced in Asia. Come Play has also recently established several joint ventures in Europe with leading toy manufacturers and continues to focus on global trends.

Carrying on the philosophy of trying to improve society, Come Play Products has taken on a major challenge in recycling and the use of recyclable materials. Within the past several years, the company has been distinguished as Vendor of the Year by WalMart Stores for its environmental efforts, and has spearheaded a program utilizing post consumer scrap as a key element in the production of many items.

As a leading producer of plastic toys, Come Play has also received awards for Vendor of

the Year from Toys R Us for two consecutive years, an honor that has only been matched by companies including Hasbro, Mattel, Fisher Price and Little Tikes.

From its beginning in a 1,500 square foot area, Come Play has expanded to utilize nearly 900,000 square feet of industrial properties throughout Worcester. As a continuing supporter of the community and its citizens, Come Play seeks to maintain its role as a pioneer in social responsibility and commitment to those most in need.

JAMESBURY INC.

FROM ITS STATE-OF-THE-ART MANUFACTURING PLANT AT **640** L**INCOLN** S**TREET IN** W**ORCESTER,** J**AMESBURY DEVELOPS VALVE SOLUTIONS THAT ARE USED ALL OVER THE** WORLD. F**ROM THE DESERTS OF THE** N**EAR** E**AST TO THE SUBZERO TEMPERATURES OF** THE A**RCTIC** C**IRCLE, THESE HIGH-TECH, MANUAL AND AUTOMATED VALVES MANUFACTURED** IN W**ORCESTER,** M**ASSACHUSETTS (AND IN** J**AMESBURY'S** C**HIHUAHUA,** M**EXICO PLANT)** ARE RECOGNIZED AS THE BEST IN THE INDUSTRY IN TERMS OF QUALITY, DEPENDABILITY AND RELIABILITY.

Jamesbury serves a wide-range of process industries (above)

Jamesbury's reputation for product and service excellence began with Howard Freeman, a Worcester Polytechnic Institute graduate who founded the company in 1954. Freeman had worked as a valve engineer in an industry that had seen very little innovation for many years. He envisioned a valve that would seal repeatedly and reliably, and made this vision a reality by utilizing new polymer technology to invent the Double Seal® ball valve.

Working with basic, general purpose machines, Freeman manufactured those first valves and, along with his brother and several

Worcester business associates, introduced the product to the market. The Double Seal® was soon followed by a line of actuators, and then by Wafer Sphere®, a product which created and continues to define the category of high performance butterfly valves. Introduced in 1968, Wafer Sphere® offered an effective replacement for large gate valves and revolutionized the fluid flow industry, setting in place a major shift to quarter turn valves. These innovations were followed by Quadra Powr®, the first effective quarter turn diaphragm actuator, Clincher® and Eliminator™ ball valves, and most recently, Emission Pak® upgrade kits, which help meet evolving clean air requirements.

By 1962, Jamesbury's growth created the need for a larger facility, and the company moved to its present headquarters on Lincoln Street. That growth continued as Jamesbury expanded its product line to meet process industry needs in the United States and overseas. Today, both the Worcester plant and the company's manufacturing facility in Chihuahua, Mexico (established in 1993) boast state-of-the-art technology and quality manufacture.

Innovative engineering of valve products is only part of the Jamesbury story. The company's ISO certification, which it received in 1992, helps ensure that its products are always top quality. Every step of Jamesbury's manufacturing process is designed for product dependability, from the use of high quality materials to state-of-the-art manufacturing technologies to the company's skilled manufacturing professionals, who work together to assure that the product that goes out the door always meets or exceeds the customer's expectations.

Jamesbury remained an independent company through the mid 1980s. In 1988, it joined with Neles Oy of Helsinki, Finland. The form-

ing of a new corporation, Neles-Jamesbury, benefited both companies by enabling them to share technology and international sourcing, and further expand the international customer orientation so important in today's global marketplace. Neles-Jamesbury then became a division of the Rauma Corporation, a $2 billion corporation listed on the New York Stock Exchange and employing more than 10,000 people worldwide. In 1997, the company was reorganized for further growth, and Neles-Jamesbury became Neles Controls and Jamesbury. This switch allowed Jamesbury to focus on its polymer seating technology and product innovation, with Neles Controls specializing in metal seating and control valve technologies.

In addition to products that lead the industry in dependability, Jamesbury offers its customers an experienced, highly skilled support staff and a network of trained distributors throughout North America. Jamesbury has forged strong relationships with its customers in almost every industry, working closely to solve technical problems and meet special engineering and delivery requirements. Sales representatives and technical support personnel undergo extensive training at the Jamesbury factory in order to learn how to tailor Jamesbury products to specific application requirements.

Jamesbury's loyal distributors were selected for and exemplify service leadership and product knowledge. They have been the cornerstone of the company's success since its founding and Jamesbury has never wavered in its commitment to doing everything possible to help them succeed as well. The company and its employees and distributors are all part of a team that has worked tirelessly to make Jamesbury a name customers can rely on.

Today, Jamesbury is more committed than ever to the team concept. The company's vision statement , "If we can envision it, we can achieve it together," reflects its goal of achieving excellence through teamwork by continuously improving products and services through innovation and technology.

Jamesbury also takes seriously its responsibility to the Worcester community. According to President John Quinlivan, Jamesbury's commitment to local education is as strong today as it was at the company's founding. This commitment is based on Jamesbury's belief in both elementary and higher education's ability to create opportu-

nities for those who would otherwise not have had them. And the return on this investment in education and the community has been more than rewarding.

The families of Jamesbury are an integral part of the Worcester community and an important part of the city's rich history. Through their employees, Jamesbury has supported and continues to support many local charitable foundations.

Jamesbury's strength lies in the brand established by Howard Freeman and nurtured by a long line of Worcester engineers, loyal distributors, satisfied customers and several generations of dedicated employees. Jamesbury's future looks bright as it prepares to utilize the high-tech tools of the 21st century while maintaining a firm grip on the values and strengths that made it a success in the past.

Distributor sales and service people receive frequent training in Worcester (above)

The Jamesbury logo shows its global corporate identity (below)

HIGGINS ARMORY MUSEUM

THROUGH THE "CASTLE" DOORS OF THE HIGGINS ARMORY MUSEUM, VISITORS ENTER AN ENCHANTING WORLD OF KNIGHTS IN SHINING ARMOR.

A gothic-style Great Hall with soaring arches, stained glass and tapestries is the backdrop for more than 70 suits of armor, hundreds of weapons and a multitude of artifacts from medieval and Renaissance Europe, ancient Greece and Rome, and feudal Japan. Live arms and armor demonstrations, multimedia shows, hands-on activities and historical exhibits bring the Middle Ages to life.

The Higgins Armory Museum is the only institution in the Western Hemisphere solely dedicated to arms and armor. The museum is the fulfillment of one man's dedication to the art of metalworking. John Woodman Higgins, affectionately known as Worcester's "man of steel," was president of the Worcester Pressed Steel Company from 1912 to 1950 and began his collection in 1927. Along with his passionate interest in steel, Higgins saw the highest technical and artistic craftsmanship in arms and armor.

To house his growing collection, Higgins commissioned Joseph D. Leland Architects of Boston to build a state-of-the-art building in 1931. Today, more than 60,000 visitors enjoy the museum's magnificent collections and outstanding programs. Curricula developed by the museum and Worcester public schools enrich the humanities and scientific experience of thousands of students and promote interdisciplinary education throughout the region.

John Higgins ardently believed that "if we can strike a spark and interest visitors, we are rewarded." He would undoubtedly be pleased and gratified by the international reputation his museum enjoys today.

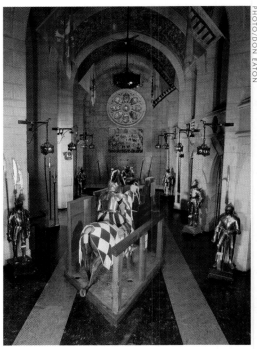

PHOTO/DON EATON

WORCESTER ART MUSEUM

IN 1896, WORCESTER PHILANTHROPIST STEPHEN SALISBURY III FOUNDED THE WORCESTER ART MUSEUM AS AN INSTITUTION "FOR THE BENEFIT OF ALL." TODAY A CENTURY AFTER ITS OPENING, THE WORCESTER ART MUSEUM IS THE SECOND-LARGEST MUSEUM IN NEW ENGLAND.

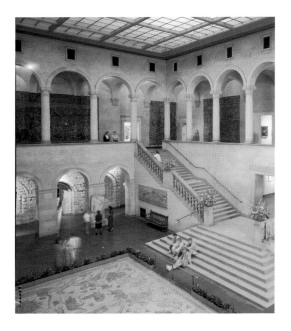

Its exceptional 35,000-piece collection of paintings, sculpture, decorative arts, photography, prints and drawings is displayed in 36 galleries and spans 5,000 years of art and culture, ranging from Egyptian antiquities and Roman mosaics to Impressionist paintings and contemporary art.

In the museum's extensive studio facilities in its Higgins Education Wing, students from preschoolers to retirees participate in quality art programs and hands-on learning. More than 5,000 students, many of whom receive scholarships, annually attend art classes.

Throughout its first century, the Worcester Art Museum proved itself a pioneer: the first American museum to acquire works by Claude Monet (1910) and Paul Gauguin (1921); the first museum to bring a medieval building to America (1927); a sponsor of the first major excavation at Antioch, one of the four great cities of ancient Rome (1932); the first museum to create an Art All-State program for high-school artists (1987); and the first museum to hold a retrospective of works by master Dutch painter Judith Leyster (1993).

The Worcester Art Museum is the sum of many parts — from its galleries and studios to its collections and staff; to the many people who volunteer their time, donate works of art and give financial support; and above all, to those who come to see, discover and learn. The museum is the place "where art celebrates life."

I N 1825, A BURGEONING ERA OF DISCOVERY AND CURIOSITY, WORCESTER'S SCHOLARS, SCIENTISTS AND NATURALISTS ASSEMBLED TO FORM A SOCIETY OF INDIVIDUALS EAGER TO SHARE AND GAIN KNOWLEDGE OF NATURAL HISTORY AND TOPICS CONCERNING THE ENVIRONMENT.

The society, then known as the Worcester Lyceum of Natural History, would soon feature prominent speakers such as Henry David Thoreau, Ralph Waldo Emerson and Oliver Wendell Holmes, and over the years amassed an extraordinary wealth of artifacts and specimens donated for study by Worcester area citizenry.

Today, in an era of conservation, urgent need for knowledge and continued discovery and curiosity, the society, now operating under the name EcoTarium, has evolved into a museum, wildlife center and nature sanctuary dedicated to environmental exploration. It is visited by people from the entire New England region.

The institution has 60 acres of woodlands and wetlands, a beautiful museum designed by the famous architect Edward Durell Stone, the Alden Planetarium and Norton Observatory, and habitats for numerous species of unreleasable native and exotic wildlife.

Visitors come to the EcoTarium to view natural history collections, explore environmental exhibits, learn about astronomy, observe wildlife from bears to frogs, participate in special programs and events, and discover the diversity and phenomena that make our universe rich.

PHOTO/PATRICK O'CONNOR

WORCESTER HISTORICAL MUSEUM

THE WORCESTER HISTORICAL MUSEUM COLLECTS, PRESERVES AND INTERPRETS THE CITY'S HISTORY IN ALL SUBJECT AREAS AND TIME PERIODS.

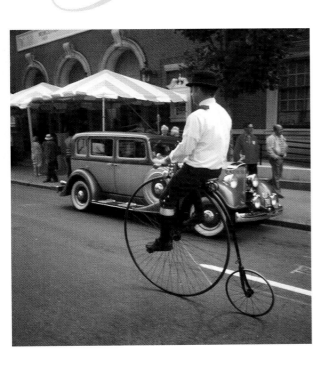

The story of Worcester, from its early years to the present time, is conveyed through permanent and changing exhibitions and special programs. The museum also provides a research library for public use.

In the museum's George F. and Sybil H. Fuller Gallery of Industrial History, visitors discover how industrial innovation and diversity allowed Worcester to become one of the most successful mid-sized cities in America. The experiences of workers, inventors and industrialists are told with the help of artifacts, photographs and audio visual presentations.

As part of its interpretive activities, the museum restored Salisbury Mansion (1772) to its 1830s appearance. The mansion, one of Worcester's few surviving 18th-century buildings, has been owned and operated by the museum since 1984 and is considered one of the best-documented historic houses in New England. It was built as a home and store by Stephen Salisbury I, the son of a Boston merchant family, who came to the county seat to open a branch of the family business.

Through programs and tours at the mansion, it is possible to trace Worcester's growth from town to city.

FLEXCON

FLEXCON IS A WORLDWIDE SUPPLIER OF PRESSURE-SENSITIVE FILM SOLUTIONS. FOUNDED IN 1956 BY MYLES MCDONOUGH, FLEXCON HAS GROWN TO BECOME A GIANT AMONG FAMILY-OWNED BUSINESSES, STEADILY CLIMBING TOWARD THE RANKS OF FORTUNE 500 COMPANIES.

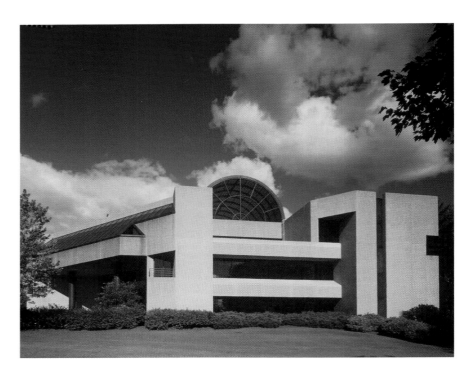

Myles McDonough was only 26 when he launched a company to produce products for niche applications, one in the shoe trade and one servicing the duPont fabrication trade for General Motors. Always ready to accept a challenge, Myles led FLEXcon to produce products for applications that larger companies declined, creating new markets that pushed the young company's expansion. Believing strongly in his employees, Myles encouraged them to explore the possibilities and learn from their mistakes. This willingness to try new methods resulted in FLEXcon emerging as one of the most innovative companies in the industry.

From the small brick building where Myles worked side by side with a handful of loyal employees pulling the wrinkles out of his pressure-sensitive film products, to the 30-acre complex where a new generation of people and machines produce thousands of products that meet ISO 9001 world-class quality standards, everyone in the FLEXcon family is dedicated to continuing the legacy of meeting every customer's individual needs.

In more than 1 million square feet of manufacturing space, FLEXcon employees brush, dye, emboss and laminate polyester, vinyl, polyethylene, polypropylene and polystyrene films to achieve the desired look, feel and function. They apply a surface primer, called a topcoat, so different types of inks used by various print technologies will adhere to the film and create a durable image. And they coat products with specially developed pressure-sensitive adhesives for labels that won't fall off in ovens, freezers, under water or when exposed to chemicals like alcohol and turpentine.

FLEXcon's pressure-sensitive film products are used to promote, protect, package and price almost every item sold today. The labels that identify and decorate foods and beverages, personal care items and household chemicals are FLEXcon material, as well as the bar code unit price labels on grocery and retail shelves, and the inventory tracking bar code label on the shipping pallet. The warning labels on power tools and lawn and garden equipment are produced from

Built in 1988, the Myles McDonough Corporate Office Building (above), proudly symbolizes FLEXcon's maturity as a leading supplier of pressure-sensitive film

Founder Myles McDonough (right), and his wife Jean McDonough

FLEXcon material, as are the product ID labels on kitchen appliances and the membrane switch that activates the touch pad on microwave ovens. Even the security holograms with machine readable features used to protect high-end consumer products are produced by the company.

FLEXcon makes more pressure-sensitive film products than any other supplier – more than 10,000 custom products for a wide range of uses. Customers can also choose from more than 350 standard products stocked for quick delivery in a Quick-Ship program at distribution centers located throughout the United States, Canada and Holland.

The company is best known for a unique ability to work closely with customers to tailor custom products for specific application requirements, and to develop new products for new application opportunities. Constantly striving to build and strengthen customer relationships, FLEXcon understands that its success depends on helping its customers be successful.

Throughout the company's progression to a worldwide supplier of pressure-sensitive film solutions, FLEXcon remained rooted in the traditional values of family and community. The largest employer in Spencer and surrounding towns, the McDonough family through FLEXcon supports numerous educational training programs. Recognizing the schools' need for assistance in keeping pace with rapidly advancing technology, Jean McDonough, Myles' wife, initiated a multi-year collaboration in the mid-1990s between the Spencer/East Brookfield school district and the EcoTarium (formerly the New England Science Center), of which she is a long-time board member. The program focuses on inquiry-based science by using computer technology and serves as a model for corporate/school collaborations in other communities. The company provides computer hardware and software for the school system, offers college scholarships and supports college internships in technical, manufacturing and marketing programs. FLEXcon is also well recognized for donations of its unique materials to schools and nonprofit organizations throughout the Northeast.

Preparing for tomorrow's leadership in a global marketplace, FLEXcon is perfecting the balance between the resources and efficiencies of international operations and the personal intimacy of small-company responsiveness. Myles serves as Chairman of the Board and continues his interest in innovation by

working closely with the FLEXcon New Ventures group. Jean remains involved in the company's money management, as she has for the past 25 years. Neil McDonough, son of Myles and Jean, began learning the business at an early age, working summers in the plants while attending high school and college. After receiving his MBA, Neil became a FLEXcon sales representative, servicing customers in the northern New England territory and assuring their needs were met. He became director of marketing in 1984, was named president in 1990 and CEO in 1994.

Neil McDonough has expanded the family tradition by encouraging employees to constantly seek the new ideas and practices that will allow FLEXcon to be measured against the best of the best in the industry and the world. While striving toward the operational excellence that will support customers in local, regional and global markets, Neil is driving FLEXcon's focus on utilizing innovative technology to develop cutting-edge solutions for customers' unique applications. Established on a firm foundation of continuous improvement and powered by honesty, loyalty and a strong work ethic, FLEXcon is forging ahead to greet both the challenges and the opportunities of the future.

President and CEO
Neil McDonough (above)

FLEXcon pressure-sensitive film products (below), are used for all types of bar code labels, personal care and beverage labeling, graphics applications, security labeling, membrane switches and more

NYPRO INC.

WITH A WORKFORCE OF ALMOST 5,000 WORLDWIDE, NYPRO INC., HEADQUARTERED IN CLINTON, MAKES A REAL DIFFERENCE TO THE AREA'S ECONOMY. CLOSE TO 1,000 EMPLOYEES WORK AT ITS CLINTON LOCATION, AND NEARLY 60 PERCENT OF THESE NYPRO EMPLOYEES ALSO LIVE IN THAT COMMUNITY.

Nypro's corporate headquarters are in a renovated pre-Civil War mill in Clinton (above)

This state-of-the-art injection molding cleanroom in Clinton is typical of Nypro plastics facilities worldwide (below)

Can you imagine a manufacturing plant in Central New England that has never closed for snow? That's Nypro. With so many employees who live within walking distance, Nypro never disrupts its continuous operations — seven days a week, 24 hours a day.

Nypro is the leading global custom injection molder. With 25 plants in 11 countries and a new plant added every six months or so, Nypro handles the most challenging types of accounts: global customers who need millions of dollars worth of plastic components in more than one country. As a result of its ability to satisfy customers worldwide, Nypro generates about a half billion dollars in sales annually.

Plastic components made and assembled by Nypro are in use all around us — hand-held safety razors, pagers and cellular phones, toothbrushes and nail polishing tools, medical devices such as inhalers, insulin pens and contact lens molds, computer parts, cartridges for inkjet printers and auto seat belt parts. The list goes on and on.

Typical companies for whom Nypro makes these parts are household names as well: Gillette, Johnson & Johnson, Hewlett-Packard, General Electric, Abbott Laboratories and Motorola.

Nypro has grown an average of 15 percent to 20 percent every year since the mid-1980s. Nypro's concern for product quality, as well as its commitment to building "next door" to major customers, has fostered its growth. When health-care manufacturers went to Puerto Rico in the early 1970s, Nypro built there to service them. American customers with operations in Europe brought Nypro to Ireland, Wales, Russia and, more recently, Germany and Turkey. The demand for American technology in Asia has led Nypro to China, Hong Kong, Singapore and India. Nypro's Mexican operations are among its fastest-growing.

In the United States, Nypro operations are close to the industrial centers that need plastics. The company has its flagship plant in Clinton and facilities in North Carolina, Georgia, Kentucky and Alabama. In the heartland, there are plants near Chicago and in Iowa. In the west there are plants in Colorado, Oregon and San Diego. An El Paso plant borders Mexico.

Nypro is also a leader in community activities. No community program is more visible or successful than the Nypro/Clinton High School FIRST team. FIRST is a program that excites high school students about technology. Hundreds of teams of students and engineers build radio-controlled robots and compete with other high school/company partnerships at regional competitions and in the national championships held at Walt Disney World in Florida. The Nypro/Clinton High School team was National Champion in its first year and has won dozens of awards since, making it the most successful team since the competition began in 1992.

FOR 35 YEARS, QUINSIGAMOND COMMUNITY COLLEGE HAS PROVIDED OPPORTUNITIES FOR A FIRST-RATE EDUCATION AND PERSONAL GROWTH TO THOUSANDS OF AREA MEN AND WOMEN.

The college offers preparation for immediate entry into a career field or for transfer to bachelor's level programs at four-year colleges and universities. It also offers numerous opportunities for personal and cultural awareness through a variety of non-credit seminars and workshops.

Qinsigamond was established in 1963 to provide access to higher education for residents of Central Massachusetts. In 35 years, the college's enrollment has grown from fewer than 300 to more than 7,000 full-time and part-time day and evening students. More than 41 associate degree and certificate study options reflect the needs of the communities its serves.

Quinsigamond Community College endeavors to meet the region's educational needs through a comprehensive selection of transfer, career and special needs courses and programs. Students may select from the various options in the liberal arts program leading to transfer to all of the state colleges and universities and most private institutions of higher education, especially members of the Colleges of the Worcester Consortium. Students seeking immediate employment after two years or less may elect associate degree or certificate programs related directly to the workforce needs of regional businesses, industries and social agencies. The special needs of nontraditional students are reflected in the many programs and individualized services available to all students wherever courses are offered.

Few colleges have as profound an impact on the greater Worcester area as Quinsigamond. In addition to the students it serves each year, the college provides a powerful resource for businesses and professionals throughout the region. Quinsigamond works to build a thriving local community through outreach

programs, direct community presence and satellite campuses. The college also hosts forums and events that give a voice to the cultural, social and economic interests of its students, faculty and community.

Quinsigamond's flexible admissions policy, low cost and extensive financial-aid program have made a college education possible for thousands of men and women. The educational experience at Quinsigamond is first-rate. The faculty are there to teach and guide. The classroom and laboratory facilities are well-equipped. And the support services — for current students and graduates — are among the best anywhere.

Quinsigamond Community College exists for one purpose, to help realize the potential of its students, its staff and the community by offering a quality education at an affordable cost.

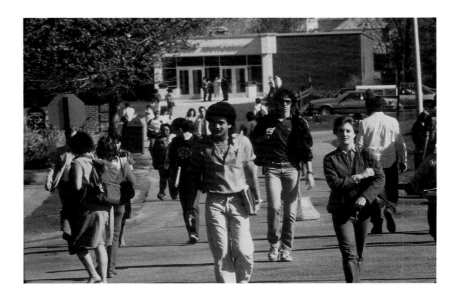

DATA GENERAL CORPORATION

TRACY KIDDER'S BOOK "THE SOUL OF A NEW MACHINE" WON A **1982** PULITZER PRIZE FOR ITS TRUE-LIFE PORTRAYAL OF A DATA GENERAL TEAM AND ITS EFFORTS TO CREATE A REVOLUTIONARY 32-BIT MINICOMPUTER. WHILE **17** YEARS IS AN EON IN THE COMPUTER INDUSTRY, THE SPIRIT OF INNOVATIVE THINKING THAT GAVE RISE TO THE ECLIPSE® MV COMPUTER IS STILL VERY MUCH ALIVE AT DATA GENERAL.

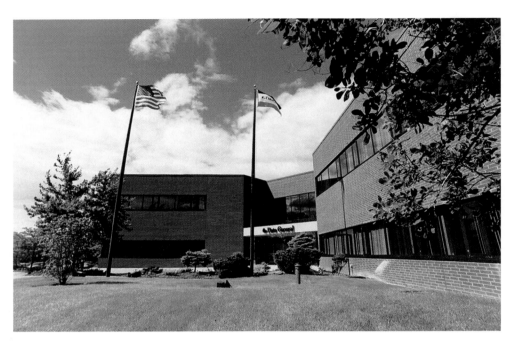

Data General corporate headquarters, 3400 Computer Drive, Westborough (above)

CLARiiON Advanced Storage Systems set the industry standard (right)

Today, more than 1,700 employees at Data General in Westborough and Southborough focus on providing high-end enterprise computing and storage solutions to customers in more than 70 countries.

For 30 years, Data General people have been reaching around the world and leading the information technology revolution from Central Massachusetts. In an industry in which the knowledge base doubles every two years, the company's legendary competitiveness and innovation have helped it survive and thrive. Today, Data General has annual revenues of more than $1.5 billion.

Data General burst on the scene in 1968 with its aptly named NOVA®, the first minicomputer based on integrated circuit technology. The company became known for a culture in which talented individuals combined challenging technological goals with aggressive marketing and pricing. Throughout the 1970s, successive generations of minicomputers were hailed for their price and performance, and company sales grew to more than $500 million by 1980.

In the 1980s, the next computing revolution on the horizon was replacement of the minicomputer by the personal computer (PC) and its cousin, the open systems server. In the minicomputing world, the software and operating systems were proprietary — that is, they could be used only on the manufacturer's machines. When IBM introduced an open standard for PCs, consumers were no longer locked into the products and peripherals of a single manufacturer; they could now mix and match software and hardware components. Many competitors ignored or resisted the advent of PC networking, but Data General embraced it.

In 1988, Data General launched its open systems strategy based on industry-standard microprocessors, operating systems and storage components. The following year, it backed up that commitment with the first AViiON® computer systems. In 1991, Data General delivered the first of its RAID storage systems, followed in 1992 by introduction of the CLARiiON® disk arrays. Since then, Data General has joined with industry leaders Intel and Microsoft to meet the demands of the

marketplace with innovative server and storage products. Data General's open-systems thinking and its focused strategy of providing a scalable family of high-end enterprise solutions, including servers, storage products, services and software, opened up an entirely new era in the company's history.

The AViiON server division focuses on providing enterprise solutions based on Microsoft Windows NT Server as well as high-end UNIX solutions using the ccNUMA technology. The division's solutions approach to meeting customers' needs has made it successful in the health-care market, where Data General now serves nearly 30 percent of U.S. hospitals. AViiON customers also include the U.S. State Department and Bloomberg Financial Markets.

Data General's CLARiiON business unit has gone from a startup venture in 1991 to sales of $500 million, with a worldwide installed base of more than 60,000 systems. The CLARiiON user base includes such industry giants as EDS, Motorola and the Kansas City Chiefs of the National Football League.

Data General's worldwide customer service network provides users with service and support 24 hours a day, 365 days a year. The company was the first major computer vendor in the industry to have its entire U.S. service and support organization certified to the ISO 9001 standard.

Through all of the technological changes of three decades, Data General — which was born in Hudson, nurtured in Southborough and developed in Westborough — has been a vital part of the Central Massachusetts community.

In 1971, Data General helped lead the growth of technology-based enterprises along Route 128 and Interstate 495, then the outer belt from Boston. Less than a decade later, Data General's presence in Westborough was the catalyst for development of several hundred acres on the town's eastern edge into what today comprises some of the finest office and research and development complexes in Massachusetts.

From all over the country and the world, individuals and their families have come to Central Massachusetts to be part of Data General. Both the company and its people, who live and work here, give to the community. Most notable in the past three years is a partnership with Worcester's North High School in which the company, volunteer

employees, teachers and students have worked together to wire the entire school, create a state-of-the-art technology lab, apply computer technology to every discipline in the school and involve students in Data General's business as interns. The Data General-North High relationship is the model for school-business partnerships in Worcester and all of Central Massachusetts.

Data General has led the way in the transition from proprietary computing systems to open systems, and is synergizing a 30-year tradition of innovation with the ability to adapt to the ever-changing world of high-end enterprise computing. The industry has changed, but the proverbial "soul" of the new machine is still very much alive at Data General in the "heart" of Central Massachusetts.

Data General president and CEO, Ronald L. Skates (above with student), at the opening of Worcester's North High School Technology Lab

AViiON servers are at the heart of health-care information systems at more than 1,200 hospitals worldwide (left)

Throughout its history, Worcester has been noted for the generosity of its citizens, both in philanthropy and community service. To ensure the constancy of this legacy, a group of citizens founded the Greater Worcester Community Foundation in 1975.

PHOTO/PATRICK O'CONNOR

Shown to the right are members of the founding committee for the Greater Worcester Community Foundation (left to right) John Adam Jr., Jean F. Hazzard, Robert K. Massey, John W. Lund, Henry B. Dewey and Robert Cushman

It is one of 500 such foundations throughout the country whose mission is to harness community resources to address local concerns.

The Greater Worcester Community Foundation is here to improve the quality of life in Central Massachusetts. It transforms the generosity of individuals and families into new hope and opportunities. Grants are made from the foundation's endowment, which was created by pooling the funds contributed by individuals and organizations. The pooling of donor resources into a permanent fund enables the foundation to make a greater impact within the community. By focusing on the entire community rather than on any special issue, the foundation is able to address the matters of greatest importance to the people of this region.

The foundation's strength lies in its knowledge of the community. As a resource for the entire region, the foundation brings people together. It helps donors find the most effective ways to achieve their philanthropic goals. Through its grants, the foundation helps make Central Massachusetts a better place to live, work and raise a family.

The Greater Worcester Community Foundation pursues its mission by making grants to non-profit organizations. Since its founding, it has made grants totaling more than $19.9 million to a broad range of organizations representing all sectors of the community:

- $8.8 million for health and human services, to help people become more productive workers, effective parents and responsible citizens.
- $4.1 million for the arts to support Worcester's rich array of museums, institutions, cultural heritage and performing arts groups.
- $3.5 million for education and youth so that young people can reach their full potential.
- $2 million for community development and civic affairs to help community organizations mobilize people and neighborhoods to renovate housing, reclaim parks and foster a healthy environment.
- $1.4 million for scholarship aid to assist men and women, regardless of age, to attend college or professional school.

The foundation currently manages more than 180 named funds. A family, individual or corporation may establish a named fund with a gift of cash, securities or other property valued at a minimum of $2,500. Gifts may be added to the fund at any time by the donor or others. With its broad range of cost-effective services, the foundation is able to tailor a fund to meet a donor's philanthropic goals. By establishing a fund at the Greater Worcester Community Foundation, individuals and families can create their own legacy, and join with countless others who are improving life in Central Massachusetts. The possibilities are endless.

PHOTO/PATRICK O'CONNOR

THE LANDMARK

THE **L**ANDMARK RELISHES ITS ROLE AS THE HOMETOWN NEWSWEEKLY IN THE **W**ACHUSETT REGION. **W**ITHOUT THE OBLIGATION OF CARRYING WIRE SERVICE STORIES ABOUT THE LATEST NATIONAL AND INTERNATIONAL SENSATIONS, **T**HE **L**ANDMARK HAS A FOCUS THAT IS CLEARLY LOCAL. **O**VER THE PAST **24** YEARS, READERS HAVE COME TO RELY ON THE PAPER TO REFLECT LIFE AS IT REALLY IS IN THIS **C**ENTRAL **M**ASSACHUSETTS REGION.

After nearly a quarter of a century, it's difficult to recall that in the mid-1970s there was no LANDMARK and indeed little in-depth coverage of the suburban communities north of Worcester. In January 1976, a group of civic-minded women answered that need by launching a community newspaper.

THE LANDMARK, which started in the basement of publisher/editor Joanne Root's home, today is an institution that's a byword at coffee shops, town meetings and informal gatherings — wherever local events are discussed. Over the years, the Wachusett region has become famous — some might say infamous — for the heat that surrounds many local issues. In the midst of it all, LANDMARK reporters consistently maintain a sense of objectivity as they cover town boards and committees.

In the late 1980s The LANDMARK's critical need for office space coincided with the obvious needs of a forlorn-looking, 100-year-old, burned-out building on Holden's Main Street. That old landmark — a former home and blacksmith shop — was salvaged and rebuilt,

and now provides a pleasant place for the staff to gather and disseminate local news.

Over the years LANDMARK staff members have earned their reputations in the community newspaper industry. Not a year has gone by without recognition from either the New England Press Association and/or the Massachusetts Press Association. Its editorial pages, along with the work of news editor Jim Keogh, education reporter Linda Lehans and cartoonist Don Landgren, have been consistent winners.

With the opportunities and challenges of the Information Age, THE LANDMARK is still spreading its wings, identifying fresh, new ways to fill its role as the conduit for first-hand local information and ideas, and for the milestones and achievements of the citizens of Holden, Paxton, Princeton, Rutland and Sterling. This reliable sharing of homespun news weaves together and builds a vital sense of community — of belonging to a larger whole — which is what communication is all about.

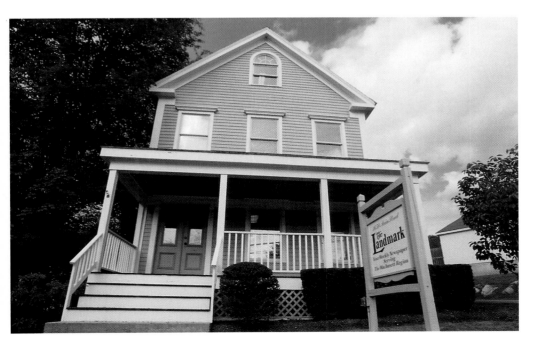

THE LANDMARK captures happenings around the Wachusett Region on film, such as this ferris wheel and midway at the Sterling Fair (above)

THE LANDMARK office at 1650 North Main Street, Holden (left)

I N THE MID-1950S, MURRAY AND IDA ROTMAN BEGAN A SMALL FURNITURE AND CARPET CONCESSION IN C. T. SHERER'S DEPARTMENT STORES AND LATER BARNARD'S, IN DOWNTOWN WORCESTER. IN 1968, AS THEIR VISION GREW, THEY LEASED 10,000 SQUARE FEET IN THE FORMER WHITTAL CARPET MILL AT COLLEGE SQUARE NEAR THE COLLEGE OF THE HOLY CROSS.

A sampling of newly remodeled and beautifully decorated showrooms at Rotmans (above)

Rotmans founders, Murray and Ida Rotman, are flanked by their children (from left) Bernie, Barry and Steve Rotman at the dedication of the new storefront at 725 Southbridge Street

Through the years that followed, Rotmans expanded into additional space in the former mill complex. The store's slogan in the 1970s, "7 stores on 5 floors under 1 roof", was changed in the 1980s to "New England's Largest Furniture and Carpet Store" as Rotmans became known for being one of the largest single store operations of its kind in the country.

Today, the slogan "Fantastic!" sums up Rotmans magnificent new interior displays, unmatched in size and beauty anywhere in New England. In one location customers can see a breadth and depth of categories not found in traditional stores. The preponderance of quality brand names such as Pennsylvania House, Thomasville and Karastan add to the credibility of Rotmans offerings.

Great ideas abound at every turn in the store's beautifully decorated and accessorized room settings. "Fantastic Facts" attached to the furniture educates customers about the construction and care of the product. Sales associates are trained in each category and can assist shoppers in selecting a single item or an entire room. Professionally trained interior designers are available when more professional assistance is needed.

To both educate and entertain its customers, Rotmans holds free interior design workshops throughout the year. Local and national experts share their knowledge and expertise on a wide range of ideas to improve the home environment.

By creating Cafe Fantastique on the third floor, Rotmans adds a wonderful dimension of fun to the shopping experience. On Saturdays, shoppers can take a relaxing break in the cafe and enjoy live concerts for children and adults.

For seven years, Rotmans has been a proud sponsor of the Furniture Exchange program, a cooperative effort among Rotmans, the Donations Clearing House and the Central Massachusetts Housing Alliance. Through this collaboration Rotmans customers donate furniture they are replacing to families in need throughout Worcester County.

The Rotman family is proud to have been nationally recognized in 1995 as "Retailer of the Year" and "Rug Retailer of the Year" but the family is most proud of its tremendous acceptance at home. Although Murray and Ida are now in their mid-80s and semi-retired, the business continues to grow and be responsive to the needs of its customers with sons Barry, Steve and Bernie at the helm. As Rotmans continues growing, the Rotman family and their associates will build on all the hard work and success of the past as they look forward to a "fantastic" future for Rotmans and its wonderful home city of Worcester.

Until the late 1980s, Central Massachusetts residents with disabling injuries or illnesses had to travel outside the Worcester area for physical rehabilitation services. That changed in 1987, when Fairlawn Rehabilitation Hospital became the first comprehensive physical rehabilitation facility in Central Massachusetts.

Fairlawn's history is a rich one. In 1894, James A. Norcross, co-owner of the company which constructed the Worcester Art Museum and City Hall, designed and built a three-story sandstone mansion on May Street in Worcester. Set amid 38 acres of broad, sloping lawns, the Norcross family home became known as Fairlawn.

In 1921, a group of Worcester's Scandinavian citizens purchased the Norcross estate to establish a small general hospital dedicated to meeting the needs of area residents. Over the next six decades, Fairlawn Hospital became known for providing quality health care in a warm, family atmosphere.

In 1987, in response to the community's need for physical rehabilitation services, Fairlawn became the first acute-care hospital in the United States to fully convert to a physical rehabilitation facility.

Fairlawn's inpatient specialty programs include general orthopedics, geriatrics, young/senior stroke rehabilitation, brain injury, spinal cord injury, amputation, neurological rehabilitation and ventilator/pulmonary rehabilitation.

Using a team treatment approach to patient care, Fairlawn's rehabilitation professionals work together to help patients reach their individual goals. Each patient's care is coordinated by a physician who specializes in physical medicine and rehabilitation, neurology or orthopedics and an internal medicine physician. Consultations are provided by other physician specialists, including neurologists, orthopedists, pulmonologists, geriatricians and physiatrists. Other multidisciplinary team members may include a primary nurse, case manager, therapeutic recreation specialist, neuropsychologist, family counselor, vocational counselor and physical, occupational and speech therapists.

Fairlawn's Outpatient Center offers single and comprehensive physical rehabilitation services as well as specialty programs for individuals with osteoporosis and neurologic, spinal, orthopedic and work-related injury or illness. Fairlawn's outpatient physicians, therapists and support staff dedicate their specialized knowledge and skills to helping people resume productive living at home, at work and in leisure activities.

Fairlawn Rehabilitation Hospital is a collaborative effort of the Fallon Clinic, UMass Memorial Health Care, and HealthSouth Corp. Fairlawn's commitment to excellence has resulted in accreditation by two of the nation's most respected health-care accrediting agencies — the Joint Commission on Accreditation of Healthcare Organizations and the Commission on Accreditation of Rehabilitation Facilities.

The first physical rehabilitation hospital in Central Massachusetts, Fairlawn is located at 189 May Street, Worcester (above)

Recognizing the integral role family plays in a patient's recovery, Fairlawn Rehabilitation Hospital and Outpatient Center strongly encourages family involvement in the rehabilitation process. Fairlawn offers a full complement of physical rehabilitation services to help people become as independent as possible

SINCE 1990, WORCESTER PUBLISHING LTD. HAS BEEN REPORTING THE CHALLENGES AND TRIUMPHS OF CENTRAL MASSACHUSETTS — FROM BOARDROOM ISSUES TO NEIGHBORHOOD CONCERNS — IN ITS AWARD-WINNING PUBLICATIONS. AS IT STRIVES TO PROSPER AND THRIVE IN THE PURSUIT OF PUBLISHING EXCELLENCE, THE COMPANY IS COMMITTED TO EXERTING A BENEFICIAL PRESENCE IN THE COMMUNITIES IT IS PART OF, AS WELL AS PROVIDING A CHALLENGING ENVIRONMENT FOR THE PROFESSIONAL GROWTH OF ITS EMPLOYEES.

Worcester Publishing co-founders (from left), Peter Stanton, Allen Fletcher and Paul Giorgio

Worcester Publishing Ltd. was founded eight years ago by a triumvirate of enthusiastic publishers — Allen Fletcher, Paul Giorgio and Peter Stanton — determined to pursue their publishing goals despite a regional recession. The company's first titles, appearing in the spring of 1990, were the WORCESTER BUSINESS JOURNAL — a biweekly business-to-business publication — and INSIDE WORCESTER — a glossy city magazine. While the magazine fell victim to the continuing recession, the WORCESTER BUSINESS JOURNAL flourished and has established itself as a primary and highly-regarded source of business information in Central Massachusetts.

The WORCESTER BUSINESS JOURNAL is recognized as an agenda-setter on a variety of municipal and regional issues, particularly urban development, where its voice has filled an editorial void in the City of Worcester. It has garnered numerous editorial, advertising and design awards, including a national first prize in 1993 for general excellence given by the Association of Area Business Publications. In 1997, the WORCESTER BUSINESS JOURNAL expanded its regional business news coverage with its EXECUTIVE FAX, sent out daily to local business leaders.

Seeking to capitalize on its proven success with the WORCESTER BUSINESS JOURNAL, the company founded a sister publication in Hartford, Connecticut in 1992 — the HARTFORD BUSINESS JOURNAL. This publication has established its own niche in a competitive market in that capital city. In 1996, the HARTFORD BUSINESS JOURNAL went from being biweekly to a weekly publication.

Expanding again in 1992, the company purchased the established local alternative newsweekly, WORCESTER MAGAZINE, bringing the publication in-house, redesigning and

injecting it with new life. The magazine's progress has paralleled the region's climb out of the recession, reaching new levels of advertising and editorial excellence. It has become an increasingly influential editorial voice in the city, as well as remaining an indispensable source of news, arts and entertainment information for the region. WORCESTER MAGAZINE has earned an armful of awards from the New England Press Association, including Newspaper of the Year in 1995.

In addition to these core products, the company has pursued a broad range of specialty publishing opportunities through its Special Projects Division, including visitors guides, college guides, calendars, maps, magazines and newsletters. Among its more recognizable titles are the annual WORCESTER COLLEGE SURVIVAL GUIDE, the VISITOR'S GUIDE TO CENTRAL MASSACHUSETTS and the JOURNAL OF THE WORCESTER DISTRICT MEDICAL SOCIETY.

The most recent expansion of Worcester Publishing's creative strengths is the publication of this book, WORCESTER: A PORTRAIT OF CENTRAL MASSACHUSETTS. By bringing together the talents of its art and design staff, editors, writers and sales team, Worcester Publishing has been able to publish this heirloom-quality book.

From its original staff of 20, the company has grown to employ a talented staff of 65 individuals in its Worcester and Hartford offices. In doing so, it has fulfilled its key commitment to provide editorial value to its readers, commercial value to its advertisers, and social value for

everyone within its organization. Located on Shrewsbury Street, the Worcester office has helped to anchor the continuing rebirth of that East Side commercial thoroughfare.

In harmony with a company ethic of civic involvement, Worcester Publishing provides sponsorships and donations to charitable and cultural organizations. Its employees participate enthusiastically in local nonprofit organizations, cultural and civic groups and business associations.

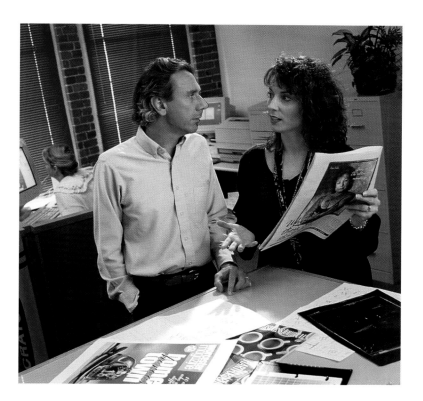

WPL's marketing and sales team meets regularly to brainstorm creative concepts for their advertising clients. Their consultative sales philosophy and team-oriented approach has produced effective ad campaigns, award-winning designs and double-digit growth in its magazine division for the last eight years (above)

By investing in a significant upgrade of its entire production system, WPL has now brought together its highly creative design and editorial teams with state-of-the-art technology to assure that each issue has the highest quality reproduction possible

THE GITTO/GLOBAL CORPORATION

IN THE SCHEME OF THINGS, THE GITTO/GLOBAL CORPORATION IS A NEWCOMER. THE COMPANY WAS FORMED IN 1992, WHEN THE GITTO CORPORATION AND GLOBAL PRODUCTS CORPORATION MERGED. HOWEVER, ITS HISTORY IN LEOMINSTER, MASSACHUSETTS, THE PLASTICS CAPITAL OF THE WORLD, RUNS DEEP.

PHOTO/LARRY STEIN

The Gitto/Global Corporation headquarters at Gianna Park in Lunenburg, Massachusetts (above)

Officers, from left, Frank Miller, chief operating officer and president; Nancy Gitto-Panagiotes, vice president and assistant treasurer; Charles N. Gitto Jr., chairman of the board and Gary Gitto, chief executive officer and treasurer

PHOTO/PATRICK O'CONNOR

At its center is Charles N. Gitto Jr., who has parlayed a flair for marketing and a penchant for perfection into a leading multi-million-dollar technology company in the specialty plastics industry. Consider, for example, a polyvinylchloride plastic which, when subjected to an open flame, will not burn. An industry breakthrough in the mid-1980s, this patented PVC plastic, developed in Gitto labs, revolutionized the wire and cable industry and made life safer for us all.

Several years and numerous innovations later, The Gitto/Global Corporation is an international supplier of high-quality specialty plastics. Applications for its products range from athletic shoes to back-up battery cases, and from wire and cable to room deodorizers. The company's history is as interesting as the markets it serves.

After beginning his career with Lynn Plastics, Charles "Charlie" Gitto resigned in 1972 to found Abbott Industries, a PVC compounder, in his hometown of Leominster. The sale of Abbott Industries enabled Gitto to start Gary Chemical Corporation in 1978, and it was here that the Gitto name became synonymous with pioneering in the specialty plastics industry.

Gary Chemical, named after Gitto's son, concentrated on two markets — wire and cable, and footwear. Though seemingly unrelated, both demand materials that are flexible at both temperature extremes, impervious to contaminants such as oil and grease, and resistant to abrasion. As its reputation for innovation grew, the company was increasingly called on to develop proprietary compounds for high-profile customers. The company, too, became high-profile and was courted by the British concern Evode Group plc. In 1989, Gitto sold Gary Chemical to Evode.

Gitto's son and daughter, Gary and Nancy, were raised in and around the plastics industry and after receiving their college degrees, they joined the family business. Both inherited their father's entrepreneurial spirit. With the sale of Gary Chemical Corporation behind them, the family formed The Gitto Corporation. To refine its product offerings and increase the market base, the new company turned its focus toward high-end olefins, which include polyethylene and polypropylene. Within two years, sales were approaching $25 million.

In 1992, Gary Gitto purchased half the stock of Global Products Corporation, a successful PVC compounder. In fact, Global was the

direct descendent of Abbott Industries, and was still at the Mohawk Drive location in Leominster, where Charles Gitto had first set up shop.

Global's remaining partner and stockholder, Frank Miller, joined Gary Gitto to form a new company, The Gitto/Global Corporation, with Charles Gitto as chairman. As a result of this merger, Gitto/Global became one of the country's largest producers of specialty PVC and olefinic compounds.

Because The Gitto Corporation had outgrown its Leominster home, Gitto/Global decided to build its new state-of-the-art headquarters in Gianna Park, in the neighboring town of Lunenburg. Fully computerized, the three-level production facility houses the most advanced equipment and technology available, including a Pomini twin screw mixer, the first of its kind in the country. Manufactured in Italy, its revolutionary design allows production of 25 million to 30 million pounds of plastic compound per year while using a much smaller footprint than comparable equipment.

The entire operation at Gianna Park reflects Gitto/Global's insistence on a tightly run ship. The plant's air filtration and water recycling systems are highly efficient and preserve the integrity of the environment both inside and out. Double-hulled storage tanks are mounted in water-filled enclosures to prevent the possibility of contamination of the surrounding ground. When visitors tour the production area they often remark they could "eat off the floor." Everyone is quick to note that the concern for quality indeed runs from the ground up at Gitto/Global, and it has become the company's hallmark.

Quality products and a commitment to research and development have put Gitto/Global on the fast track. While the company offers "standard" products, its reputation for never saying "it can't be done" has led to major advances in TPO and PVC compounding technology. In fact, the company maintains separate R&D labs for each product line. Most notable is its work in flame-retardant olefins for the wire and cable and power supply markets. Gitto/Global has developed plastics that neither burn nor emit toxic fumes when subjected to flame. Many of these compounds become jacketing and insulation for construction and communications wiring or find their way into airplanes and automobiles. Similarly, plastics that are flame retardant as well as impervious to acid have been heralded

by the battery and power supply industries both here and abroad.

Gitto/Global has developed materials for shoe soles that remain flexible in subzero conditions, won't slip on wet boat decks, and don't conduct static electricity. Gitto/Global makes materials that look like rubber but smell like vanilla. Its customers mold and extrude the company's compounds into medical tubing, plug-in air fresheners, window frame components, electric blender housings, extension cords, food packaging, submarine cables, and on and on and on.

You will probably never buy a product directly from The Gitto/Global Corporation, but if you wear shoes, have a kitchen, use a computer, drive a car, or work in an office building, there's a good chance a Gitto/Global product has touched your life.

One of a fleet of Gitto/Global tractor trailers (above)

Extrusion and sifting of Gitto/Global compound before it is bagged for shipment (below), shown with Charles Gitto

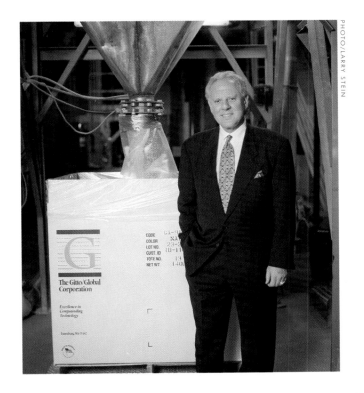

UMASS MEMORIAL HEALTH CARE IS THE LARGEST NON-PROFIT HEALTH CARE SYSTEM IN CENTRAL MASSACHUSETTS AND ONE OF THE LARGEST IN NEW ENGLAND. WITH A FUNDAMENTAL MISSION OF IMPROVING THE OVERALL HEALTH AND WELLNESS OF THE REGION, **UMMHC** IS COMMITTED TO PROVIDING PRIMARY AND SPECIALIZED MEDICAL SERVICES OF THE HIGHEST QUALITY AVAILABLE ANYWHERE.

PHOTO/DANIEL DUFFY ASSOCIATES

UMass Memorial, University Campus and the University of Massachusetts Medical School (above)

Lecture in the endoscopic media suite at UMass Memorial (right)

PHOTO/CHRISTOPHER NAVIN

UMass Memorial offers an unmatched continuum of complete health care to the residents of Central Massachusetts through its network of community hospitals, acute-care hospitals, primary-care physician offices throughout the region, home health and hospice services, outpatient rehabilitation services, and an array of inpatient and outpatient mental health services.

At the many sites that make up UMMHC, area residents can access physicians, services and health and wellness programs featuring health topics for all stages of life. The health and wellness programs, ranging from prenatal exercise to newborn and child health issues, from cardiac rehabilitation to stress reduction, are offered to help people cope with illness, learn how to prevent it and simply get the most out of life.

UMMHC was formed in April 1998, when Memorial Health Care, comprising Memorial Hospital and Hahnemann Hospital, merged with the University of Massachusetts Medical Center Clinical System. The merger of UMass and Memorial Health Care represents the joining of two strong, local health care systems, each with long-standing ties to the Worcester community and region.

Today, UMMHC serves the region with six hospitals: two acute-care hospitals, UMass Hospital and Memorial Hospital, which comprise UMass Memorial Medical Center; the community hospitals of Marlborough Hospital and Clinton Hospital; and a third community hospital system, HealthAlliance, comprised of Leominster Hospital and Burbank Hospital in Fitchburg.

UMass Memorial provides the region's only comprehensive pediatric services through the Children's Medical Center, including specialists in every pediatric health field. More babies are delivered here than at any other hospital in the region. UMMHC has the region's only newborn and pediatric intensive care units, and provides the only pediatric AIDS treatment in the area.

The Center for Women and Children at UMass Memorial features comprehensive services and information on family health. Among its many offerings are parenting workshops, outpatient outreach for teens and new parents, and support groups.

As the advanced tertiary care referral center for the region, UMMHC is widely renowned for its specialized treatment in cardiovascular medicine, bone disease, neurology, psychiatry, radiation therapy and other forms of cancer care. The Cancer Center bridges basic and clinical research to patient care. A major theme of the evolving research at the Cancer Center involves the application of gene therapy and marrow transplant as treatment for cancer patients.

UMMHC also houses Life Flight, the helicopter ambulance service that has transported more than 10,000 patients over the past 14 years.

The University of Massachusetts Medical School opened in 1970 and its teaching hospital opened in 1976. UMMS has earned a national reputation for excellence in health sciences education, research, patient care and public service. UMMS has become a leader in developing primary care doctors and is now ranked eighth nationally by U.S. NEWS & WORLD REPORT in that category.

UMass Medical School is one of just 17 Centers for AIDS Research nationwide, designated and funded by the National Institutes of Health. CFARs provide a pool of shared resources and facilitate interdisciplinary and international collaborations, academic-industry collaborations, research dissemination activities and community outreach, in order to advance AIDS research. UMMHC, as the clinical partner of the medical school, plays a key role in the new center, building upon established clinical expertise in AIDS treatment, prevention and outreach.

UMMHC is committed to providing care for those in need, especially children. It has taken a leadership role in delivering programs and services to help the region's youth and their families. UMMHC participates in the School/Physician Partnership Program in collaboration with Worcester's public schools. This collaborative effort brings physicians, nurse practitioners, teachers and public health nurses together in public schools on behalf of children and their families.

UMass Memorial provides a director and a youth outreach worker to staff the Youth Center, located in downtown Worcester. It provides pediatric services for teen parents,

parenting support groups, medical consultations, health education and workshops on violence prevention. UMMHC's commitment to young people reflects its unshakable belief in the promise and potential of the region's youth.

The vast resources and expertise of UMass Memorial Health Care are available to the other health care providers that are part of the UMMHC network. An affiliation with UMMHC means that patients throughout the region receive local access to high-quality health care.

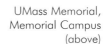

UMass Memorial, Memorial Campus (above)

Liver transplant team at UMass Memorial (left)

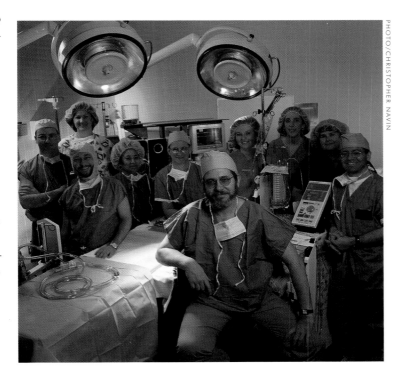

STEVE BABINEAU
Steve Babineau is one of the largest suppliers of professional hockey photography in the world. He has been the official photographer for the Boston Bruins for the past 25 years. Steve's photos have been published in Hockey News, Sports Illustrated and on posters and hockey cards. Steve resides in the Medford, Massachusetts area.

STEPHEN DiRADO
Stephen DiRado is a nationally recognized photographer with work in many public and permanent collections, including the Houston Museum of Fine Arts, the DeCordova Art Museum and Worcester Art Museum. He has received numerous awards including an NEA and three Massachusetts Artist Foundation Fellowships. He teaches at Clark University, and lives both in Worcester and on Martha's Vineyard. Locally his work is represented by the Fletcher/Priest Gallery.

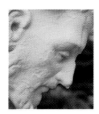

PETER FAULKNER
Peter Faulkner is an environmental photographer who has taught photography at the Worcester Center for Crafts since 1979. His black and white photographs are in the collections of the Worcester Art Museum and the Worcester Historical Museum, as well as in many personal collections. His images have been shown extensively throughout the region in one-person and group shows. Faulkner is the recipient of several grants from the Worcester Cultural Commission, was a finalist in the Massachusetts Artists Fellowship, and has been chosen as a Top 100 Photographer through the 1996 Golden Light Awards Maine Photographic Workshops.

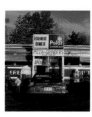

ALLEN FLETCHER
Allen Fletcher is chairman of Worcester Publishing Ltd. and co-owner of the Fletcher/Priest Gallery in Worcester. He is an avid student of the urban landscape. His photographs have appeared in Inside Worcester and Worcester Magazine.

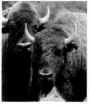

STEVEN KING
Steven King, staff photographer for The Landmark newspaper in Holden, Massachusetts, credits his rural upbringing as a major influence on his photographic subject matter. Many of his subjects were captured while King worked as a herdsman on a dairy farm in Barre. A graduate of the Hallmark

Institute of Photography, King resides in Barre with his son Brendon.

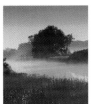

LARRY KNIVETON
Larry Kniveton is a Massachusetts native, currently living in Ashland. He attended Eastern Illinois University, where he graduated with a degree in economics while serving in the United States Air Force. His pencil art led him into the self-study of photography in the mid 1980s. He is a regional specialist, photographing outdoor New England and location assignments of all types.

ROSEMARY LeBEAU
Rosemary LeBeau has lived in Worcester for nearly 20 years. During that time she has been making images of her favorite places, both public and private. She feels fortunate to live in an area so rich in diversity of architectural and cultural style. Rose says she is often drawn to the fading glory of the city and its suburbs, from the rusting diner to the closed drive-in movie marquee. Many of the places she has photographed have met their fate in the name of progress. Rose is glad, however, that she has preserved them in her photographs.

NASH STUDIO
Robert Nash is president and owner of Nash Studio Inc., a commercial photography studio located in Worcester. Over the past 20 years Bob has created award-winning images for corporations and advertising agencies throughout the Northeast. Whether it is digital or film, the art of photography is the criteria for all projects. And his love of photography is obvious in the thousands of scenic images Bob takes in his spare time.

CHRISTOPHER NAVIN
Christopher Navin is an editorial and commercial photographer who seeks a variety of subjects and assignments, but considers his ability to photograph people, in all settings and activities, his real passion. He is well known as a portrait artist with a keen, revealing eye. His work has been in numerous national and regional publications, which has provided him the opportunity to work with celebrity musicians

and sports figures. For his commercial clients, Christopher does a substantial amount of high-end still life photography, as well as corporate and annual report work.

PATRICK O'CONNOR

Patrick O'Connor is a commercial/editorial photographer with a studio in Worcester. His commercial work is seen on advertising layouts, annual reports and billboards for such clients as Hasbro, New Balance, Fallon and UMass Memorial. Editorially his work may be seen in WORCESTER MAGAZINE, RHODE ISLAND MONTHLY, BOSTON MAGAZINE and YANKEE, along with many trade periodicals. Named Photographer of the Year by the New England Press Association in 1989 and 1995, O'Connor has won more than a dozen NEPA awards for excellence, as well as numerous Holland Awards from the AdClub of Greater Worcester. He makes his home in West Boylston with his wife and two daughters.

FREDERICK PECK

Frederick "Rick" Peck is an editorial and freelance photographer, whose work appears regularly in the WORCESTER BUSINESS JOURNAL. His commercial clients include BankBoston, Allmerica Financial and Worcester's Centrum Centre. His other editorial clients include the BOSTON BUSINESS JOURNAL, and AIM INDUSTRY REPORTER. Peck's other areas of expertise are nature photography and environmental portraiture. He travels to all areas of the country from his studio in Worcester.

ROBERT A. RASLAVSKY

Robert Raslavsky began his career in photography as a passionate hobby, and soon his avocation became his vocation. With more than 15 years of work in various disciplines of commercial photography, he found new opportunities and a new creative outlet with aerial photography. According to Bob, the perspectives in the air are so unique and incredibly aesthetic that he is constantly amazed at the photographic opportunities he has. With his pilot's license, Bob travels from Maine to Florida and from the Bahamas to Alaska on photo assignments.

CHERYL RICHARDS

Cheryl Richards is a fine art photographer, specializing in photojournalistic-style weddings and natural light black and white studio portraiture. Cheryl has also been exploring the nuances of alternative process photography and has been producing her own line of hand-made greeting cards. Her work has been shown in many galleries including ARTS Worcester, the Fletcher/Priest Gallery, Worcester Art Museum, the Vose Gallery and the John Callahan Gallery. Cheryl is the recipient of numerous photography awards including BEST OF BOSTON Wedding Photographer, 1996 and 1998. Cheryl was named Photographer of the Year in 1996 and Master Photographer in 1997 by the Professional Photographers Association of Massachusetts.

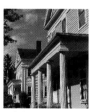

MARI PORTER SEDER

Mari Porter Seder started out as an abstract painter, graduating from Wheelock College. She then studied at the Art Students' League in New York and at the School of the Worcester Art Museum. She took her first course in photography at the Worcester Craft Center, and then earned a master's degree from Clark University. She began a small business in child photography, and also photographed the streets of Worcester and other places. She is a professor of Early Childhood Education at Quinsigamond Community College in Worcester. Mari's work is shown in galleries and collections in Boston, Worcester and Oaxaca, Mexico. Mari is a frequent lecturer on children's art throughout Massachusetts.

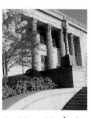

LARRY STEIN

Larry Stein is Worcester native, and a graduate of the Rochester Institute of Technology with a BFA in Photo Illustration. He spent 13 years working freelance in New York City for clients including Sony, American Express, IBM, Nynex, FORBES, Ciba-Geigy Pharmaceuticals and Bloomingdale's. He has had three books published on the Fabergé eggs. For the past eight years he has been based in Worcester, with his wife June, shooting advertising, annual reports, corporate capability brochures and catalogs for advertising agencies and large corporations throughout the Northeast.

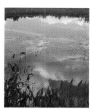

SHANNON TOWER

Shannon Tower hails from Sterling, Massachusetts, and is a graduate of the University of South Carolina. He is a freelance photographer who enjoys photographing abstracts and shadows, as well as natural and urban landscapes.

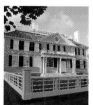

DAN VAILLANCOURT

Dan Vaillancourt's interest in photography began at age 10 with a camera ordered from a cereal box. A graduate of the Hallmark Institute of Photography, Dan worked as a photographer in New Hampshire before coming to Worcester. His work appears regularly in WORCESTER MAGAZINE and other publications for various clients in Central Massachusetts.

AMATEUR PHOTO CONTEST WINNERS

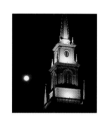

STEVEN P. BALL

Worcester

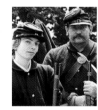

ERWIN G. MARKOWITZ

Worcester

ERIKA SIDOR

Princeton

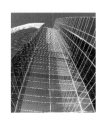

PHILIP C. WARREN

Grafton

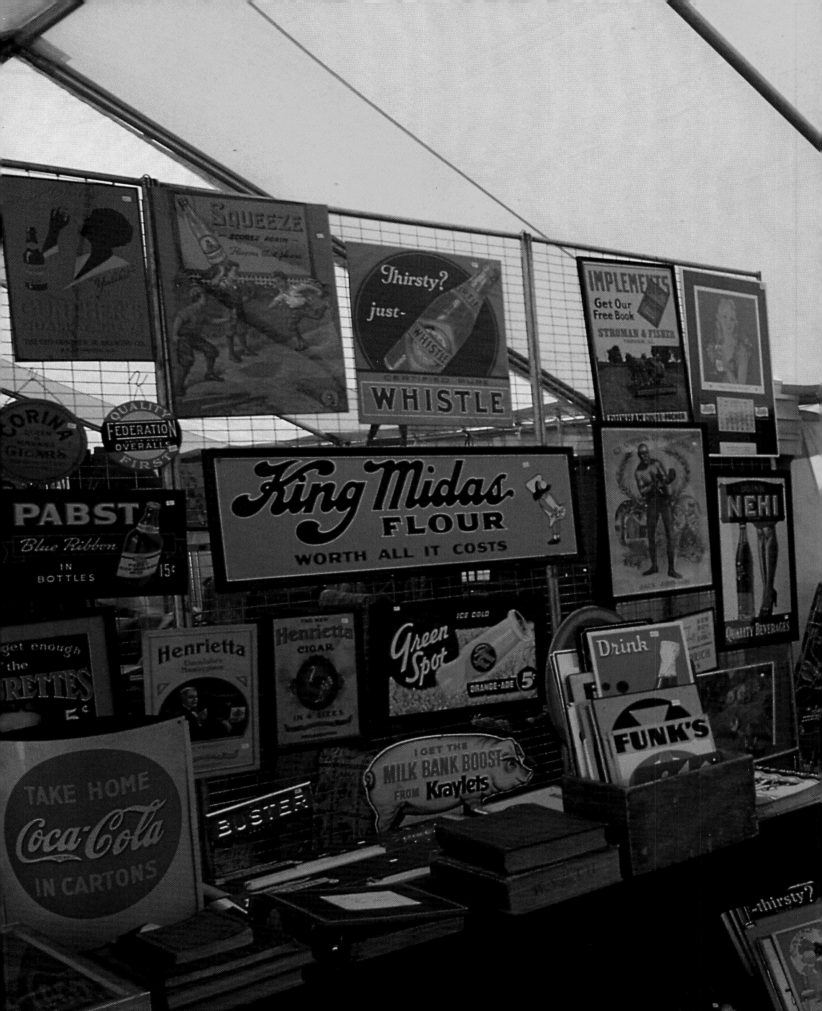

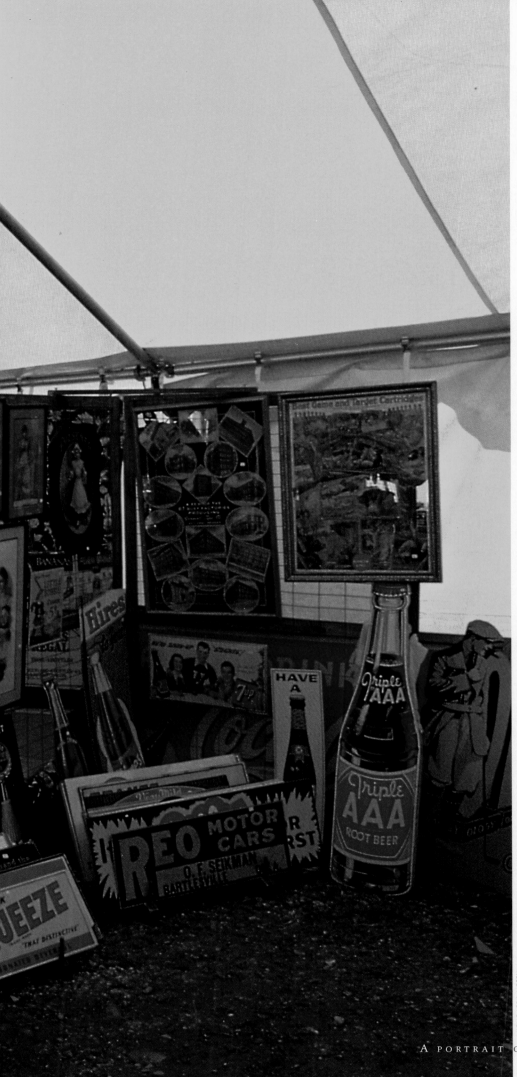

ALLEN FLETCHER

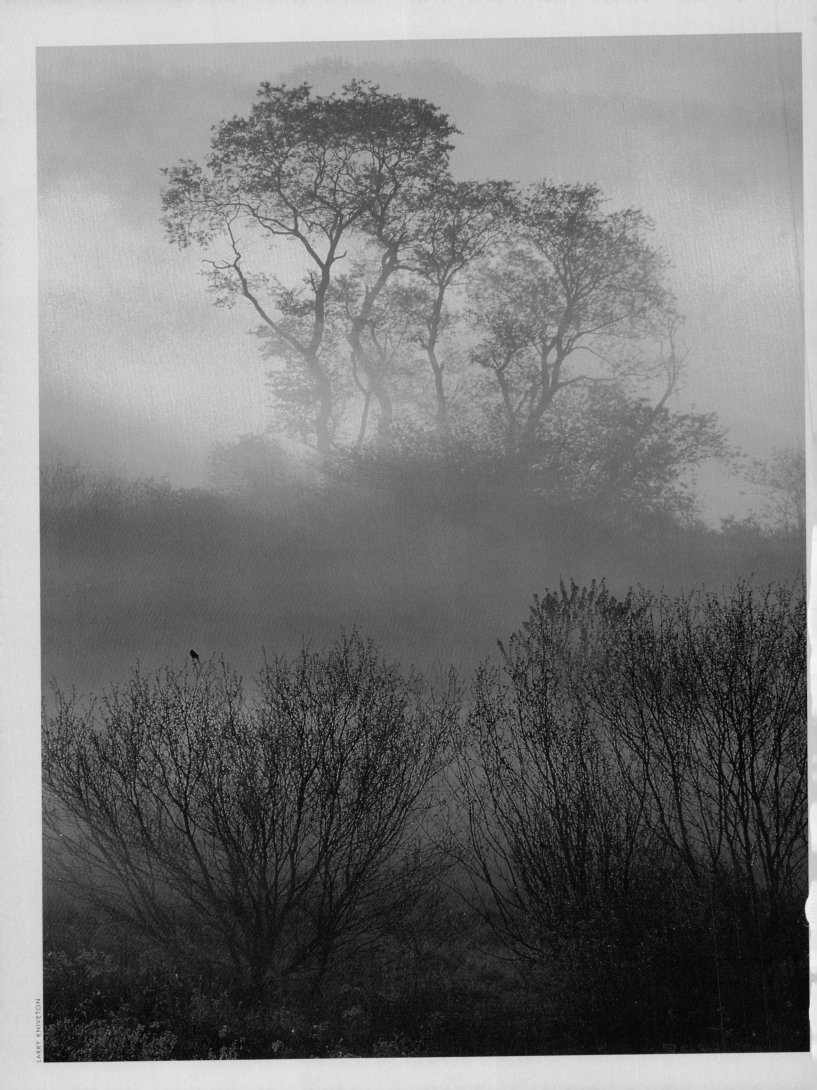